DOWN & DIRTY

DOWN & DIRTY

ARCHAEOLOGY
of the South Carolina Lowcountry

M. Patrick Hendrix

With Contributions by Christopher Nichols

Charleston · London

History PRESS

Published by The History Press
Charleston, SC 29403
www.historypress.net

Copyright © 2006 by M. Patrick Hendrix
All rights reserved

Cover image: Tobacco pipes. *Courtesy of New South Associates.*

First published 2006

Manufactured in the United Kingdom

ISBN-13 978.1.59629.092.1
ISBN-10 1.59629.092.7

Library of Congress Cataloging-in-Publication Data

Hendrix, M. Patrick.
 Down and dirty : archaeology of the South Carolina Lowcountry / M. Patrick Hendrix.
 p. cm.
 ISBN-13: 978-1-59629-092-1 (alk. paper)
 ISBN-10: 1-59629-092-7 (alk. paper)
 1. Charleston Region (S.C.)--Antiquities. 2. Excavations (Archaeology)--South Carolina--Charleston Region. 3. Charleston Region (S.C.)--History. 4. Charleston Region (S.C.)--Social life and customs. 5. Plantation life--South Carolina--Charleston Region--History. I. Title.
 F279.C447H46 2006
 975.7'915--dc22
 2006031698

Notice: The information in this book is true and complete to the best of our knowledge. It is offered without guarantee on the part of the author or The History Press. The author and The History Press disclaim all liability in connection with the use of this book.

All rights reserved. No part of this book may be reproduced or transmitted in any form whatsoever without prior written permission from the publisher except in the case of brief quotations embodied in critical articles and reviews.

Contents

Preface	7
Acknowledgements	11
CHARLESTON'S FIRST INHABITANTS	13
Native American Occupation on the South Carolina Coast and the Arrival of the Europeans	
THE BEGINNING OF SOMETHING GRAND	36
Archaeological Investigations at Albemarle Point and the Charleston Peninsula	
THE CHARLESTON FRONTIER AND THE AFRICAN POTTERS OF CHRIST CHURCH PARISH	55
Life at Thomas Lynch's Wando River Plantation	
BAPTIST ENCLAVES	80
Archaeology at Schieveling Plantation	
THE DECLINE OF THE ASHLEY RIVER ESTATES	106
Reconstructing the Planter's House at Spring Farm Plantation	
THE CONFEDERACY'S SECRET WEAPON	119
The Raising and Excavation of the *H.L. Hunley*	

Contents

Morris Island 136
 How the Land Shaped History and History Shaped the Land

Bibliography 157

Preface

When I finally sat down to write this book, it was still unclear in my mind as for whom it was intended. I had no preconceived ideas of it being an academic document or a school or college resource. Ultimately, my goal in writing this book is to offer a unique historical perspective of Charleston by looking at the area's archaeology. Since I began working in archaeology in 1990, I noticed that archaeologists tended to write exclusively for other archaeologists with little concern for public consumption. I found this amazing. Charlestonians love their history and they were being shut out of their history by the inaccessibility of archaeology. I wanted to write a book that examined Charleston's archaeological riches and to do so in a way the public can understand. As a result, this work may appear more historical or journalistic than archaeological but I felt that was necessary to provide the appropriate context and narrative framework for the findings and theories of this work. Additionally, I have taken certain liberties to tell the story. For instance, although the spelling of the settlement of Charleston changed several times throughout its history, I have referred to it here only as Charleston (except in the case of Charles Towne Landing) for ease of reading. This journalistic approach will no doubt make archaeological purists unhappy, but that was a group I was willing to annoy in order to tell the story in a way that I felt would make it more accessible to the general public. In fact, I would be greatly disappointed if I was not criticized by archaeologists for my approach to this book. Archaeologists are the Olympic gold medalists of peer criticism and it is this competition that pushes the discipline forward.

Though there are many fine histories of Charleston, I hope this work provides a unique perspective often ignored in the historical record. Even for parts of Charleston

Preface

where the historical record has been intensively studied—downtown Charleston, for example—the material record provides us with new insights into the lives of people who lived there. It is physical evidence that enables us to study the lives of those who left no written record documenting their own existence and to assess the veracity of records left by those who did. This approach is most important in the lives of slaves where the material record is far more democratic.

Similarly, because the prehistoric past has seemed like an impenetrable mystery for most people, there has been little interest in the daily lives of ancient people and hardly a suspicion of how different everything might have been. Likewise, the crude stone implements found by archaeologists have not attracted the same attention as familiar relics from the colonial and antebellum periods. Yet it was these stone tools that opened the dark continent of prehistory and expanded the dimensions of human history a thousandfold. The path into South Carolina's past no longer runs solely through Europe, but also through the buried remains of people who left no great monuments. It was not until archaeologists began to investigate America's prehistoric people that they discovered a new history that was far more extensive and more ancient than was suggested by the written word. Few other concepts have done so much to deprovincialize our thinking and expand the vistas of South Carolina's past. This work will attempt to bring some humanity to the artifacts left by South Carolina's first inhabitants and introduce the reader to new theories on the peopling of North America.

This story covers thousands of years of history. I wish I were an expert on the whole of this period. The fact is, I am not. The subject is just too vast and there is too much ground to cover. Additionally, I have not included bibliographical sources in the main text as it detracts from the narrative and I thought it might spook some readers that have little interest in scholarly writing. Readers hoping to learn more about archaeology should consult the bibliography to find more in-depth works. The Charleston County Library has a great selection of works done by Martha Zierden and Ron Anthony with the Charleston Museum. Martha has served as the de facto city archaeologist for many years and her contributions to Charleston archaeology are immeasurable. New South Associates is a close second in work done downtown. Anyone hoping to learn more about downtown archaeology should go to the library to find a copy of their report on archaeology at the Charleston Judicial Center. Stan South with the South Carolina Institute of Archaeology and Anthropology (SCIAA) is one of the best archaeologists South Carolina has ever known and his works are as well written as they are fascinating. Stan has produced nearly a dozen books and they are available at SCIAA and copies can usually be found at the Charleston County Library. In many respects this work is modeled after Jim Michie's work, *Richmond Hill Plantation, 1810–1868*. Though Jim passed away in 2004, he will be remembered quite simply as the greatest archaeologist in South Carolina history. The archaeological works done by firms like Brockington and Associates are more difficult to obtain and that is one of the reasons I have concentrated on their work in this book. I hope I have done justice to all the archaeological works I am covering and it is my greatest fear that I have not.

Preface

My success in this endeavor remains for the reader to judge; my intellectual debts, however, are there for all to see. My ability to write this little book would have not been possible without decades of scholarly research in Charleston. Unfortunately, I did not have the time or resources to write a complete synthesis of Charleston's archaeological history. My goals were less ambitious. I have written for the widest possible audience and hope this work will be read by those who would not normally be interested in such a subject. If these people find this book worthy of their time, I will be delighted.

Acknowledgements

Now that it is in the final stages, I have been encouraged by the responses of those who have read this manuscript. Your feedback has made it all worthwhile. Without your comments, insights and gentle guidance, it would not have developed the way it has. In fact, without technical assistance from archaeologists Stanley South, Eric Poplin and Martha Zierden, this work would have been a total disaster. Their eleventh-hour readings of portions of my manuscript and the care they took are evidence of their personal and scholarly generosity. Only they will know the embarrassing errors from which they saved me. Though their advice made this manuscript immeasurably better, any mistakes are mine alone.

To help the reader better understand this work, I have included as much photographic and graphical detail as my publisher would allow. On this front, I would like to give thanks to Tommy Charles, Nina Rice, Chris Amer and Stanley South with SCIAA for providing images used in the text. Similarly, Joe Joseph and Theresa Hamby with New South Associates provided information and images without which this work would not have been possible. Most of the archaeology covered in this work was done by researchers at Brockington and Associates. I worked at Brockington for four years and can never express my deep gratitude to everyone there. Despite complaints about "for-profit archaeologists," I can assure you that these people perform their work with a professionalism and love of the work that is hard to find in other careers. Archaeology is a tough living and I think these people deserve credit for helping to save our cultural history. Among those I would like to thank are Carroll Poplin, Kristrina Shuler, Eric Sipes, David Baluha, Josh Fletcher, Inna Burns, Bruce Harvey, Susannah Munson,

Acknowledgements

Brent Landsdell and the countless field crews and lab technicians who helped bring these archaeological sites to life. Thanks also to Ralph Bailey, whose not-so-gentle criticisms made me a better writer. Likewise, I would like to thank the many public and private groups that paid for archaeology in Charleston. It is easy to say that developers were compelled to do this work; however, I know that the developers of Appian Way, Schieveling Plantation, the Judicial Center, River Town and many other projects across Charleston were very enthusiastic about making these projects happen. But I owe no one more than Eric Poplin. I had been working on and off in politics when I decided to try a stab at archaeology and history. Eric took a chance on hiring someone with no experience and has acted as a selfless mentor to me ever since.

I would also like to give thanks to a number of people who have contributed to this work. Toni Hendrix and Judy Corbett came on board as soon as I started working on the manuscript and provided invaluable editorial advice. Thanks to their careful reading and incisive criticism, I was able to produce a book that hopefully tells the story without being too bogged down in technical language. Keith Derting was the genesis of this work with his nonstop complaints about the formal nature of archaeological writing. His advice was both aggravating and very helpful. The chapter on Morris Island was written almost entirely by Chris Nichols as a portion of his master's thesis. He deserves all praise (and criticism) for that portion of the work. He also provided many of the maps and other graphics for the book. Chris has been a friend since childhood and we are bound together by our sad love of watching the Gamecocks. My brother, Nick Hendrix, helped draw many of the sketches and was supportive throughout. Thanks also to Adam Hester who provided many fine photographs for this book.

There was as well the type of institutional support without which no work of history would get done. The staff at SCIAA provided information, images and advice critical to the completion of the manuscript. I owe a great deal to the staffs at the Charleston County Library, the South Carolina Department of Archives and History, Brockington and Associates, New South Associates, the Charleston Museum and Charles Towne Landing. Their knowledge and engagement in the project was a godsend. Finally, I would like to give praise and thanks to Kirsten Sutton and the staff at The History Press. Their great passion for history and professionalism has made writing this book a pleasure.

Most of all, this work is dedicated to Heather Spires, the very mention of whose name makes me smile. She helped guide and support me when I was at my most intolerable, which is saying a lot. Without her this work would never have been written.

Charleston's First Inhabitants

Native American Occupation on the South Carolina Coast and the Arrival of the Europeans

In the beginning, according to Hesiod, Cronos created men of the Golden Age who never grew old. Labor, war, and injustice were unknown. They eventually became guardian spirits on earth. Then in the Silver Age, when men lost their reverence for the gods, Zeus punished them and buried them among the dead. The Bronze Age, which followed (when even houses were made of bronze), was a time of endless strife. After the brief interlude of Heroic Age of godlike leadership in their Isles of the Blessed, came Hesiod's own unfortunate Iron Age. Yet worse was still in store for mankind, a future of men born senile, and of universal decay.
—Daniel J. Boorstin, The Discoverers

The Dark Continent of Prehistory

Until recently, archaeologists believed the first humans in South Carolina came from Asia about 13,000 years ago, not long after people first crossed into North America from Siberia during the final stages of the last Ice Age. The theory was that they came across the Bering Strait and then through Canada between two massive glacial sheets that dominated North America. Their culture was named Clovis after their distinctive spear points found near Clovis, New Mexico. Archaeologists believed that as these Ice Age Siberians spread into the American interior, they left these spear points as the common indicators of their epic travels, and that within a thousand years the ancestors of today's Native Americans had spread to the tip of South America, developing distinct cultures

and languages along the way. For perhaps 8,000 years, small kin-based bands of 50 to 150 individuals roamed the New World, hunting mastodons and mammoths, wild horses, elk, ground sloths, camels, deer, giant bison and small mammals that roamed the forests and grasslands. This theory has remained gospel for decades, and for most archaeologists the 13,000-year chronology was simply too satisfying to abandon. For them, the whole of New World prehistory ran from the Bering Strait to the arrival of Europeans in the fifteenth century. The theory would dominate and even tyrannize archaeology. But there was a problem. The facts did not fit.

The stone tools and hearths that have been unearthed from South America to South Carolina suggest that Stone Age America was far from empty when Siberians followed migrating animals here from Asia. According to a growing body of evidence, America was settled by sea-faring southern Asians, East Asians and even perhaps Africans and Ice Age Europeans long before the "discovery" of the New World by Christopher Columbus. DNA studies of Native Americans have identified at least five genetically distinct migrations, four from Asia and one possibly from Europe. "It's very clear to me," says anthropologist Dennis Stanford of the Smithsonian Institution, "that we are looking at multiple migrations through a very long time period—migrations of many different peoples of many different ethnic origins. Some of these people probably survived, some of them may have gone back home and some of them probably did not survive."

Archaeological sites themselves seem to intimate a chronology of prehistory far more extensive and ancient than has been suggested by graduate school textbooks. Archaeologists in Monte Verde, Chile, and Allendale, South Carolina, have made astounding discoveries of pre-Clovis-era artifacts, suggesting that people were in the New World much earlier than previously thought. Al Goodyear's team at the Topper site in Allendale has recovered tiny microblade tools struck from wedge-shaped cores of stone, which were presumably inset into long, narrow rods of bone, antler or ivory. Through geoarchaeological research, it has been determined that the stone artifacts were buried in the Ice Age Savannah River floodplain more than 15,000 years ago. The subsequent discovery of plant remains and charcoal from an ancient hearth may expand the horizons of South Carolina's past to 55,000 years ago.

Although several other potential pre-Clovis sites have been reported, none has yet to extend the dimensions of New World history the way Topper has done, and therefore not all archaeologists agree that Topper's antiquity is now firmly established. Some archaeologists believe that the broken charcoal and stone tools and other materials were actually formed through natural processes. Archaeologists are also puzzled by the absence so far of any human sites in North America that predate Topper. If the theory does prove true, the numbers of migrating human bands must have been so small, and their movements so nomadic, that they left few impressions on the land.

Discoveries at Topper raise other important issues for archaeologists. Most importantly, if people arrived in South Carolina more than fifty thousand years ago, then who were the Clovis people? It is generally accepted that they were big game hunters who migrated through a corridor between the ice sheets and spread remarkably

fast to the southern end of America, but this analysis has been steadily undermined by a series of archaeological discoveries, including a site in South America that predates the Siberian migration by more than one thousand years.

Another crack in the old theory is the absence of Clovis technology in Siberia. If northern Asians were the people who brought the Clovis spear point to the New World, it stands to reason that the same tools would have been found in Russia. At the very least, Dennis Stanford has reasoned, if the Asian immigrants had invented Clovis technology after reaching the New World, evidence of a transition from Asian microblade tools to Clovis technology must exist. But nothing resembling an intermediate form between the two technologies has been discovered in North America. At an impasse, Stanford and lithics expert Bruce Bradley looked elsewhere for the genesis of Clovis technology and found a likely parent in an unlikely place—Europe. Stanford and Bradley believe that the Solutrean people, who lived in northern Spain and southwestern France in the Paleolithic period, carried their pre-Clovis technology across the Atlantic.

Suggesting Ice Age Europeans as the source of Clovis technology is heresy in the archaeological community, but for Stanford and Bradley, the Clovis spear points look nearly identical to those made by the Ice Age Solutreans. According to Stanford, "There is very little in Clovis—in fact, nothing—that is not found in Solutrean technology." Stanford suggests that the construction of animal-skin boats and finely crafted stone tools would have made it possible for Ice Age Europeans to migrate across the ice sheets that at that time stretched from France to Pennsylvania. The ice sheets may appear a hopeless and frozen desert to modern people, but it was actually a land that offered abundance to those strong and smart enough to brave the arctic environment. The icy waters would have provided an inexhaustible nursery of fish, sea mammals and birds. The theory of the peopling of North America is no longer that of scattered groups following Ice Age animals, but of extraordinarily sophisticated travelers fighting it out at the dawn of New World history in a landscape calling for every bit of wit and spunk that man could muster.

Unfortunately, none of this evidence rises to proof amounting to mathematical certainty, so archaeologists have to look to the less mutable parts of man, namely his DNA. Scientists at Emory University and the Universities of Rome and Hamburg studying the mitochondrial DNA of America's indigenous people have discovered a genetic marker in about twenty thousand Native Americans that is present in Europeans but not in Asians. The geneticists believe that the marker may have existed in the Americas 12,000 to 34,000 years ago, perhaps brought by the Solutreans. This would help explain how DNA from ancient Europeans has been found in Native Americans.

Having made it to the mid-Atlantic region, these Ice Age travelers would have continued to hunt, explore and settle the areas south of the glaciers. This would explain why the oldest Clovis sites have been located in the southeast United States. Using their animal-skin boats, the Clovis people probably advanced quickly into the American interior. There would have been terrific collisions, not only of people but

also of their technologies. If pre-Clovis people had already established themselves in the New World, one can only imagine the disequilibria caused by the clash of cultures and the introduction of Clovis technology. Contrary to widespread impression, not all stone tools are created equal. The finely crafted Clovis point could kill the great Ice Age animals with a staggering efficiency unknown to pre-Clovis people. The wide distribution of such artifacts suggests the Clovis technology was adopted by established populations and spread like wildfire through the eastern woodlands and into the Great Plains and Canada.

The Paleo-Indian Period (14,000 to 10,000 Years Ago)

Whatever the origins of man in the New World, human beings were well established in South Carolina by the end of the last Ice Age. Paleo-Indians, as archaeologists have named them, were well adapted technologically and socially to climates, vegetation and animal populations very different from those of today. The masses of ice did not reach as far as South Carolina, but they did cause the climate to be much cooler than it is now. Thirteen thousand years ago South Carolina may have looked a lot like present-day Canada.

Paleo-Indians' primary prey was the great herds of mammoth, mastodon and bison that grazed on the grasslands along the coastal plain. Hunting and stalking such formidable prey was dangerous but worth the risk—the meat, skins and other parts of the animals could be used for food, clothing, tools and many other needs. Archaeological evidence indicates that the Paleo-Indians adapted to a nomadic relationship with these animals, living in hunting camps only as long as sources of wood, workable stone and game animals lasted. Populations were small, and hunting camps were probably occupied only by extended families and those with no surviving family of their own.

That all these first South Carolinians should be known for is their tools is inevitable, since the overwhelming majority of the evidence of their existence during this span consists of the implements they used, lost and broke while camping, hunting and butchering. Unlike flesh, bone or wood, stone is durable, and therefore lithic tools are left as the common indicators of the earliest people in an area. The Paleo-Indians were very discriminating when it came to the type of rock they used to make their tools, and it would not have been unusual for them to travel hundreds of miles to get high-quality coastal plain chert. Chert was preferred for practical considerations but it was likely chosen for spiritual reasons as well. Selecting a rock with some mystical quality may have shown the proper respect for the animals on which the Paleo-Indians relied for survival and, in their minds, ensured abundant game for the future.

In South Carolina, sources of such stone are rare and Paleo-Indians moved great distances to obtain it, primarily from the Savannah River area. The exceptional quality of the chert, combined with an abundance of game, drew Paleo-Indians to the same place on the Savannah River that pre-Clovis people went to quarry stone.

Unlike the majority of Clovis sites, which are mostly the remains of temporary camps, the Topper site appears to have been inhabited over long periods and thus contradicts the standard view that Clovis people were always highly mobile, nomadic hunters. Many of the artifacts found at Topper are tool fragments left behind by people who stuck around long enough to not only break their tools, but also to salvage and rework them.

No archaeological sites from the Paleo-Indian period have been discovered in Charleston; most discovered sites are concentrated at the edge of the Piedmont, called the fall line, where the rivers drop to the coastal plain, suggesting that Paleo-Indians moved from the Upcountry to the coast, depending on the season. However, at that time, the ocean was still far below its present level. If people had wintered near the Atlantic Ocean, their campsites would now be underwater, which would explain why there are no *known* sites in Charleston.

While far from conclusive, evidence points to the existence of archaeologically rich sites off the coast. Stone artifacts of the Paleo-Indian period have been recovered by divers in the Charleston Harbor and nearby estuaries. Similarly, shrimp trawlers have even netted spearheads from depths of sixty feet off the South Carolina coast on what was once shoreline. Perhaps the best example of an underwater find is the discovery of a mineralized mastodon bone from Edingsville Beach on Edisto Island. After examination by a number of experts and further work with a Scanning Electronic Microscope, archaeologists determined that the distinctive cut marks along the rib bone were from a human tool. Researchers do not know for certain that these submerged finds come from wintering settlements, but such findings are intriguing. Archaeologists now recognize that important data may be located along the ocean floor, though these sites are nearly impossible to find, excavate and interpret.

Although no sites have been discovered, artifacts from this period have been recovered in Charleston. One of the strangest discoveries of a Paleo-Indian artifact came when a team of archaeologists working with Brockington and Associates, a cultural resource management firm, were excavating the trash pit of a nineteenth-century slave cabin located in the shadow of the Family Circle Tennis Stadium. They expected to find fragments of animal bone, ceramics, bottles and the everyday trash associated with a domestic occupation. They were startled to find an 11,000-year-old Clovis point discarded among the household items of a slave house. The discovery prompted a number of theories. Dr. Eric Poplin, the leading archaeologist on the dig, thought that recent strikes on the blade suggested it had been used as a flint to start fires for the cabin chimney. But he thought that the simplest explanation was perhaps the best explanation: years ago, someone found the spear point and having found it fascinating or beautiful, brushed the sandy soil off the blade and pocketed it as a keepsake. The slave, perhaps aware that he or she had found an artifact from a bygone era, certainly never conceived that it was crafted in the age of the mastodon.

DOWN & DIRTY

THE ARCHAIC PERIOD (10,000 TO 3,500 YEARS AGO)

By about ten thousand years ago (8000 BC), the earth's warming trend and consequent glacial retreat had released enough water back into the Atlantic Ocean that the coastline was edging closer toward present-day Charleston. In general, the ways of the Paleo-Indian continued for no more than another thousand years. While the Ice Age had been dominated by large animals such as mammoths, these animals were now dwindling because of climate changes and the consequent loss of food sources. These game animals migrated northward, in pursuit of the receding glaciers, and the people who had depended on the ready accessibility of these large animals struggled to adapt to the new oak and chestnut forests that arose in the southeast United States. They came to rely more on plants, nuts and fruits, and on fish and small animals such as deer, rabbit and turkey. The subsequent revolution in human culture and technology is known as the Archaic period (8000 BC–1000 BC), further subdivided by archaeologists into the Early Archaic, Middle Archaic and Late Archaic sub-periods.

During the Early Archaic period (8000 BC–6000 BC), humans learned about new foods and developed tools with a higher level of specialization for hunting, gathering and processing these foods. Nurtured by the milder environment and longer growing season, populations grew rapidly. Rather than drifting, the Archaic people lived according to a set path of seasonal harvesting. They were essentially settled along this seasonal migration, usually building their most substantial camps in their wintering places. Thus, several residences were constructed strategically so that foods in different areas could be exploited when they were available. Social gatherings must have occurred during the Archaic period so that different tribes could meet peaceably and where hostilities were temporarily laid aside. These meetings may have served as informational exchanges, but they also helped affirm social networks and alliances. In South Carolina, the annual journey could have taken these people 180 miles across the coastal plain into the Piedmont with harvesting of various plants and animals along the way.

Population growth and settlement of areas around Charleston's rivers and inlets is evident in the Early Archaic period. Archaeology suggests that people tended to camp along river terraces, with fewer occupations away from these areas. Typically, sites dating to the Early Archaic period represent short-term hunting and collecting camps where people struck out to hunt and gather food. More substantial base camps may have existed around the estuaries, where shellfish were probably an important food source throughout prehistory. Few Early Archaic archaeological sites exist near Charleston, and traces of dwellings are nonexistent. Dwellings would have been lightweight and temporary, perhaps inhabited for only a single visit to a campsite.

The high degree of craftsmanship evident in the Paleo-Indian period continues in well-made Early Archaic toolkits consisting of corner-notched hafted points. In Charleston County, Early Archaic sites are represented by Kirk and Palmer corner-notched and big sandy side-notched projectile points. Other types of tools from

this period include scrapers for working wood, bone and hide; larger blades used as knives; and heavier items such as axes and nutting stones (mortar and pestle). Early Archaic people were some of the most discriminating when it came to lithic materials, preferring the chert found near the coastal plain. Bone and antler were likely fashioned into a wide variety of tools. Being long, straight and hard, deer bones from the limbs were undoubtedly used, sometimes as mounts fitted with blades to form spearheads or knives. Although wood must have been commonly used, wooden artifacts have not survived in Charleston's acidic soils.

The Middle Archaic period (6000 BC–2500 BC) witnessed a gradual population increase in the Charleston area and throughout much of the Southeast. This long period corresponds with another episode of environmental change. Climactically, the Charleston area was getting warmer, and an oak/hickory forest dominated the coast until after 3000 BC, when pine became more common. As wetlands and marshes developed, the coastal plain became more environmentally diversified. This pattern was periodically interrupted by heavy periods of precipitation, sea-level rise and changes in vegetation. In Charleston County, Middle Archaic archaeological sites are more numerous than sites from earlier periods, but still few in number. Possibly, Paleo-Indian, Early Archaic and Middle Archaic peoples lived farther east, closer to the ocean. Stemmed projectile points and ground stone artifacts are most associated with this period, and sites increased in size and density of artifacts. Most of these sites appear to be similar in function, indicating that groups moved their residences frequently, continuously looking for food with less concern about how and where they would travel than their forebears.

Compared to the Early Archaic period, stone tools were simpler and toolkits less diverse in the latter portion of the Middle Archaic period. Because of the unpredictable environment, people produced a few simple tools with diverse applications with expediency as the rule. Archaeological evidence indicates that these people tended to use local workable stone rather than travel great distances for better lithic materials. Many of the stone blades found during the Middle Archaic period have similar size and function, which is not likely the result of chance. This consistency is the result of people crafting socketed or slotted tools of bone, antler or wood that could be fitted with standardized blades. The stark contrast in style and craftsmanship between Middle Archaic points and earlier ones has led some researchers to suggest a migration of people from the north into South Carolina. The first solid archaeological evidence of the *atlatl* (Aztec for "spear thrower") use also comes in the Middle Archaic period, though it might have been used earlier. An *atlatl* is a device used to throw a dart with much greater velocity than a thrusting spear.

The Late Archaic period (2500 BC–1000 BC) in the Southeast is broadly characterized by increases in population, social complexity and long-distance trading networks. By the end of the Late Archaic period, two developments occurred that changed the way people lived on the South Carolina coastal plain. The sea level rose to within a few feet of present levels, and the extensive tidal marshes were established along the coast. These estuaries were a reliable source of fish, waterfowl

Down & Dirty

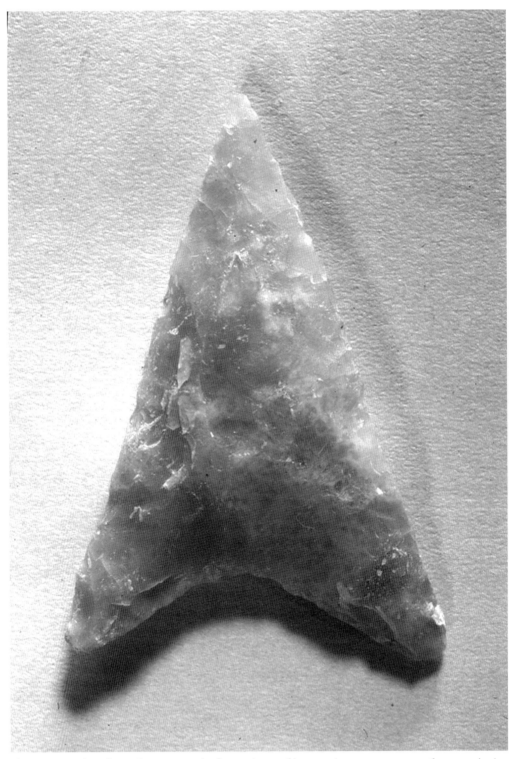

The presence of small triangle points are the first evidence of bows and arrows. *Courtesy of Tommy Charles. SCIAA/University of South Carolina Photo.*

and shellfish, making it an attractive place to live most of the year. Sites from the Late Archaic period suggest that people stayed in the same spots for longer periods of time; with food in ready supply, they rarely had need to move camp. Because the sea level has changed little since that time, the shell middens (mounds of used and discarded oyster and other shells) that bear witness to this change in the way of life have been preserved, unlike so much evidence from earlier times.

Late Archaic sites away from the tidal marshes continue to represent short-term camps occupied during seasonal hunting and gathering forays as Archaic peoples adapted to the established longleaf pine forests. The scarcity of wild game in the pine forests may have fostered a comparatively simple, more mobile egalitarian society. Still, the adoption of widely popular stone tool technology suggests that extensive trading networks had developed among the bands of people. Additionally, tools made of coastal plain chert are found in the Piedmont and the presence of tools and bowls made from Piedmont soapstone have been found along the coastal plain. Also, it is during this time, known as the Ceramic Late Archaic period, that the first pottery appeared on the South Carolina coast. No overnight change from a pre-ceramic, Late Archaic stage to Ceramic Late Archaic stage is recognizable in the archaeological record. Instead, there was a slow adoption of pottery into the culture as people discovered that it was more suitable for cooking and holding water than the baskets that had up to that time served their purposes. In the Charleston area, the pottery was tempered with sand and vegetable matter, often Spanish moss, which helped make the vessels more durable. Decorations include punctuation, incising, finger pinching and stamping. Some designs could be done with the bare hand, like pinching the rim, while others required a paddleboard to press a design into the clay surface.

The best-known Ceramic Late Archaic sites are shell rings, which occur frequently along tidal marshes. There are some thirty known sites along the Southeast coast from Sewee, just north of Charleston, to central Florida. Shell rings are manmade structures consisting of a doughnut-shaped circle of shells in the form of a ridge usually around 2 feet high and from 130 to 300 feet in diameter. The interior portion is usually flat and devoid of shells. Invariably, the shell ring is composed of varying proportions of oyster and other shells combined with earth and a moderate frequency of artifacts, including pottery fragments, animal bones and shell tools. The pottery fragments from the sites are tempered with vegetal fiber and are among the oldest evidence of pottery in North America. In addition to artifacts, archaeologists have found postholes and large oyster roasting pits at these sites. SCIAA director William Edwards was the first to recognize the importance of shell rings and test sites on Hilton Head Island. The earliest testing of a shell ring in Charleston County was conducted by Dr. E. Thomas Hemmings at a shell ring near Edisto Island.

After excavations at Lighthouse Point in 1985, archaeologist Michael Trinkley described the shell rings as "mundane occupation sites for fairly large social units which lived on the ring, disposed of garbage underfoot, and used the clear interior as areas for communal activities." Recent excavations at the Fig Island ring near Edisto

Island, however, suggest that these sites were more than the everyday remains of coastal settlements. Archaeologist Rebecca Saunders with Louisiana State University has discovered that one of these rings was connected to a large cone-shaped mound by a meticulously constructed ramp. Postholes indicate multiple structures, and it appears that the shells were carefully layered rather than piled. To archaeologists working on the site, the shell ring could only represent a ceremonial center.

Similar cultural and technological developments were happening throughout South Carolina. Near present-day Edgefield County, a dynamic and innovative new culture was evolving in the Savannah River valley. The Stallings culture began around 4,500 years ago, and appears to have lasted a thousand years. The Stallings culture is named after an island in the middle of the Savannah River, about eight miles from Augusta, Georgia. Archaeologists have been studying the site since the 1850s and it has proven to be one of the most important sites in the United States. Researchers have concentrated their efforts on a two-acre accumulation of mollusk shells that reached 12 feet tall, 500 feet wide and 1,500 feet long. In this mound, archaeologists have unearthed thousands of exceptional artifacts, including fragile awls and fishhooks made of bone. They have also identified stone spear points, shell beads, decorative pins and bone and stone pendants, and some seeds and nuts have been sifted out of the soil. Chunks of animal bone also managed to survive in the shell mounds, physical remains of a hunter's last kill. But for archaeologists, the broken pieces of Stallings pottery are the most important artifacts because they are considered the oldest in all the United States. The widespread use of this pottery suggests a network of kin and allies that reached as far as the coasts of South Carolina and Georgia. After reaching its cultural zenith about 3,500 years ago, Stallings Island and the surrounding villages were mysteriously abandoned, and the people dispersed.

The Woodland Period (3,500 to 1,200 Years Ago)

Archaic people lacked two things that most people associate with prehistoric Indians. These cultural elements are the bow and arrow and widespread use of pottery. In fact, these two great advances mark the opening of South Carolina's next cultural stage, called Woodland (1500 BC–AD 1100), further subdivided into Early Woodland, Middle Woodland and Late Woodland sub-periods. Small triangular and stemmed projectile points, fitted to arrow shafts, are recovered for the first time on Woodland archaeological sites. A hunter could shoot an arrow farther and more accurately than he could throw a spear. It was also an efficient means of hunting since now a single hunter could stalk and kill prey. Prior to that, the hafted stone tools of Archaic peoples and Paleo-Indians were used for spears, knives and darts used with the *atlatl*. Pottery also underwent a long period of acceptance. In the Early Woodland period (1500 BC–200 BC), the region was an area of interaction between widespread ceramic decorative and manufacturing traditions. The Woodland people of Georgia and Florida decorated their pottery with

designs pressed into the surface of the clay with a carved paddle. Woodland people of the mid-Atlantic preferred to impress the surface of their pottery with cords made of vegetable matter.

Despite the introduction of these new elements into the way people lived, Middle Woodland Indians (200 BC–AD 500) still hunted or gathered food rather than grew it. Archaeological sites from the period are found in all portions of Charleston, although tidal marsh expansion caused an increase in the number of marine resources, such as oyster beds, and a corresponding increase in campsites near the coast. People still spent considerable time at shell middens, although less than in the Early Woodland period. Archaeology indicates people settled in larger, semi-permanent villages along rivers and streams with fewer permanent camps at oyster beds. People also practiced agriculture during this period but their crops were not of sufficient importance, nor had their methods of cultivation become intensive enough, to tie them closely to the ground. Stanley South, a veteran archaeologist with SCIAA, uncovered the remains of a Woodland period house during excavations at Charles Towne Landing. A radiocarbon date of AD 1105 was obtained from a thirty-two-foot circle of postholes containing charcoal. This is the only fully documented site of a Woodland period structure recovered in Charleston to date. Subsistence remains at the site indicate that oysters and fish were major sources of food, while hickory nuts and acorns have been recovered from other archaeological sites. The Late Woodland period represents the most stable prehistoric period in terms of sea-level change and climate. It is thought that this general environmental stability resulted in a stable settlement pattern, but the archaeological information is not available to address this theory.

Distributions of ceramic (pottery) styles and other artifacts suggest to archaeologists that Woodland Indians began to recognize territorial boundaries. The period apparently saw the expansion and subsequent interaction of groups of different regional traditions. Variations in pottery styles may reflect different tribal affiliations or cultural traditions. One type of pottery has only been found along the Wando River, indicating how provincial some of these groups might have been. The more obvious boundaries may reflect early language groups of the Siouan, Iroquoian and Algonquian Indians later met by the Europeans. Intangible cultural elements cannot be recovered from archaeological deposits at any site; consequently, related questions about tribal affiliations, language or religious practices will remain unanswered forever.

THE MISSISSIPPIAN PERIOD (1,200 TO 300 YEARS AGO)

Between 1,200 and 1,000 years ago, a distinct shift away from the way people lived in the Woodland period occurred over a broad area of the Southeast. Archaeologists define this as the Mississippian period. In contrast to the relatively egalitarian, tribal organization of the Woodland period, regional Mississippian populations were typically organized into chiefdoms—territorial groups with hereditary, elite leadership classes. Only a revolution in agriculture could account for this change. The widespread cultivation of maize and

Engraving by Theodore DeBry, after a watercolor by John White. Courtesy of the Library of Congress.

beans fostered the Mississippian tradition with its population increases, surplus foodstuffs, enormous earthen platform mounds, more complex political organization and the emergence of numerous powerful chiefdoms throughout the Southeast. New varieties of corn spread that could mature within a 120-day season, allowing two crops to be harvested annually. In addition to maize cultivation, the gathering of plant foods such as nuts and the cultivation of sunflowers, beans and squash contributed to a balanced diet. Presumably, religious ideas also spread throughout the Southeast, supplanting what had been distinct regional traditions in many areas.

Though Mississippian culture was slow to establish itself in South Carolina, between AD 1200 and 1300, the newcomers constructed an important ceremonial center along the Savannah River. The Mississippian mound building culture flourished and large, permanent towns developed in the Savannah River valley. Centers typically included one or more flat-topped, earthen "temple" mounds, public areas and buildings used for religious and political assemblies. Wooden palisades, earthen moats or embattlements were placed around many villages for defensive purposes.

During the Late Mississippian sub-period, the regional chiefdoms apparently realigned, shifting away from the Savannah River centers to those located in the Oconee River basin and the Wateree-Congaree basin. The chiefdom of Cofitachequi, located at Mulberry Mound (Kershaw County), was a powerful political entity that covered thousands of miles of central South Carolina. Mulberry Mound was the center of Cofitachequi and the residence of the political leadership. Though dozens of houses surrounded the mound, most common people lived in outlying villages along the Wateree River or its tributaries. Evidence unearthed by archaeologists paints a picture of a vibrant Mississippian community, with houses of thatch and mud plaster stretching out far and wide among cultivated fields. Traders from distant places arrived via the river, bringing not only basic items but also coveted luxury goods such as copper, mica, pearls and conch shells.

It is unclear how early and to what extent similar developments occurred in the Charleston area. The archaeological record indicates that seasonal villages and maize horticulture were present in the area and that significant mound centers were present in the interior coastal plain to the north and west. The Charleston County area apparently lacked any mound centers and was well removed from the core of Cofitachequi, the powerful chiefdom in the South Carolina interior.

Mississippian societies described by early French and Spanish colonizers of South Carolina were organized along strict lines of social hierarchies determined by heredity or exploits in war. A spectacular group of artifacts, decorated with distinctive motifs, reflects a need for personal status identification and perpetuation of family lineages. Other artifacts bear witness to a widespread religion known as the Southern Cult. The ritual objects include marine shell discs used as gorgets (chest decorations) and conch shells decorated with incised designs such as human eyes, elaborate crosses and sunburst motifs. Other objects include pottery vessels made in new and elaborate shapes, polished stone axes, painted textiles, embossed copper sheets and pottery vessels in the shape of effigy heads, which may be have been representations of ancestors.

The most extensive excavations at a Mississippian site in Charleston were conducted by Stanley South at Charles Towne Landing. South uncovered a significant number of prehistoric artifacts while unearthing remains of the colonial-era Charleston settlement, prompting a major recovery effort. Excavations uncovered two stockaded, squared Mississippian enclosures, one 208 by 200 feet in extent and the other roughly half that size. Both were found and mapped along with the outline of an earlier Woodland period house. A number of burials were located, and several unusual structures within the enclosure indicated to archaeologists that the compound was not a fortified village, but rather a ceremonial center.

According to South, the ceremonial center at Charles Towne Landing State Park was in use in the early fourteenth century and functioned as a center for the burying of the dead and for the playing of the game chunkey. The palisaded area at Charles Towne Landing had no temple mound such as those found at ceremonial centers in the South Carolina interior. The archaeological evidence suggests a class-structured social organization, with "flexed burial proscribed for a lower class, and flexed burial with grave goods for the members of the upper class." The burials and ceremonial structures were oriented on a north-south axis. This alignment correlated with the shadow of the sun at sunrise of the vernal equinox and the summer solstice. According to English colonists four hundred years later, these dates coincided with important ceremonies for the Native Americans that lived in Charleston.

The palisades likely served as protection against enemies to the west, though local groups may have also skirmished with one another. By the mid-seventeenth century, the greatest danger came from the Westoes, who had only recently arrived along the Savannah River. They were said to be fierce warriors and cannibals with a particular taste for babies. But what the Westoes were really good at was enslaving other Native Americans to sell to the Europeans. They remained a lingering threat to the coastal tribes until 1681, when they were utterly destroyed by the Savannah (Shawnee).

The Arrival of the Europeans

The first forays by Europeans into South Carolina began with the Spanish explorations in the 1520s, their arrival being a disaster that has no exact parallel in South Carolina history. Though supplies of gold and silver proved nonexistent, the Spanish predatory enterprises were a steady profession and South Carolina was made a focus of their sack and slaughter. Lucas Vasquez de Ayllon and a large body of Spanish infantry first landed on the banks of the Combahee River where they were well received by the Native Americans, who offered food and supplies. The Spanish repaid this kindness by inviting 140 Indians aboard their ships, enslaving them and sailing for Cuba. Before reaching their destination, every captive had drowned or died of disease.

Having made few friends on his first trip, Ayllon's second expedition into coastal South Carolina was stoutly attacked and nearly annihilated by the Native Americans. Ayllon was followed in 1540 by Hernando de Soto, who passed through South Carolina

French landing at Port Royal. *Courtesy of John Frost, 1860.*

and visited Cofitachequi. The Mississippian leadership accepted the approach of the enemy without adopting any measures of defense, of negotiation or of a retreat. De Soto was given food, shelter and freshwater pearls by an Indian princess who welcomed the Spanish to the town. Failing to find precious jewels and metals, de Soto decided to push on. Considering it impossible to march through South Carolina without being attacked, he seized the Lady of Cofitachequi and obliged her to issue orders that the Spaniards should be supplied with whatever her territory afforded. She finally escaped near the frontier. Unfortunately, her captors had already crossed much of the state, spreading infectious disease that carried off the native inhabitants, and leaving deserted villages and towns in their wake.

For more than twenty-five years, the Spanish continued to claim Florida, and even the whole of North America, without so much as a fort on the whole of the continent. It was not to be expected that so ridiculous a claim would remain unchallenged by the more powerful European nations. In April 1562, a 150-man expedition led by experienced seaman Jean Ribault reached Florida, then sailed north to South Carolina, naming rivers and erecting stone monuments along the way, laying claim to the land for France. Port Royal so delighted Ribault that he landed and chose Parris Island as the site of his colony. After a tense introduction, the French were cordially received by the local tribes, who were flattered by their polite deference and glad to have any ally against the Spanish. Having erected a fortified settlement called Charlesfort and placed the settlement in a promising condition, Ribault left 26 men and returned to France for reinforcements and supplies. Reinforcements and supplies, however, did not reach the little colony. Civil war in France prohibited Ribault from reaching port, and across the ocean the settlers at Charlesfort were forced to rely upon their Native American neighbors for food after a fire destroyed their supplies.

With help from Orista Indians, the Frenchmen constructed a ship and set sail for their home country in April 1563. After a few weeks at sea, their slender stock of provisions was exhausted, and the French were forced to eat their leather shoes and jackets, eventually cannibalizing one of their shipmates. After weeks adrift, the pitiful lot was mercifully rescued by an English vessel and returned to France. When the French attempted to return to Port Royal, their expedition became grounded near a Spanish garrison in La Florida. The Spanish negotiated a surrender of the surviving Frenchmen, and then promptly put them all to the sword as heretics. Once news of the slaughter reached France, a contingent of soldiers and sailors under the command of Dominique De Gourgues sailed to La Florida and massacred the Spanish. An inscription was made on a tree where their fellow Frenchmen had been put to death stating: "Not because they are Spaniards, but because they are traitors, robbers, and murderers." De Gourgues, who had no intention of settling in the New World, returned to France a hero.

In May 1564, a Spanish ship commanded by Manrique de Rojas was dispatched to Port Royal to locate and destroy Charlesfort. All they found was a French boy who had run away from the settlement, living with a group of Indians to the north of Port Royal. The boy, Rouffi, guided the Spanish to the abandoned settlement, which they burned to

the ground. Two years later, the Spanish returned and built the city of Santa Elena on Parris Island. This fortified settlement became the home of five hundred Spaniards and served as the capital of Spanish La Florida from 1568 to 1576.

The colonists were protected by a garrison of 80 soldiers at Fort San Salvador and Santa Elena became a base of operations for explorations into the South Carolina interior. In 1576, Captain Juan Pardo brought an additional 250 soldiers to Parris Island and constructed Fort San Felipe. Not content to stay on the coast, Captain Pardo led a detachment of 125 soldiers across a wild country, intersected by broad streams, swamps and forests, to establish friendly relations with the Native Americans and to find an overland route to Mexico. They traveled as far as the Appalachian Mountains where they built Fort San Juan in the foothills to protect Spain's new possessions. On his second expedition into the interior, Pardo built and garrisoned four additional forts. Though nothing is known for certain, the forts were likely destroyed by Indians in retribution for atrocities committed by the Spanish.

Santa Elena continued to grow as colonists were lured to South Carolina by the prospect of free passage, fertile land and government subsidies. Though most colonists were farmers or soldiers, the settlement also had blacksmiths, carpenters, a barber and artisans of all types. Despite the presence of a fine church, tavern and other signs of prosperity, Santa Elena was far from self-sufficient. Plagued by disease and chronic food shortages, the Spanish settlers were obliged to depend entirely on the Indians for food, a situation that brought the colonists into constant conflict with their immediate neighbors. Though it appears that the Spanish had initially come with a sincere desire not to provoke the Native Americans by acts of cruelty, soon the Indians looked at the Spanish as nothing more than a band of thieves and murders.

The situation was further inflamed when, in the summer of 1576, the Spanish murdered three local chieftains and marched against several local villages, leaving the region little better than a barren waste. The Edisto and Guale nations determined to rid themselves of the Spanish and launched a sudden attack of five hundred warriors upon the Spaniards, killing thirty members of the garrison. The Spanish finally repulsed their infuriated opponents, but not before chaos took over Fort San Felipe. Reduced to great extremities by the attacks of the natives, and with scant food supply, the Spaniards fired the town and retreated to St. Augustine in 1576.

No sooner had the Spanish abandoned Santa Elena than the French resumed their schemes of colonization. In the summer of 1576, the French ship *Le Prince* arrived in Port Royal Sound, where the large contingent of colonists were shipwrecked, and upon washing ashore found the first French settlement entirely destroyed. Finding themselves in a nearly hopeless situation, the French saved from the wreck provisions, arms and various articles, and established themselves on a spot of high ground where they built a fort. Their attempt at self-sufficiency was an utter failure and those who were not killed by the natives established themselves among the friendlier local inhabitants.

Word of a French garrison at Port Royal brought the Spanish back to South Carolina. After killing the remaining Frenchmen living among the Indians, the Spaniards erected a prefabricated fort near the former location of Fort San Felipe. Called Fort San Marcos,

Reduced by attacks from local groups and the scanty supply of food, the Spanish temporarily abandoned South Carolina in 1576. Courtesy of John Frost, 1860.

the fifty-three-man detachment of Spanish infantry pushed into the interior to conduct a vindictive warfare against the local tribes. At length the Indians were completely defeated, pursued into the forests and their leaders forced to surrender.

With the colony on solid footing, the number of Spanish continually increased, the area of the settlement was extended and the arrival of a considerable number of women gave a stability and appearance of home to the town. During this period of prosperity, Fort San Marcos was the only colony of importance held by the Spaniards in North America; here alone did they occupy lands, build homes and found a thriving community of four hundred farmers, soldiers and artisans. Excepting a small military detachment, St. Augustine was completely abandoned and Parris Island became the focus of Spanish settlement in North America.

For ten years, Santa Elena prospered, and many colonists must have come to think of South Carolina as home. All seemed to be going well, but in reality a fearful change was taking place. In 1584, the English determined to expand their empire at the expense of Spain by establishing a colony at Roanoke, North Carolina. Acting with the consent of the English monarchy, Sir Francis Drake swept down into the Caribbean and destroyed a number of Spanish military outposts. In 1586, Drake passed by Santa Elena and sacked and burned St. Augustine. Fearing an imminent attack, the colonists equipped Fort San Marcos with a newly excavated moat, reinforced curtain walls and new casemates and gun platforms. Afraid they would never be able to hold both St. Augustine and Santa Elena, the Spanish authorities decided to consolidate their North American forces. After a decade of prosperity, the South Carolina colonists were ordered to destroy their homes and depart. Such reverses diminished the attractions of the Carolina coast in Spanish eyes, and the idea of colonizing it seems to have been permanently abandoned.

Today, archaeologists have located and excavated the French settlement of Charlesfort and subsequent Spanish settlements at Santa Elena. Archaeologist Stanley South has been conducting excavations at Santa Elena since 1979. The location of the French settlement Charlesfort proved more elusive, but in 1991, the mystery was solved when South, joined by colleague Chester B. DePratter, discovered French stoneware pottery mixed in the soil with Spanish majolica and redware at a site on the southern tip of Parris Island. The archaeologists concluded that the Spanish fort, San Felipe, was built over the remains of Charlesfort.

Archaeological excavations at Parris Island unearthed thousands of artifacts dating to the Spanish settlement at Santa Elena. One of the most important finds was the buried remains of a pottery kiln found at the edge of town. Archaeologists discovered four different types of Spanish redware vessels that were fashioned into cooking pots, plates, jars, bowls, tiles, pipes and flowerpots. One type has no antecedent in Spain, looking more like something made in the Moorish ceramic tradition. Based on the large number of Native American artifacts located at the site, almost all settlers used locally produced vessels in their homes. There were also goods from all over the Spanish empire. The settlers at Santa Elena were not typically wealthy but archaeology suggests some had expensive goods and other indicators of their affluence.

The Founding of Charleston

By the founding of Charleston in 1670, Native American groups in coastal South Carolina apparently lived in small politically and socially independent groups that stayed generally in one area. Researchers have identified nineteen distinct groups between the mouth of the Santee River and the mouth of the Savannah River in the middle of the sixteenth century. Many of these groups probably were controlled by Cofitachequi prior to its collapse. By the seventeenth century, all were independently organized. These groups included the Coosaw, Kiawah, Etiwan and Sewee "tribes" near the Charleston peninsula. The Coosaw inhabited the area to the north and west along the Ashley River. The Kiawah resided at Albemarle Point and along the lower reaches of the Ashley River in 1670, but gave their settlement to the English colonists and moved to Kiawah Island until the early eighteenth century when they moved south of the Combahee River. The Etiwan were settled on or near Daniel Island to the northeast of Charleston, but their range extended to the head of the Cooper River. The territory of the Sewee met the territory of the Etiwan high up the Cooper and extended to the north as far as the Santee River. Mortier's map of Carolina, prepared in 1696, shows the Sampas (Sompa) between the Cooper and Wando Rivers, to the northeast of Daniel Island, and the Wando Tribe and Sewee Tribe fort east of the Wando River, northeast of Daniel Island.

In the first years of settlement, the English colonists were almost totally dependent on their indigenous neighbors for food and access to the land. In turn, they brought beads and steel knives and whiskey and muskets, but above all they brought disease. The results were apocalyptic. The few tribes that survived participated in a system of European politics, settlement and foreign trade that destroyed their way of life. By the middle of the eighteenth century, very few Native Americans could be found near Charleston; most had been dispersed or obliterated by disease and the emerging plantation society. The blow was mortal, but they went down fighting. For years the Native Americans emerged from their remote hamlets to kill the European settlers. Though many survivors continued the struggle in a few distant outposts, the establishment of the colony marked the end of Charleston's Native Americans. As we look back at the Native Americans' long tenure in Charleston, we cannot but regret that the end came so suddenly.

The Beginning of Something Grand

Archaeological Investigations at Albemarle Point and the Charleston Peninsula

*And take upon's the mystery of things,
As if we were God's spies.*
—William Shakespeare, King Lear, act five, scene three

It was August 17, 1669, when the *Carolina*, *Port Royal* and *Albemarle* sailed from Devonshire, England, for the New World. After eight torturous months of hurricanes and shipwrecks, the voyage ended in April 1670 when the *Carolina* and its ninety-three passengers arrived along the Carolina coast. The scene was of a nature to deeply impress the imaginations of the Englishmen on the deck of the two-hundred-ton frigate. To the west was an ocean of leaves, glorious and lush in the varied but lively landscape of spring vegetation. The lower branches of cypress and oak were bent by the weight of trumpet vines, their summits towering above endless expanses of marshland and oyster banks. But it was the appearance of the boundless forest that set the backdrop to Charleston Harbor that spoke of grandeur.

These Englishmen first settled at Albemarle Point on the west bank of the present-day Ashley River, a spot offered by the Kiawah Indians but chosen largely for its defensibility. The Spanish claim to the Atlantic coast north of Florida included South Carolina, and the English were well aware of the attack on a French settlement farther down the coast. With that troubling knowledge foremost in their minds, the first act of the English in their new settlement was to build entrenchments and establish a watch for the inevitable Spanish attack. The fortified settlement in its completed form was better adapted to resist an isolated attack by the Native Americans or Spanish infantry than to withstand

The Beginning of Something Grand

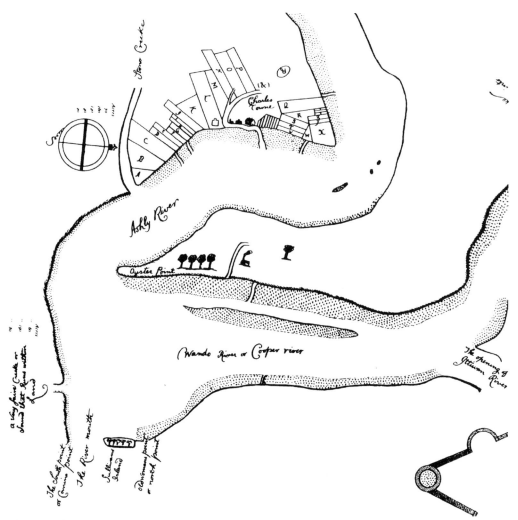

The 1671 Culpeper Map showing the settlement at Albemarle Point. *Courtesy Christopher Nichols.*

a sustained siege, but the logistics and dangers of transporting heavy artillery up the Ashley River rendered the occurrence of the latter a probability so remote as to scarcely enter into the estimates of the builders.

The combination of archaeological and archival research indicates that the settlement was surrounded by a sequence of palisades and contained strongholds of earth and logs and a dry ditch. The six-hundred-foot defensive perimeter was extended into the marsh to prevent attackers from flanking the palisades and entering the town. A few timber buildings, which served the double purpose of dwellings and fortifications, were located within the walls of the ten-acre settlement. Several light field-pieces stood within the fort, ready to be conveyed to any point where they might be required, and one or two heavy iron guns looked out from the palisades in warning to anyone who might think to attack. A combined Indian and Spanish force was so intimidated by these defenses in

August 1670 that they called off an attack, causing more fear than damage inside the English settlement.

In addition to security, housing was of primary concern to the first settlers. Archaeologists located one of their first dwellings at Charles Towne Landing. The presence of gunflints from flintlock muskets suggests that it was a temporary shelter for soldiers on duty within the palisades. The dwelling was built in a common fashion for the period, framed with large, evenly spaced posts set into the ground. It was built on high ground at the center of the settlement with palisades on either side. The remains of the house indicate that it was a single-room, daub-walled affair made from timber, with a roof of thatched palmetto leaves. The doors and windows had to be built with tools and metal hardware brought aboard the ship, while hand-wrought nails bound together the roof and door.

European pottery, wine bottles and tobacco pipes indicate the soldiers also ate and slept at the dwelling. The dirt floor would have been covered in pine straw, and the house's large, cluttered room would have accommodated sleeping, eating, cooking and socializing. Though almost nothing has survived in the archaeological record, most of the furnishings were probably homemade, although some prized pieces of furniture—a chair, chest of drawers or cupboard—surely must have made it across the Atlantic Ocean. The colonists probably walked around the house in filthy shoes on floors of dirt and straw, and sat on crude chairs or benches at a table cluttered with wooden bowls and wine bottles. Meals might have consisted of corn and a side of venison from a pot. Anything that fell to the floor would have been picked up and brushed off if it wasn't first snatched up by one of several dogs that likely shared the house. Trash was thrown out the door into the yard, or into a nearby ditch. Life in the house was undeniably crude, but it was also the best the colonists could do until better accommodations could be built.

By 1680, steady growth and concerns over defense prompted the settlers to move downriver to Oyster Point, the present location of Charleston. About twenty houses had been built at the confluence of the Ashley and Cooper Rivers, and more were under construction by the time the official settlement was moved. With an aim to avoid the irregularities of European cities, Charleston's streets were planned on a wide and regular grid. Within the first year of Charleston's founding, approximately one thousand residents and one hundred wooden structures made up the settlement. By 1704, the town had become a walled port, bounded on the west by Meeting Street, on the south by Water Street, on the north by Cumberland Street and on the east by the waters, creeks and marshes of the Cooper River.

According to Catherine Saunders with the Historic Charleston Foundation, delineation of the walled city dictated Charleston's growth and appearance for the first two decades of settlement. The irregular trapezoidal shape pictured in early maps of Charleston was the result of the use of streams and mudflats as defensive complements to walled fortifications. Despite the city's rapid rise to prosperity, Charleston faced the likelihood of attacks by Frenchmen, Indians and Spaniards. Colonists were pressed into service to build and repair the city's walled fortifications, a service that was

The Beginning of Something Grand

grudgingly given, and when refused resulted in jail time. Today, almost nothing is left of these colonial defenses, but a succession of archaeological investigations over the last half-century has begun to illuminate something of this long-forgotten component of Charleston's history.

Engineers of the colonial city's fortifications realized from the very start that the Cooper River side of Charleston was the most vulnerable to fire from enemy ships and amphibious invasion. Bearing that in mind, the builders constructed coastal defenses along the Cooper River and covered the corners of the walled city with bastions guarding the river and harbor approaches. Two of these bastions have been identified and archaeologically recorded. The Granville Bastion at the southeast corner of town was discovered beneath the nineteenth-century Missroon House during remodeling and expansion. Archaeological excavations indicated that the bastion was constructed of brick placed on a lattice of palmetto logs, extending fourteen feet below street level. Similarly, the Half-Moon Bastion, unearthed in 1965 during a renovation of the cellar of the Old Exchange Building, was an enormous battery that extended into the water and provided the formal entrance to Charleston. The bastion's half-moon shape and high brick walls protected the city watchtower and the armory from cannon fire. Additional excavations in 1980 in front of the Exchange Building revealed that the battery was damaged in the hurricane of 1752 and repaired using a cofferdam. An extensive deposit of broken barrels and debris, preserved in spilled naval stores, marked the hurricane's high-water surge. A portion of the original Half-Moon Bastion is currently open to the public as part of the tour of the Provost Dungeon in the Old Exchange.

Excavations in recent years by archaeologists Theresa Hamby and Joe Joseph with New South Associates have continued to reveal the dimension and construction of Charleston's colonial defenses. The evidence suggests a fortified city with brick walls along the eastern boundary and earthen walls formed in part from the soil of an encircling moat on the other three sides. Archaeologists believe that a portion of the earthen walls was crowned with a series of palisades set firmly in the ground, which gave the appearance of a fortified medieval city. Entry was made across a drawbridge near the intersection of current-day Meeting and Broad Streets. On the city's north and south sides, the encircling moat was dug between the wall and streams to provide a less attractive point of attack. If an enemy attempted an amphibious invasion from either of these sides, they would have been cut down slogging across the mudflats, streams or moat before they even attempted to scale the earthen ramparts.

The English, having grown confident behind their defenses, decided to conduct expeditions against Spanish-held St. Augustine in 1702 and 1706. The assaults were a failure that brought disgrace upon Governor Moore and heavy debt on the colony. In 1706, the Spanish, by way of retaliation, appeared before Charleston's formidable walls and summoned it to surrender. The invaders sent ashore a small party who were quickly surrounded and cut off, whereupon the whole fleet, struck with general panic, at once abandoned the assault. Eagerly pursued, many of them were taken and a portion of the Spanish fleet was captured. There followed several years of peace,

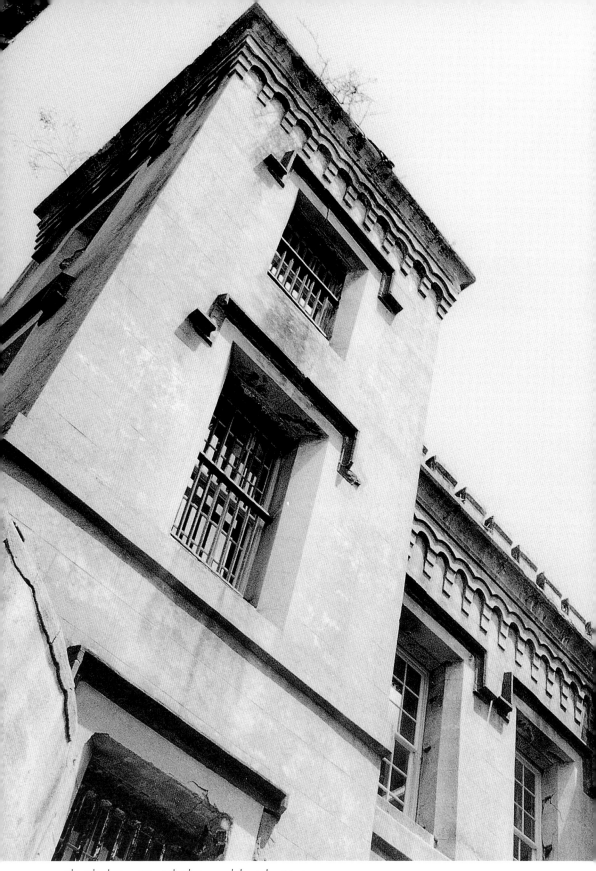
The Charleston City Jail. Photograph by Adam Hester.

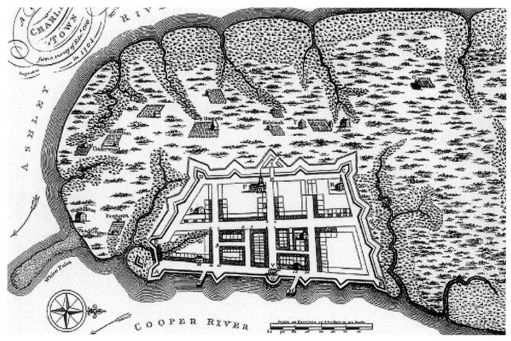
1704 Crisp Map showing Charleston's original defenses. *Courtesy Christopher Nichols.*

which ended in a war with the Tuscarora Indians, who had massacred more than one hundred English settlers in the Roanoke colony. The Tuscarora were quickly routed by nearly one thousand colonists under the command of Captain Barnwell.

Angered by ongoing mistreatment and encroachments on their land, the native tribes between Cape Fear and the Gulf of Mexico united in a grand confederacy to annihilate the English colony. On Good Friday 1715, the Yamasee and their allies, numbering six thousand warriors, attacked the frontier plantations, killing one hundred people the first day. Refugees fled to Charleston as war parties moved to the Stono and Ashley Rivers, burning homes and killing settlers. The colony, with the aid of the Cherokee, raised a considerable force to march against their enemy. Both sides massacred indiscriminately, and terrible cruelties were perpetrated to take possession of the land. Battles at Port Royal and Salkehatchie proved decisive, and the Yamasee were crushed and driven south of the Savannah River. Their removal was followed by a war of extermination and the emigration of nearly every tribe in the vicinity of Charleston. Hunted and disheartened by continual abuses, the Native Americans had totally abandoned the Lowcountry by the mid-eighteenth century.

After the Spanish and their native allies were relegated to La Florida, Charleston's fortifications were no longer revered as a source of enduring security, but esteemed as an inexhaustible mine of building materials, cheaper and more convenient than the distant brick kilns. Petitions addressed to the assembly repeatedly expressed the desire for land just beyond the fortifications. Charleston's walls still described the old circumference, but the city began to push against those limits, and the vacant mudflats were soon converted

The Beginning of Something Grand

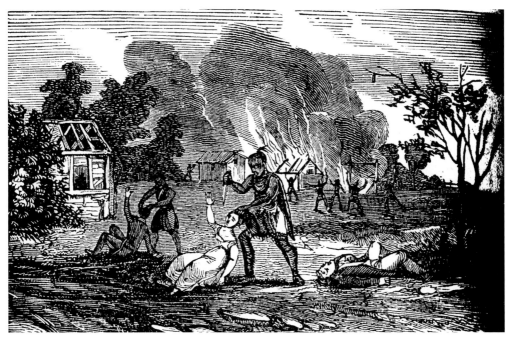

Incited by the Spanish and abuse at the hands of the settlers, the Yamasee, Creek, Catawaba and other tribes united in a confederacy to annihilate the South Carolina colonists. *Courtesy of John Frost, 1860.*

to high land suitable for construction. Archaeological evidence indicates the earthen walls were shoveled and pushed back into the moat as public and private development necessitated the infilling of low-lying areas to create more space for urban expansion. By about 1717, these early fortifications were largely dismantled or engulfed by the rapidly expanding town, and the chasms were perforated or enlarged to receive the piers that supported the shops or warehouses of merchants.

Within a few years, Charleston had evolved from a frontier settlement to the fourth largest port city in North America. One contemporary found Charleston to be a pleasant town with "very regular and fair streets" lined "with good Buildings of Brick and Wood" and already in the throes of expansion. Merchants that had previously sailed back to England after making their fortunes now began to build permanent homes and townhouses on the peninsula. According to archaeologist Martha Zierden and historian Jeanne Calhoun, the waterfront, East Bay, Broad, Elliott and Tradd Streets, developed as the core of the mercantile community. Archaeological excavations indicate that businesses, many of which doubled as residences, were tightly packed into this area, their foundations only a few feet or inches apart.

By 1739, the town line had been moved northward to the vicinity of present-day Beaufain and Hasell Streets, and whole city blocks were solidly filled with row houses. The city's population had increased 500 percent since 1700, and its physical size had almost doubled. The number of wharves, or "bridges," along the Cooper River had also increased from two to eight. Archaeology suggests there was a great

deal of architectural variety during the early years, in both building materials and architectural styles. Sadly, the events of one day would forever alter the architectural character of the town. On November 18, 1740, a fire raced across Charleston, and three hundred buildings, crowded along close and crooked alleys, supplied ready fuel for the flames. Every house and building from Broad and Church Streets to East Battery burned to the ground.

As the colonists rebuilt, the waterfront community along Bay Street (now East Bay) began to emerge as the focal point of Charleston's commercial activity. It also became the location where British transatlantic traders disposed of cargoes of enslaved Africans, enriching the local merchants and supporting the physical growth of the city. Private wharves, warehouses, storehouses and merchant shops were built in an effort to increase the city's trade. Rather than build the wharves on piers, engineers constructed cribs of palmetto logs on shore and then floated the structures to their desired locations. The cribs were then filled with cobblestones, brick and coral to anchor the raft in place. Thus the colonists got a wharf and at very much less cost. Most of the buildings along this thoroughfare had retail shops on the ground floor with apartments for the owners above. It may have looked a lot like Charleston today, full of commercial activity in the daytime and buzzing with entertainment at night. Many eighteenth-century observers found the waterfront promoted "vice and irreligion in many degrees" and "was plagued by drunkenness, idleness, and quarreling." Students of history must be careful not to let these biased observations prevent them from hearing the voices of the actual residents who lived out complex and colorful lives on Charleston's waterfront. Contrary to condemnations by the city's more "refined" residents, the water's edge was primarily home to merchants, coopers, shipwrights, jewelers, rope makers, tanners and artisans of all types.

The discovery of the remains of a sugarhouse at the Charleston County Judicial Center is the physical evidence of the hard work and industry often absent from the historic record. Excavations indicate that the 1730s earth-walled structure was built using the rammed-earth technique, an ancient form of construction. The technique involved the processing of clay, water, brick, wood and Spanish moss into a malleable building material. The mixture was poured into wooden molds, pounded until solid and immediately roofed. This type of architecture, though odd, had many practical benefits. Among the advantages were simplicity of construction, climate control, durability and resistance to fire and insects. Archaeologists believe the structure at the judicial center was originally used as a combination kitchen and servants' quarters. However, Philip Meyer bought the lot at 8 Courthouse Square in 1773 and established a series of buildings and a work yard for the processing of refined sugar for sale in Charleston. Archaeological investigations indicate a ramped entryway connected the sugarhouse to a cellar beneath the Meyer-Peace House.

Archaeologists working at the site believe Meyer mixed sugar and water in a tub somewhere in the work yard. The mixture was then taken into the sugarhouse and boiled in a copper pan over a brick cauldron. According to investigators,

The Beginning of Something Grand

once the boiling was complete, the sugar was removed from the Sugar House and taken to another building...where it was poured into molds and the molds placed over syrup jars. Claying, draining, and drying took place in this structure for a number of days until the sugar loaf sugar was taken back to Sugar House, and placed on shelves where it was heat dried and baked. The heat needed for this process was generated by the cauldron when in use, but could also be provided by a fire in the second hearth in the building. Once baked, the loaf sugar was taken back into the yard, packed in hogsheads, and then rolled down the ramp for storage under the Meyer-Peace House until ready for sale.

Meyer died in 1785, and the business was taken over by his wife, Mary, who operated the bakery until her death in 1800. The property passed to her granddaughter, Mary Rudhall Peace, who renovated the sugarhouse to serve as a combination kitchen and servants' quarters.

While many artisans and merchants began to cluster near the center of the city at the intersection of Meeting and Broad Streets, the more affluent purchased property south of Broad Street where they could find "spacious lawns and healthy breezes" on the city's waterfront to offset the "sickly season." It was a time when the prosperous planters and merchants were highly conscious of architecture and wanted something outstanding for their money. Some of these ample houses are still standing; however, for the most part, they are bereft of the fanlights, molded mantels and fine detail that once made them extraordinary. Only a few still attest to the immense wealth that once clustered around thoroughfares like King Street, where one of America's finest townhouses still stands.

In 1769, Miles Brewton, a wealthy merchant and slave trader, finished construction of what many consider the finest townhouse ever erected in America. Only thirty-four years old when he acquired the unimproved lot at 27 King Street, Brewton hired London architect Ezra White and builder Richard Moncrieff to build a house "meticulously and self-consciously designed in the latest architectural mode, sumptuously decorated and specifically Palladian in inspiration." In its completed form the house was extraordinary, even by today's standards. Measuring fifty-four by sixty-five feet on a substantial brick foundation, the house was built over an "elevated basement, with a hipped roof, a two-tier portico, and intricately carved fretwork frieze." The house was surrounded by a series of brick service buildings that formed an urban compound, not unlike South Carolina's nucleated plantation settlements. The compound included a kitchen, laundry and carriage houses; stables; storerooms; slave quarters; a dairy; a cistern; and a privy. The home's interior was impressive, with paneled rooms, mahogany doors, marble mantels and intricately carved woodwork.

Miles Brewton's house was adorned luxuriously and stocked with goods from all over the world. A taste was established for particulars that had previously been beyond the means of anyone outside Europe. When Bostonian Josiah Quincy visited the house, he was astounded by "the grandest hall I ever beheld." When he sat down at Brewton's table, three courses were served on a collection of fine plates and complemented with the finest wine Quincy had ever tasted. Quincy was also impressed with a tropical bird that "kept familiarly playing over the room, under our chairs and our table."

The Miles Brewton House at 27 King Street. *Photograph by Adam Hester.*

Tragically, the sea, which had brought so much fortune and power to the slave trader, claimed its forfeit; Miles Brewton and his family were lost at sea on their way to Philadelphia in 1775.

Despite the fact that a great deal has been written about the city's colonial and antebellum homes, researchers are just beginning to learn about everyday life in Charleston's urban compounds. Archaeological excavations conducted by the Charleston Museum in the work yard and garden at the Miles Brewton house have begun to add a vividness to our understanding of Charleston's past. Through these investigations, archaeologists have recovered artifacts that reflect the residents' possessions and their efforts to live lavishly in spite of the early city's rural nature and distance from Europe. Examination of bones and pollen and other plant materials has yielded clues about the diet and even something about the gardening practices of the eighteenth and nineteenth centuries. Ceramics and glass offer a record of items used in the household and the residents' participation in the consumer culture of the day, and buried postholes and architectural materials provide information about the nature, use and location of vanished buildings.

Since so many of the structures that once existed downtown were built of wood, it is inevitable that all that might be left of them is subtle soil stains indicating postholes and builder's trenches. It is only by open-air excavation that indications of vanished structures, called "features," can be mapped and recorded. By recording the arrangement of the soil stains or buried foundations, archaeologists can draw the

outlines of structures and better understand the organization of a site. The features can also produce artifacts that were packed along with dirt into the postholes. By dating these artifacts, researchers can sometimes determine when the building was constructed. For instance, if archaeologists find a sherd (a broken piece of ceramic) from a broken plate not manufactured before 1800 packed into a posthole, they can reasonably assume that the building was not constructed before the nineteenth century. This does not sound exactly like hard science, but when combined with archival evidence, these finds can be very useful in dating a site.

Through careful examination of the almost imperceptible changes in soil texture and color, archaeologists discovered that modifications were made to the Miles Brewton compound over time. Digging adjacent to the property's brick enclosing wall, archaeologist Martha Zierden discovered that an informal wooden fence had originally surrounded the property. Evidence of this vanished fence line, as revealed by excavated postholes and a well-defined postmold, suggests repair, replacement and reorganization. Variations in the brickwork indicate that a brick and iron fence was built over the former locations of the picket fence lines. Eventually, this second fence was replaced with an imposing eight-foot brick wall covered with a stuccoed interior. The new fence line may have added to the residents' sense of privacy as well as rendering the compound more aesthetically pleasing from the street.

Though the Miles Brewton compound has remained largely unchanged, each successive owner reorganized and modified the complex of buildings to make it more fashionable or functional. Around 1780, the owners of the house reorganized the servants' quarters, kitchen and other areas frequented by slaves in an attempt to keep a better eye on the activities of their bondsmen. All over Charleston, servants' work areas and residences were moved to the rear of the lots. Though many whites presented these changes as improvements to the living and working conditions for their slaves, they also restricted access to areas that had previously been hard for the landowners to watch. The most obvious modification to the Miles Brewton House was the wrought-iron fence added by owner William Alston following the failed slave insurrection led by Denmark Vesey. This fence, still visible today, was presumably built to keep the home safe in the event of a slave rebellion, and features fearsome barbed spikes called "chevaux-de-fraise."

Martha Zierden believes that behavioral alterations to life in the urban compound documented in the archaeological record were part of a larger effort to improve sanitation and prevent the spread of disease. While the city's merchants were accumulating Charleston's first fortunes, they complained loudly about the practices that were polluting the city's streets. In addition to problems caused by waste from tanneries and slaughterhouses, the lack of public sanitation contributed to making city life less than healthy. It appears that eighteenth-century residents at the Miles Brewton compound disposed of refuse right in the yard. Based on the large quantities of hacked skeletal remains, even cattle were raised and butchered on site and their carcasses disposed of in the yard. The decreasing frequency of nineteenth-century artifacts indicates that owners of the Miles Brewton compound eventually stopped throwing garbage into the yard,

Barbed fence at the Miles Brewton House. *Photograph by Adam Hester.*

instead disposing of their trash and "night soils" on empty lots nearby. By the nineteenth century, most of Charleston's older privies were filled with garbage and new ones were constructed as far from the house as possible. These small improvements probably made living and working at the house much healthier and far more pleasant.

Archaeological data suggests that the European emphasis on symmetry and architectural designs was focused primarily on the main house and attendant buildings but did not extend to the work yard. This area fell in the domain of the slaves. It was here that they worked apart from their white masters and carved out their own private space. While white owners focused their attention on the main house and roads, the footpaths, work yards, alleys and adjoining swampy lots all provided areas where slaves could slip off to socialize without being bothered by whites. This supposition was bolstered by the discovery of a pit in the work yard filled with charcoal, tobacco pipes, oyster shells, bricks, broken wine bottles and a type of handmade pottery associated with African slaves. Archaeologists believe this pit was an outdoor hearth used for cooking and socializing similar to the cooking arrangements found in Africa.

As the Charleston Museum archaeologists continued excavations on the Miles Brewton property, they discovered thousands of artifacts dating to the eighteenth and nineteenth centuries. Based on the large number of expensive artifacts located on the property, the affluence of the Brewton household is well represented in the archaeological record. The ships that crossed the Atlantic to buy rice and sell slaves brought with them all sorts of manufactured articles, including many that might be considered luxuries. The owners of the Miles Brewton house were among the wealthiest in all of South Carolina, and they purchased these goods as props for their stunning affluence. In particular, the preponderance of expensive table glass and Chinese porcelains recovered from the garden deposits suggests that the owners went to great lengths to have the best tableware available at the time.

Based on many of the broken cups, saucers and pots found by archaeologists, tea must have been very popular at the Brewton house. The beverage briefly lost favor with Americans between 1767 and 1773 when an English tax on tea was enforced. However, in the post-Revolutionary War period, tea drinking became more fashionable than ever. Direct trade with East Asia was opened, making available a wide variety of tea vessel forms made of Chinese porcelain, as well as complete tea sets. Teapots made of Jackfield, tortoiseshell, basalt and red stoneware, agateware and plain Queensware also were popular. At the Brewton house, serving tea and having the appropriate service was a distinct sign of one's gentility and "an important occasion of polite family life."

By the early nineteenth century, greater prosperity, a "revolution in manufacturing, distribution, and retailing, and lowering prices" allowed middle-class consumers to acquire the manners and habits of planters and merchants. The wealthy class, concerned with maintaining their elite status, sought more expensive goods to show off their wealth. The Brewton household, being among the wealthiest in South Carolina, therefore moved on to elaborate silver and porcelain tea services. The broken plates, bowls and assorted serving dishes found at the compound reflect significant wealth that few South Carolinians possessed during the eighteenth century.

The Beginning of Something Grand

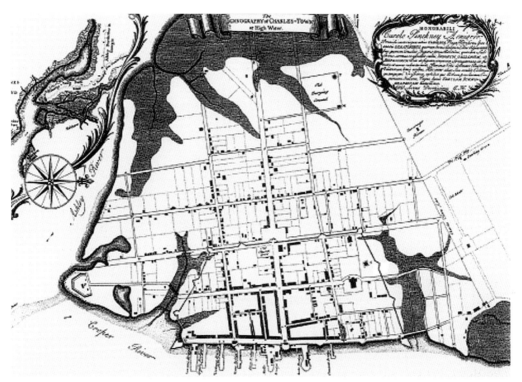

What was once waterfront was deliberately filled by city residents to cover Charleston's first wharves. The creation of the "made" land helped create the shape of the Charleston peninsula. *Courtesy of Christopher Nichols.*

Attire was another important indicator of wealth at the Miles Brewton house. Archival research suggests that wealthy Charlestonians attended balls dressed in the best silks, elaborate gowns, petticoats, waistcoats, jackets and breeches. But clothing was often as diverse as Charlestonians themselves, for whom affluence, style and professional demands all determined the way they dressed. It appears that at the Miles Brewton household, dress was influenced by the fashionably excessive European styles of the time. Even slaves in the household out-dressed many of the poor whites in Charleston. Because slave attire was a reflection of an owner's prosperity, many whites went to great lengths to see that their bondsmen were well dressed. Expensive breeches and shirts were often accompanied by stylish boots, gloves and hats. Unfortunately, clothing-related artifacts are rare and often tell little of life at a given location. At the Brewton household, less than 1 percent of the recovered artifacts are related to clothing.

One difficult aspect of interpreting the archaeological remains at the Brewton compound is the close proximity that slaves lived in relation to whites, thereby mixing artifacts in the soils. The slaves and masters likely ate the same foods served on similar dishes, though meals may have been prepared differently. At the Miles Brewton townhouse, it is almost impossible to separate the artifacts and food remains from the two groups. However, some archaeologists believe that a few artifacts can be directly

Down & Dirty

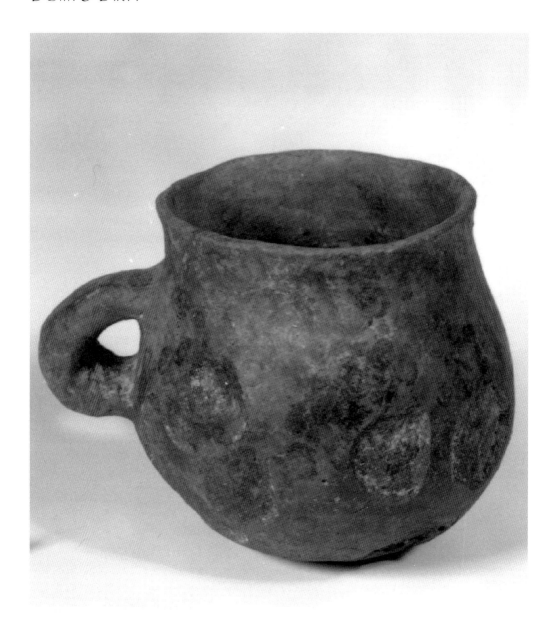

The presence of slave-made pottery indicates cultural continuity with Africa during Charleston's early years. Courtesy of Sharon Pekrul. SCIAA/University of South Carolina Photo.

attributed to African culture. According to archaeologist Leland Ferguson, slaves often used and modified European ceramics and other items of material culture in African religious practices. For instance, coins, glass beads, chandelier crystals and other everyday objects were appropriated by slaves and given special spiritual significance. Sometimes these goods were hidden beneath floors, in walls or in other locations. Sometimes they were more conspicuous, worn as charms or placed around the house to protect the

The Beginning of Something Grand

dwelling from spirits. Even the common broomstick assumed extraordinary significance when used in ceremonies. During slave marriages, an elder typically read passages from the Bible before the bride and groom jumped over a broomstick.

Surprisingly few artifacts that could be directly related to African or African American residents were recovered from the Brewton compound. Archaeologists discovered a few green glass tube beads covered in opaque red glass. These objects may have nothing to do with African Americans but some archaeologists believe that glass beads were used in African American rituals at plantation sites throughout South Carolina. Archaeologists also discovered a pieced silver coin and a "cowrie shell, of tropical or possible African origin." Perhaps the rarest slave-related discovery was a slave tag. These artifacts are small copper badges worn or carried by bondsmen hired out by whites to do work on the peninsula. Slave tags are rarely found outside downtown Charleston and are highly sought after by relic hunters.

One area in which African and African American traditions have been largely ignored in downtown Charleston is the burial ground. Where downtown is crowded with many cemeteries for whites, there was essentially only one for slaves. At the death of a slave downtown, the deceased would be taken to Charleston's extensive public burying ground at the outskirts of the town. It should be remembered that many blocks surrounding The Citadel and the Medical University were once a "potter's field" for paupers, sailors, orphans and slaves. Unfortunately, nobody kept records of slave burial rituals at the Charleston potter's field and what little we know about the death of slaves comes from accounts on plantations. According to historian Charles Joyner, Waccamaw River slave processions usually took place at night and were marked by melancholy singing during the walk to the gravesite and joyous singing after the burial. For many African slaves, the passing meant the departed was reunited with kin and released from the misery of bondage. Upon reaching the burial ground, the slaves said a service over the graves. Saying such a service would have been easy; they had said them so many times. Bowls, glasses, plates, seashells and other personal objects of the dead were often used to decorate the grave. Archaeologists believe this practice is an African custom that persists today in remote sections of the South Carolina and Georgia Sea Islands.

Today the Miles Brewton house stands as an enduring reminder of the stunning affluence of colonial Charleston. Since its completion in 1769, the house has been occupied by some of South Carolina's most affluent merchants and planters, two invading armies and countless slaves. Though historians have long studied Charleston's fine homes and their wealthy owners, archaeology has now revealed aspects of the larger urban community not found in the historic record. Combined with excavations throughout the downtown area, the artifacts at the Miles Brewton compound tell us about a global economy, material change over time and cultural transfer between Europe and Africa.

Every day, new archaeological sites are discovered as heavy machinery peels back the asphalt and building foundations to make way for new homes and buildings. This development has helped revive a city that many had thought was lost to time and nostalgia. A joke often heard around South Carolina goes: "How many Charlestonians

does it take to change a light bulb? Three—one to change it and two to discuss how great the first one was." But Charleston's leap into the twenty-first century has created new problems. As new buildings, sewers and parking garages are added to the flourishing city, many of the rich archaeological deposits that are hidden beneath the surface are being destroyed. As we lose these records, we also lose our shared cultural heritage. As guardians of the past, we should be more considerate of these archaeological sites and look after them as much as we do our colonial and antebellum homes.

The Charleston Frontier and the African Potters of Christ Church Parish

Life at Thomas Lynch's Wando River Plantation

Destiny waits alike for the free man as well as for him enslaved by another's might.
—Aeschylus

From Ireland to Carolina

On the morning of September 28, 1066, nearly one thousand ships carrying some seven thousand armed men appeared off the coast of England. After waiting the summer for favorable winds, William of Normandy had crossed seventy miles of hostile water to take the throne of England. He was joined by a formidable army of vassals, buccaneers, mercenaries and adventurers. All were promised the spoils of conquest. With swift, overwhelming and decisive military action, the Normans annihilated the English armies at the Battle of Hastings and extinguished forever the rule of the Saxons. In one ruthless and devastating act, taking less than ten days' time and rendering any Saxon retaliation virtually impossible, south and southeastern England were destroyed at William's command. The trembling multitude quickly lost heart and accepted the conquest with a sad fatalism. The deserted villages and open towns were abandoned to the flames and the ravages of the Normans were equal to those of the fiercest Scandinavians.

The English had seen invaders before; indeed, the Vikings had been coming for centuries but as soon as the Norsemen's rapacious demands were met, the invaders took to their ships and the people were restored, in some measure, to the enjoyment

of peace and plenty. The Normans, themselves of Viking blood, were something different. They were not there for simple pillage; they were there to take the land and rule the people. In the county of Kent, William gave one of his followers a small estate to rule over. His name was Lynch and in the division of land, he became the lord of a hostile and alien people. Lynch, like most Norman lords, also employed most of his lands to the exercise of hunting and relegated the small remainder to a careless cultivation, and then blamed the scantiness and sterility on the English peasants. The Norman soldier never imagined that the first duty of a landed lord was immediate tillage of the soil. Lynch and his subjects became every day more alienated from each other, and the foreign invader became the object of popular hatred and contempt. But to enjoy the wealth that the land generated, he had to ensure that the social and legal institutions that controlled the English were tightly knit. Surrounded by a resentful people, Lynch realized it would become necessary to fortify his estate against assault from the villagers. From his castle, he taught even the fiercest of the English hordes to tremble and obey.

The ambition for land and power would not stop at England. In 1172, members of the Lynch family joined two thousand trained mercenaries under the command of the Earl of Pembroke, nicknamed Strongbow, to invade Ireland. The undisciplined, poorly armed Irish were no match for the Norman cavalry and they were quickly routed. With the destruction of the native system of government and the failure of the Irish to form a united front to drive out the invaders, the victory of the Normans in Ireland was assured. Once again the Lynches were rewarded with lands of a conquered people. Initially, they settled in Dublin, but they soon moved to Connaught, where they established Green's Rest, the family seat. Ironically, after several centuries, the invaders became more Irish than the Irish themselves. Those Norman surnames such as Burke, Fitzpatrick, Fitzgerald, Power, Pendergast, Walsh and the family name Lynch "became the backbone of southern Irish society." According to one genealogist of the Lynch family,

> *the now Irish family Lynch emerged in later years as a distinguished family in Galway in Ireland. This ancient Norman family arrived with Strongbow and became one of the "Tribes of Galway." They were very influential in the local politics, no less than 84 Mayors of Galway were from the family Lynch, as were many of the Wardens of Galway. Gradually the religion changed from Protestant to Catholic and they became staunchly Irish patriots. Lynch Castle was built in 1320 and they formed many branches of the same name.*

In the following centuries, the Lynch family would learn what it was like to be the victim of invasion. The Norman conquest was followed by Cromwell's invasion in 1640, when further loss of land befell the unfortunate Irish people, including the first Norman settlers. Ulster in the north was populated with Protestant Scottish and the Lynches were among the families to lose their ancient territories in southern Ireland. The time seemed right for another move west.

The Charleston Frontier and the African Potters of Christ Church Parish

After William's conquest at the Battle of Hastings, the Normans quickly constructed stone castles from which to rule the people. *Courtesy of Christopher Nichols.*

The precise year Jonack Lynch emigrated from Ireland to America is uncertain, but it likely coincided with the early settlement of Charleston. Similarly, we can only speculate on his reasons for moving to the New World: a strong desire to emulate the character, condition, style and wealth of his ancestors. Jonack Lynch received his first land grant of six hundred acres on April 30, 1677. In May 1679, an additional grant was made of "one hundred acres of land marked and builded on by the said Lynch already." Lynch, like many of Charleston's earliest inhabitants, carved his first plantation, Blessing, from

the virgin forest and built himself a modest home overlooking the Cooper River. He was a wayfarer in the wilderness, and neither his previous environment nor his social status would have accustomed him to the depredations and dangers of the frontier. It was a hard life, as any frontier life must be, but not without its rewards. Blessing's profits allowed Lynch and his descendants to acquire additional lands in the young colony and rise to a high position among Charleston's planter elite.

Upon his death, Jonack Lynch left his son Thomas (born circa 1675) a slight inheritance that, "through industry and the purchase of a large tract of land devoted to the cultivation of rice, was increased to an impressive fortune." Between 1697 and 1715, Thomas Lynch acquired 1,171 acres of land on the east bank of the Wando River and 500 acres at the head of White's Creek. It was on this remote tract that Lynch settled. By the first decade of the eighteenth century, his holdings had grown to include seven plantations and more than two hundred slaves. Thomas Lynch's most productive plantations were on the Santee River, that fertile stream that would provide the basis of the family fortunes.

With so many plantations to choose from, Thomas Lynch must have seen great beauty and practical benefit in settling along the Wando River. It was a comparatively unpeopled place, teeming with game and covered with soil rich with centuries of decayed vegetation, land ready to produce the fortunes for future growth. Robert Fenwick, George Logan and Arnoldus Vanderhorst also recognized great promise in this area and laid out plantations of their own. Soon other families were moving to Wando Neck, settling along the riverbanks in dispersed rural neighborhoods. After constructing simple clapboard houses and outbuildings on their homesteads, settlers cleared small cornfields from the wilderness, felling trees and burning off the undergrowth. The Wando Neck was beautiful in itself, but it was most beautiful to those who had the greatest stake in it.

Due to the relative isolation of the plantation settlements, it was not unusual to find a bride among your neighbors. Thomas Lynch did not have to look farther than the Wando Neck. He married Margaret Fenwick, whose dowry and name helped complete Lynch's transformation from an ambitious young bachelor to a Carolina gentleman. The plantations were not healthy places, and Margaret Fenwick died young, leaving one child, Margaret. In a society where death came early, the passing of a spouse was mourned only briefly before loneliness or necessity led to remarriage. For his second wife, Lynch took Sabina Vanderhorst, daughter of his neighbors Margaret and John Vanderhorst. Lynch and his second wife had seven children: Jonah, Ulick, Thomas, Mary, Sabina, Sarah and Elizabeth. It stands to reason that the frontier would be a tough place to raise so many children, but rice had brought about a manifest and beneficent change. Despite the colony's humble beginnings and distance from England, Thomas Lynch surrounded his children with the elite forms of European culture and goods. The children were educated in Huguenot schools in Charleston until the boys reached the appropriate age to continue their studies in England. The family likely resided in Charleston between March and November, when tropical diseases carried off many plantation residents. Removal to town was a good idea since

The Charleston Frontier and the African Potters of Christ Church Parish

Evidence of the South's plantation settlements remains today primarily as archaeological sites, although a few have stubbornly survived and are still occupied. *Courtesy of the Library of Congress.*

Though a man of great wealth, Thomas Lynch's first home was a simple log cabin with a chimney on the side. Illustration by Pat Hendrix.

it was on the frontier that Margaret Fenwick and several children were overcome with fever and perished.

Despite the family's seasonal migration to the Charleston peninsula, their permanent residence remained the Lynch Plantation in Christ Church Parish. Archaeologists discovered the remains of the family's first home on a low bluff above the upper confluence of the Wando River and Horlbeck Creek. At a purely descriptive level, the Lynch house was a simple log cabin with a standard fireplace and a kitchen behind. It may seem counterintuitive to most readers that a wealthy family lived in a log cabin with a dirt floor, but archaeology indicates that they did. Trees were felled and stacked in horizontal tiers with the ends notched together using a woodsman's axe. Archaeologists discovered that the house was not supported on a brick foundation, nor did it possess substantial wooden posts. The arrangements were exceedingly simple and cheap, but they were sufficient for the Lynch family until a more substantial house could be built.

Though it was a crude, impermanent residence, the expensive ceramics located by archaeologists indicate that the uninviting character of the cabin's exterior was relieved by the neatness and comfort within. Broken plates, cups and miscellaneous ceramics excavated from the house site represent a broad variety of types and forms available during the first half of the eighteenth century. The assemblage included European tableware that suggests Thomas Lynch and his slaves had access to the same expensive

The Charleston Frontier and the African Potters of Christ Church Parish

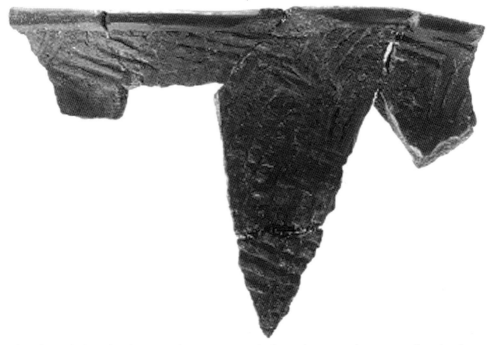

Archaeologists believe that this type of pottery was made during the sixteenth, seventeenth and early eighteenth centuries by Native American groups. *Courtesy of New South Associates.*

cups, plates and other tableware available to the residents of Charleston and comparable to that found at neighboring plantation sites. One can only imagine domestics serving the Lynch family a hardy meal of beef and vegetables on expensive porcelain dishes in a dirt-floored cabin.

"Slavery is our King…our Truth…our Divine Right"

From the vantage point of the twentieth century, it might be assumed that African slaves were the first laborers to accompany the Lynch family to the Wando Neck, but archaeology suggests another possibility. Excavations at the area associated with the first planter's house recovered a sample of Native American Ashley or Mississippian Burnished Plain ceramics. According to archaeologist Eric Poplin, this pottery appears to have been made during the sixteenth, seventeenth and early eighteenth centuries by Native Americans. Presumably, these ceramics were manufactured on site by Native American slaves or were sold to Lynch by Native Americans who lived nearby.

The use of enslaved Native Americans at the Lynch Plantation fits well into the evolution of slavery on the Charleston frontier. From the moment the Europeans arrived on the South Carolina coast, there was a shortage of labor to clear land and plant crops on the plantations. Historian Patrick Minges writes,

No sooner had they set foot on shore near Charleston...than did the English set about... establishing the "peculiar institution" of Native American slavery. Seeking the gold that had changed the face of the Spanish Empire but finding none, the English settlers of the Carolinas quickly seized upon the most abundant and available resource they could attain. The indigenous peoples of the Southeastern United States.

Having been born in South Carolina, Thomas Lynch never knew a world where Native Americans were not enslaved. By his early twenties, Lynch was a captain in the militia and had joined his neighbors in defending the frontier settlements against Indian raids. The threat was real. Thomas Lynch's father-in-law was so fearful that he fortified his Wando Neck plantation with palisades and a blockhouse. During times of warfare, which were often, Lynch and his neighbors struggled to keep the roads open, the fields in cultivation and the Native Americans at bay. But, as the militia was more anxious to steal than fight, they seldom pursued war parties in the Lowcountry swamps. Instead, they chose to kidnap Native American women and children under the pretext of defense. Statutes forbade the enslavement of "free" Native Americans, but the colonial authorities made no meaningful attempt to stop the abuses. Native American slavery was central to planters like Lynch. By selling captives to the West Indies, Carolinians generated hard currency and they also removed the population that might slow the growth of their plantation society. Estimates put the number of Native Americans enslaved in South Carolina between thirty and fifty thousand between 1670 and 1715.

"THE BAIT PROPER FOR CATCHING A CAROLINA PLANTER"

During the first two decades in Carolina, Native Americans probably worked on the Lynch Plantation alongside a few African slaves brought from Barbados and even, occasionally, white indentured servants. After rice planting took hold in the 1690s, Lynch brought in a large African workforce familiar with growing rice and resistant to tropical diseases. The majority of those slaves were taken from a part of Africa that extended along the West African coastal line from Senegal to Angola and perhaps as far as five hundred miles into the interior.

The coastline of West Africa encompassed a rich diversity of peoples and cultures and Charleston's planters actively sought out certain groups. In *An Account on Life in the Carolinas in 1750,* Johann Martin Bolzius claimed, "The best Negroes come from the Gold Coast in Africa, namely Gambia and Angolo." Slave trader Henry Laurens advised his suppliers to "let your purchase be of the best kind of slaves...free from blemishes, young, well grown, the more Men the better," but added, "there must not be a Callabar among them." On another occasion he remarked that the "Gold Coast or Gambias are best; next to Them The Windward Coast are prefer'd to Angolas." For planters like Thomas Lynch, the Senegambian peoples were preferred for their

The Charleston Frontier and the African Potters of Christ Church Parish

Archaeology indicates that Africans recently arrived to South Carolina constructed temporary shelters of clay that resembled the dwellings they knew and built in Africa. *Illustration by Nick Hendrix and Pat Hendrix.*

familiarity with rice culture and it was these people that accounted for nearly two-thirds of South Carolina's population in 1740. Small wonder that Swiss immigrant Samuel Dyssli commented in 1737 that "Carolina looks more like a Negro country than like a country settled by white people."

Though South Carolina was an alien world, in many ways West Africans were better suited culturally and technologically to the tropical environment than Europeans. Excavations by Thomas Wheaton and Patrick Garrow on the Santee River indicate that some of these slaves built houses with earthen walls, nearly identical to those they constructed in West Africa. Small pits were dug for an adequate supply of clay, which was then blended with small switches and formed into the shape of West African huts. The house roof was thatched and covered with palmetto leaves. Dirt-floored houses were simple to build from available resources but were probably cold in winter and hot during summer. The "wall-trench structures" were quite small by European standards, usually with no fireplace and only a single shuttered window to keep bad weather at bay. Often called a "ground house" by slaves, these structures were used primarily for sleeping, shelter and storage areas, with cooking and socializing centered on an outside hearth. Despite their utility, most Europeans did not want mud huts as permanent fixtures on their plantations. Within a few years, slaves were directed to replace these temporary shelters with framed, single-room houses sided with heavy clapboard, sitting on piers of brick or wood, and fitted with an end-gabled chimney.

"A Fatal Golde Seede"

Due to the high salinity of the Wando River, Thomas Lynch could not have possibly grown substantial amounts of rice at the plantation; and by all indications he did not. Instead, his slaves probably sowed it in the inland swamps or used one of the various dry rice cultivation methods, both of which were familiar to West Africans. But Thomas Lynch was a pioneer in rice cultivation, and within a few years he was experimenting with new engineering methods that could produce higher yields and profits. Under Lynch's direction, slaves constructed levees to Horlbeck Creek, which had formerly drained into the river, creating a reservoir that could be used to flood the fields. According to one observer, these new techniques for growing rice would have doubled the necessity of employing Africans for the purpose of cultivation:

> *The utter inapptitude of Europeans for the labor requisite in such a climate and soil, is obvious to everyone possessed of the smallest degree of knowledge respecting the country; white servants would have exhausted their strength in clearing a spot of land for digging their own graves, and every rice plantation would have served no other purpose than a burying ground to its European cultivators. The low lands of Carolina, which are unquestionably the richest grounds in the country, must have remained a wilderness, had not Africans, whose natural constitutions were suited to the clime and work, been employed in cultivating this useful article of food and commerce.*

Within a decade, Lynch's new method for growing rice had revolutionized the Charleston economy and reconfigured life on the plantations. With the advent of the "rice regime," the relative autonomy of the frontier years was obliterated and slave life bent to the seasonal demands of rice cultivation. One contemporary of Lynch left a detailed account of the labor on the plantations that must have looked a lot like work on the Wando Neck:

> *The method is to plant it in trenches or rows made with a hoe, about three inches deep. The land must be kept pretty clear from weeds and at the latter end of August or the beginning of September it will be fit to be reaped. Rice is not the worse for being a little green when cut. They let it remain on the stubble till dry, which will be in about two or three days, if the weather be favorable, and then they house or put it in large stacks. Afterwards it is threshed with a flail, and then winnowed... The next part of the process is grinding, which is done in small mills made of wood of about two feet in diameter. It is then winnowed again, and afterwards put into a mortar made of wood, sufficient to contain from half a bushel to a bushel, where it is beat with a pestle of a size suitable to the mortar and to the strength of the person who is to pound it. This is done to free the rice from a thick skin, and is the most laborious part of the work. It is then sifted from the flour and dust, made by the pounding, and afterwards by a wire sieve called a market sieve it is separated from the broken and small rice, which fits it for the barrels in which it is carried to market.*

The Charleston Frontier and the African Potters of Christ Church Parish

Most slaves on the Lynch Plantation labored in his rice fields producing the fortunes that would transform Charleston from a backwater to one of the wealthiest places on earth. *Photograph by Adam Hester.*

From his first years, scratching it out on the frontier, Lynch would emerge as one of the wealthiest men in South Carolina. Rice would build his mansions, educate his children and form the basis of his wealth. But to sustain his prosperity, Lynch would have to rely on a foreign and disaffected workforce. By the 1730s, the large number of African slaves living along the Wando Neck had grown so great that a missionary working at Christ Church Parish stated that "the people are forced to come to church with Guns loaded."

"The New Dwelling House"

Not all of Thomas Lynch's slaves labored in the rice fields. Some bondsmen worked at the river's edge handcrafting bricks at a kiln; others ventured out into the forest to cut the lumber for a fine plantation house. The men labored from sunup to sundown as an architect directed their every move down to the last wooden pin, pane of glass and hinge. They worked that way for two years as the spartan shell was transformed into an edifice befitting a member of the colonial elite. The work was finished by August 1713, when a property conveyance reported the "laying out" of "a private foot path or Road from the most convenient landing from that Branch of Wando River Commonly called Wappshaw along the present foot or horse Path unto the *New dwelling House* on the Plantation of Capt. Thomas Lynch."

Down & Dirty

The Lynch Plantation house. *Illustration by Nick Hendrix.*

From the Wando River a visitor might have seen the Lynch Plantation, no longer consisting of a plain log cabin, with its considerable open ground dotted with slave quarters and barns, constructed mostly of heavy timber, beautified with flourishing orchards and garnished with enriched fields in which crops were growing in the warm summer sun. Virgin forest still flourished in immediate contact with those fields, giving a wild and solemn backdrop to the plantation setting. One or two roads wound around the settlement, turning aside to visit every building; and at the termination of the open country was a home strongly built of brick and timber. The house's southern orientation provided sunlight for warmth in the winter and maximum exposure to the prevailing winds during the warmer months. It was modest in size but with a good deal more pretension than its neighbors.

But what would Thomas Lynch's new house have looked like? According to archaeologists, the buried house remains appear to represent a hall and parlor plan. These houses have their origin in the medieval architecture of England, where the hall, or great room, was where the lord of the house conducted his business and entertained guests. It was also where domestic activities, including dining and sleeping, were centered. Opening out of the hall, the smaller parlor room was where the head of the household could find a quiet place to entertain or sleep and where the dead were laid out before burial. By the time Europeans began to settle in South Carolina, the parlor would

The Charleston Frontier and the African Potters of Christ Church Parish

often have a chamber above it and adjoining rooms forming a parlor wing. These houses were not confined to wealthy merchants and planters but were also built by middling artisans and farmers.

Throughout most of the English colonies in North America, newly arrived colonists constructed hall and parlor houses similar to the medieval-style dwellings they lived in or knew from home. Indeed, excavations at the Thomas Lynch house demonstrate how little settlers adapted European architecture to the sub-tropical environment. Slaves would have felled several large trees, trimmed the branches and split the timbers to create a substantial frame strengthened with horizontal beams. The siding was made from halved, or cleft, cypress timbers rather than complete logs. The ancient bald cypress, particularly old-growth trees found in the deep swamps, was especially coveted because it was resistant to rot. The gaps between timbers were filled in with panels, saplings woven into flat mats and covered in clay in a process called "wattle and daub." The house was small, but the heavy timber frames and chimneys gave it an appearance far larger than the actual size. Thomas Lynch's home appears unpretentious as measured by most observers in the late twentieth century, but it probably fit well within the acceptable expressions of wealth and status during the late seventeenth and early eighteenth centuries. At that time, social standing was expressed not through large plantation homes, which did not appear until the mid-eighteenth century, but through expensive furnishings and decorative elements such as gable-roofed entryways.

Thomas Lynch frequently entertained guests, and his home had to conform to the high standards of decency and comfort expected of the Charleston elite. Since plantations were widely separated, the Lynch family had many overnight visitors, some staying for days or weeks. The guest bedrooms had all the comforts a home could offer: curtains, carpets, feather beds and hot water basins with which to wash. During the evening the rooms glowed with the soft light of a candle or a shaded lamp. The parlor had many luxury items including tea tables, mahogany furniture, armchairs and couches. A fine book collection was a necessity when your closest neighbor was miles away and you might not have a visitor for weeks during the winter months. When it could be purchased in Charleston, tea was served in the home at breakfast and at afternoon social gatherings. The combination of archaeological and archival evidence suggests the Lynches maintained a household of high social standing.

Besides Thomas Lynch, his wife and their children, the plantation consisted of a labor force that varied in size but usually comprehended three main divisions: field hands, skilled laborers and domestics. All in all there were forty slaves living at the plantation in 1737. These shadowy figures had names such as Jupiter, Pirate, Sheelah and Highway, to name a few. Besides planting and harvesting crops, there were numerous other types of labor required on the Thomas Lynch Plantation. Enslaved people had to fell trees, dig rice reservoirs, tend to the large herds of domestic animals, slaughter livestock and build and repair the plantation's buildings. The less rigorous tasks were delegated to the old and infirm. Thomas Lynch's estate inventory indicates that black laborers also worked as blacksmiths, drivers, carpenters, stable hands, mechanics and in other skilled trades. Women shouldered the additional burdens of cooking, caring for children, making

clothes, cleaning the home and tending the gardens. Children paddled canoes, tended to household chores and sometimes accompanied their parents to the fields. Other slaves worked as domestics, providing services for the Lynch family and their guests. Women's household jobs included the washerwoman, maid and the nursemaid. These people were designated as "house servants," and though their work appeared to be easier than that of the field hands, in many respects their lives were more complicated. They were under the attentive eyes of Thomas and Sabina Lynch, and they also lacked the privacy of those who worked the fields.

Most women at the Thomas Lynch Plantation worked in the kitchen, and the cook was considered the most essential of all household slaves. Cooking activities at the plantation occurred within the planter's house rather than in a separate building. Excavations indicate that the chimney base inside the house foundation was surrounded by a brick floor. This floor provided the plantation cook with a good working surface for preparing hot meals. Similar arrangements could be found from Georgia to Virginia until the late eighteenth century, when most builders separated the kitchen from the main house. Moving the kitchen a safe distance from the planter's house was a wise reorganization since it was in the kitchen that most fires originated.

The archaeological record indicates that the plantation cook had a full complement of iron pots, skillets, brass kettles and serving platters. Many of these implements were probably hanging from long iron rods in front of the stove hearth. There was also a spit used to impale meat, which was rotated over the fire by a slave child too young for the fields. Dutch ovens and cast-iron skillets with three legs and heavy lids were set directly over white coals and then covered in the smoldering embers. The cook used a long-handled shovel to move and shift the coals and stoke the flames. The fire was kept hot all day, meaning the heat manifested itself like a malevolent force in the kitchen, especially during the summer months. Cooking over an open hearth was also physically demanding and dangerous to the cook. She was constantly moving heavy pots, her clothes dangling over the flames and coals; and if a hook snapped, the cook could be scalded as the contents of the pot crashed to the floor. Though the cook enjoyed a high level of prestige among plantation slaves, cooking at the Lynch house was tough work.

Once the meal had been prepared, the cook had the children carry food "to and fro between kitchen and dining room to supply the butler and maids with hot food for the table." Wealthy families during the eighteenth and early nineteenth centuries would have had slaves who served their meals and catered to their every need. Yeoman families with no servants put food directly on the plates or placed it on the table in serving dishes to be passed from person to person. Not the Lynch family. At their plantation the food would be placed buffet style on a sideboard or served directly at the table by servants on the best ceramics that the colony had to offer. The wide variety of broken plates, cups and table glass excavated by archaeologists suggests that the household had everything necessary to prepare and consume foods in the highest fashion of the time.

It was during the first years that slaves were brought to the Thomas Lynch Plantation that some of the indigenous recipes of Africa began showing up on the plantations. A few staples of the West African diet accompanied the slaves across the Atlantic,

including the African yam, okra, black-eyed peas and kidney and lima beans. As the Africans learned their new surroundings, they made do with the ingredients at hand. The fresh vegetables found in Africa were replaced by foods from garden plots and the Lowcountry environment. When they could be found, foods such as apples, peaches and berries, nuts and grains became puddings and pies. With an array of new ingredients at their disposal and a well-tuned African palate, the plantation cooks created a unique African American culinary tradition.

Archaeology at the Thomas Lynch Plantation suggests that wild game was a favorite for slave and planter alike. Remains of these wild species show that residents of the plantation, the vast majority of whom were slaves, hunted, fished and trapped animals from the surrounding woods and salt marshes. Deer was the primary supplement to the plantation diet with raccoon, opossum, squirrel, rabbit and fish also making an appearance in the archaeological record. Birds, primarily turkey, were raised or hunted and undoubtedly graced the table of both planter and slave alike. Among the other animals eaten by residents at the Lynch Plantation were turtle and alligator. Turtles were often used in stews, while one slave said of alligator, "eat every part but don't eat the head and feet. Eat body part and tail." Plantation cooks deep-fried alligator, a technique common to both Africans and Europeans.

Excavations indicate that seafood was also a popular food for the residents of the Lynch Plantation. Oyster, crabs, shrimp and fish could be taken from the Wando River but were especially abundant in the salt creeks and marshes that surrounded the plantation. Trout, stingray and redfish could be seasoned and cooked fresh over an open fire, fried or brined to be eaten later. Mullet caught during the autumn fish runs were smoked and served over rice through the fall. Off times provided an opportunity to catch shrimp and crabs that were served in stews with vegetables from the garden. Cornbread sweetened with molasses worked well with stews, but grits and hominy was the perfect companion to seafood. Oyster roasts must have been very popular on the plantations, as they were in prehistoric times and today.

Planters not only encouraged slaves to hunt and fish, but even supplied firearms to their servants despite statutes explicitly forbidding the practice. Archaeological investigations across South Carolina have uncovered large quantities of firearms-related artifacts from settings associated with slave cabins; these artifacts bear witness to the practice of arming bondsmen. It was a good law to break. Hunting and fishing supplemented the often monotonous and meager plantation diet and also provided some pleasure in the life of the slave. The practice was common enough that visiting missionaries complained that both slave and planter would rather hunt and fish than see to their spiritual nourishment at Sunday services.

The unclaimed forests and swamps also provided a rich range on which to forage livestock. This was evidently the case at the Lynch Plantation, where the most prevalent among the animal bones recovered were those of domestic species. Though sheep, goats and chickens were all a part of the Lynch Plantation diet, pork may have been especially prized among slaves. The forests of the Wando Neck, whose acorns fattened droves of rooting pigs, provided a plentiful supply of cheap and wholesome meat. These half-wild

After the American Revolution, Charleston's early rice plantations were eclipsed by Georgetown's industrial plantations, like Chicora Wood. *Courtesy of the Library of Congress.*

Hams, sausages and other side meats were probably cured and stored in a smokehouse like this one. Courtesy of the Library of Congress.

razorbacks were leaner than today's hogs but were a popular and low-maintenance food source for Charlestonians. In colonial South Carolina the entire neighborhood, including Europeans and Africans, were invited to large celebrations centered on the cooking of a pig. And these celebrations are the genesis of the Southern barbeque. The word is most likely a derivative of the West Indian/Native American term *barbacoa*, meaning burning pit.

The cooking of a hog provided entertainment but also meant benefits that extended beyond one meal. The lard, ribs, bacon and chitterlings often went to the slaves, a godsend in a diet dominated by rice and potatoes. With fat from the slaughtered pig and cracklins from its skin, slave cooks could also add needed calories and flavor to one-pot dishes. One of the favorite plantation recipes was "Hoppin' John," created by adding salted pork to a pot of red pepper, black-eyed peas and rice.

While some plantations had salt works, most did not; consequently, meat had to be smoked for preservation. The hams, sausages and other side meats were probably cured and stored in the smokehouse. Based on the location of discarded animal bones, the Lynch Plantation smokehouse was near the brick kiln. The animal carcasses were brought to the area for butchering, and the unwanted remains were tossed into a fire for disposal. Often all that remained was the head and feet. Evidence of sawing of bone implies that portions of the butchered animals were being prepared for tables on the plantation, in Charleston or in the Caribbean.

The Charleston Frontier and the African Potters of Christ Church Parish

Thomas Lynch's enormous herd of two hundred cattle provided the plantation with milk, cheese and labor animals; but invariably they became a source of sustenance and income. Beef was used to make stews, steaks and roasts; however, the better cuts ended up on the planter's table or were barreled and sent to Charleston or the Caribbean. The beef market was located at the periphery of the city just across the drawbridge and moat into Charleston. Beneath City Hall, archaeologist Martha Zierden, with the Charleston Museum, has discovered rich deposits of animal bones related to the market. Apparently, it was a "Beef Market" in name only; archaeologists have also discovered the bones of pig, sheep, goats, fowl and a wide variety of wild animals. The beef market was consumed by fire in 1796 and remains today as an archaeological site at the northeast corner of Meeting and Broad Streets.

THE AFRICAN POTTERS OF CHRIST CHURCH PARISH

Food and food preparation not only provided nourishment necessary to sustain life but also played an important symbolic role in slave life. Slave cooks not only maintained cultural continuity with West Africa in their creative recipes but also in the manner in which meals were made and served. Some slaves prepared and ate their meals in their cabins, but typically they ate stews cooked in a communal pot. The plantation cook usually had the stews simmer throughout the day to be ready in the evening as slaves finished their work. The presence of these one-pot meals is not only supported by the food remains found by archaeologists at the Lynch Plantation but also by a type of earthenware pottery known as *colonoware*.

In *Uncommon Ground*, Leland Ferguson cites Shad Hall of Sapelo Island, Georgia. Hall reminisced:

> *My grandmother Hester said she could remember the house she lived in, in Africa. She said the roof was covered with palmetto and grass, and the walls were made of mud…I remember some pots and cups that she made of clay. She brought these from Africa.*

Today, *colonoware* is a term used by archaeologists to classify locally made, low-fired pottery, likely produced by African Americans and Native Americans throughout the Southeast. In South Carolina, archaeologists believe the pottery was principally produced by enslaved Africans recently arrived to the Lowcountry plantations.

First identified in the 1930s at Virginia's Colonial Williamsburg and other Virginia plantation sites, archaeologists assumed this crude pottery was constructed exclusively by Native Americans for trade with Europeans. Ivor Noël Hume, director of archaeology at Colonial Williamsburg, provided the first published description of this pottery, calling it *Colono-Indian ware*. He believed that this category of ceramics extended from "Delaware to South Carolina…with variations of rim ornament and temper along the way." The theory of exclusive Indian manufacturing was widely accepted until the 1970s, when excavations in South Carolina recovered thousands

Down & Dirty

Colonoware vessels were likely made by Africans recently brought to the New World. Archaeologists have also located slave-made vessels that bear the incised "X," a religious symbol brought by West Africans. *Courtesy of SCIAA/University of South Carolina.*

of sherds of this type in sites associated with slaves. About 1975, Richard Polhemus, laboratory director with SCIAA, was visiting his brother in Africa when he noticed the locals using pottery identical to artifacts found at plantation sites in the Lowcountry. "The Ghana vessels are flat bottomed, fine grit or sand tempered, plain burnished, and bear the incised 'X' on the base which many Colono-Indian vessels from South Carolina also possess," Polhemus wrote his fellow researchers. Leland G. Ferguson, an archaeology professor at the University of South Carolina, was intrigued by the possibility that *Colono-Indian ware* was in fact made by enslaved Africans laboring on Lowcountry plantations. After scrutinizing dozens of *colonoware* collections across South Carolina, Ferguson was convinced.

> *The most obvious evidence that pottery was made on plantations in South Carolina is the sheer quantity of artifacts found on these sites. The fact that hundreds of people who were capable of making pottery lived in just the location where it is abundantly found*

The Charleston Frontier and the African Potters of Christ Church Parish

Based on archaeological evidence at Thomas Lynch's plantation, his slaves produced vessels in a variety of styles beyond those that were necessary just to make pots for home use. Some of the potters imitated vessels like those pictured here. *Courtesy of New South Associates.*

argues for their making it. Oral accounts from former slaves of pots their forebears built, makes a firmer case. The archaeological evidence from South Carolina is, however, even more direct. Lowcountry plantation pottery exhibits all the archaeological criteria for on-site manufacture.

Archaeologists have presented various theories on the most common uses of *colonoware* on plantations with enslaved Africans. *Colonoware*, while serving primarily as a food consumption vessel for the slaves, was also used to prepare and serve food in European homes during the first years of the colony. This may relate to the shortage of European plates, pots and serving dishes in early eighteenth-century South Carolina. African-style meals often consisted of a starch-based stew such as rice, cassava, millet or manioc served in a large container and eaten by hand from a communal pot. Dipping sauces or relishes of vegetables were served in shared bowls that also doubled as drinking vessels. The pattern of eating at Southern plantations, where hominy, grits and rice were staple dishes often supplemented by small amounts of meats and vegetables served in stews, was probably similar to the culinary traditions of West Africa. *Colonoware* pottery served both circumstances quite well.

Archaeologists have also discovered many shallow *colonoware* vessels displaying an African cosmographic symbol associated with healing and religious rituals. The cosmogram etched into the sides of these vessels is associated with the BaKongo people from the Congo-Angola region of Africa. The symbol is believed to be a depiction of the "sun rising over the earth to return to the underworld at night." The Congo believe in a cosmos consisting of "this world" and "the land of the dead," where the two worlds are divided by a body of water, traditionally called Kalunga, but also known as water, ocean and great river. To the Congo, the rising and setting of the sun represents the exchange of day and night between the living and the dead. Life is a cyclical path between two worlds, and death is merely a transition in the process of change.

Most of the cosmographic marked vessels have been found on the silt-covered bottoms of Charleston's rivers. Leland Ferguson believes that these bowls and jars were connected with *minkisi*, or sacred, spiritual medicines. Since water represented the shadowy plain between the Congo's physical and spiritual worlds, slaves may have tossed the "magic bowls" into South Carolina rivers for healing or ritual purposes. With the acceptance of Christianity, many African Americans may have abandoned the tradition for the established practice of baptism in local rivers. Production of these vessels was discontinued in the Charleston area around 1800 but was sustained for decades on Beaufort plantations, an area considered to be the heartland of Gullah culture.

Archaeologists Connie Huddleston and Eric Poplin noted that *colonoware* unearthed from the Thomas Lynch Plantation possessed more burnishing and smoothing than collections from later sites in the region. Also, there appeared to be a greater occurrence of European forms or attributes and an increased incidence of micaceous clays. They developed a hypothesis to explain these variations based on two assumptions. They assumed that there was less emphasis on the purchase of Africans that possessed certain skills, particularly knowledge of tidal rice agriculture, during the early eighteenth century than during the middle and late eighteenth and early nineteenth centuries. Thus, the segments of the African population enslaved during the early eighteenth century were more diverse in terms of the skills represented than the segments captured during the following decades, even though larger numbers of Africans were taken during these years. It follows that Africa-trained potters should be present in greater numbers among the slave populations of early eighteenth-century sites than among later slave populations. This suggests that plantations created during the early eighteenth century had a greater opportunity for the African slaves who made *colonoware* to have learned pottery making while still in Africa than the plantations that developed later in the century. It is assumed that Africa-trained potters had practiced this craft before their enslavement, presumably providing vessels for their families and their communities in Africa. After their enslavement and arrival in North America, they again began to manufacture pottery for themselves, their neighbors and Europeans. They copied European vessel forms, creating plates, cups, strap-handled jars and chamber pots,

The Charleston Frontier and the African Potters of Christ Church Parish

and incorporated European decorative elements such as notched ("pie crust") rims into more traditional African vessel forms such as bowls and jars. This ability likely developed in response to the ethnic diversity of West African populations, a diversity that extended centuries into the past.

Through time, the market for slave-made *colonowares* was lost. The planter families replaced the pots their slaves had made with European tableware found in the Charleston shops. Without a market for diverse styles and forms, the plantation slaves only had need to make a few functional "African" bowls and jars for their own homes. Eventually, the slaves replaced their own homemade pottery with the castoff finery of the planter's house. By the early nineteenth century, the African potters of Christ Church Parish had all but disappeared.

THE STEADY MARCH OF TIME AND NATURE

Unlike many of Charleston's grand estates that lasted for more than 250 years, the Thomas Lynch Plantation did not last much longer than the man himself. Thomas Lynch died sometime before December 20, 1738, when his estate was inventoried posthumously. The fourteen-page itemized inventory is an astounding list of properties, houses, furniture, timber, cattle, rice, bags of silver and various plantation goods. The Wando River lands apparently were occupied by his widow, Sabina Lynch, until her death in 1741; at that time, they passed to Thomas Lynch II. Lynch II had already established himself at Hopsewee Plantation on the Santee in Georgetown County and is reported to have built the present house there. Like his father, Thomas Lynch II served in the assembly, held militia commissions and was highly esteemed among his peers. He was a staunch Patriot and often spoke out against the Crown during the 1770s. He was elected to the First Continental Congress as one of South Carolina's representatives. Following a cerebral hemorrhage in February 1775, Lynch was "replaced" in the Congress by his son, Thomas Lynch Jr. This Thomas Lynch, grandson of the Lynch who resided on the Wando River, would sign the Declaration of Independence for his ailing father. Thomas Lynch Jr. was born in South Carolina on August 5, 1749. He was educated in England and graduated with honors at Cambridge. After studying law in London, he returned home in 1772. He was politically engaged as soon as he returned and was commissioned as a company commander in the South Carolina regiment in 1775. Soon afterward he was elected to a seat in the Continental Congress, replacing his father. He fell ill shortly after signing the Declaration of Independence and retired from the Congress. At the close of 1776, he and his wife sailed for the West Indies. The ship disappeared, and there is no record of his life after.

After Thomas Lynch II's removal to the Santee, the Wando River lands were broken up. The selling of the property by the Lynch family marks the beginning of a long period of decline for the plantation. Rice and cotton agriculture continued to play a role in the economy of Christ Church Parish during the first half of the nineteenth century, but to a considerably lessened extent than they did in other portions of South

Few plantations have survived. Often all that bears witness to this era are the old cemeteries, many overgrown and forgotten. *Courtesy of the Library of Congress.*

Carolina. Income at the plantation was generated from cutting the timberlands on the interior portions of the property, with provisions and cotton produced near the river. Cattle were raised and pastured freely in the woods. By 1803, the Thomas Lynch house had fallen into ruins and the plantation was staffed by a dwindling number of laborers. By the mid-nineteenth century, the plantation had been virtually abandoned and the forests had crept into and over everything.

Notwithstanding its history as a plantation, the Lynch Plantation today is home to a new generation of Charlestonians. The upland fields that once grew corn, peas and indigo are now covered by beautiful homes and manicured golf courses. As with the Native American cultures that predated the plantation era, a new world has been

The Charleston Frontier and the African Potters of Christ Church Parish

built along the Wando River. Long marsh grasses have supplanted the rice stalks of the colonial period, and the faded traces of the dikes are barely visible. Along the river are reminders of the years when the plantation reached its peak: towering oaks whose origins might be traced back to the days when elements of traditional African cultures joined European and Indian influences to create a unique ethnic landscape.

Charleston stoop. Photograph by Adam Hester.

Ironwork along Meeting Street. *Photograph by Adam Hester.*

Oyster Point was the location of the second English settlement in the South Carolina Lowcountry. Photograph by Adam Hester.

Unlike many Southern cities, many of Charleston's fine colonial and antebellum homes have survived to today. *Photograph by Adam Hester.*

Colonial architecture located along Broad Street. *Photograph by Adam Hester.*

Oysters have remained a popular food source for Lowcountry residents for thousands of years. Courtesy of the Coastal Conservation League.

Generation after generation, fishermen, shrimpers and crabbers have made a living from the Lowcountry creeks and estuaries. *Courtesy of the Coastal Conservation League.*

Oysterman. Courtesy of the Coastal Conservation League.

Catching mullet. Courtesy of the Coastal Conservation League.

Lowcountry cuisine has roots that reach from the plantation to the west coast of Africa. *Courtesy of the Coastal Conservation League.*

Plantation house remains. *Courtesy of the Library of Congress.*

Miles Brewton slave quarters, circa 1865. Courtesy of the Library of Congress.

Miles Brewton work area, 1865. Courtesy of the Library of Congress.

Tabby plantation ruins. *Courtesy of the Library of Congress.*

BAPTIST ENCLAVES

ARCHAEOLOGY AT SCHIEVELING PLANTATION

The earth seemed unearthly. We are accustomed to look upon the shackled form of a conquered monster, but there—there you could look at a thing monstrous and free.
—Joseph Conrad, The Heart of Darkness

NEW BEGINNINGS

In 1663, King Charles II made a proprietary grant to a group of powerful English courtiers who had supported his return to the throne in 1660, and who sought to profit from the sale of lands on the unsettled South Carolina coast. These Lords Proprietors, including Sir John Colleton, Sir William Berkeley and Sir Anthony Ashley Cooper, provided the basic rules of governance for the new colony. The proprietors and their king hoped England would flourish in the New World, which they expected to fill with English institutions and people. Their initial efforts focused on settling Barbadian planters, great numbers of whom had left the islands and were living in Charleston in a state of comparative poverty and others in absolute want.

The creation of the Charleston settlement coincided with major religious upheavals in British society. A nation once esteemed to be the most judicious in Europe had changed its character, substituting persecution for tolerance and pettiness for magnanimity. Thus it happened that a considerable number of South Carolina's early settlers were Baptists who sought the prospect of religious liberty. Among the crowds who left England for Carolina was a shipwright named Thomas Butler.

Baptist Enclaves

Thomas Butler emigrated from "Redriffe near London" in August 1672 with three servants, each bound to serve two years in return for the passage to Carolina. The Proprietors promised Thomas Butler three hundred acres of land and an additional one hundred acres for each servant he brought. When Butler's party arrived off the coast of South Carolina, they would have seen in the distance a clearing on the riverside and the outlines of many buildings. As they entered the harbor their senses would have been assaulted by the haughty smell of pluff mud, smoke and the sweetly scented blooms of lavender, wild hibiscus and mullein carried on the southwest sea breeze. For an Englishman, ascending the Ashley River must have been akin to traveling back to the beginning of time. Though a few plots had been cleared outside the defensive walls, the scene would have been dominated by heavy and motionless foliage hanging from the trees lining the banks of the Ashley.

Once ashore, Thomas Butler and his servants cleared a plot of land and built shelters of logs and mud, and eventually heavy timber. Butler, like the other colonists, hoped his plots would one day provide a crop as profitable as sugar had been for the Barbadians. While none starved, the first year was difficult. The hardy children of the north, who endured with stoic indifference the cold, wet winters of southern England, were unable to resist the summer heats and dissolved away in languor and sickness under the beams of the South Carolina sun.

Butler received his first warrant for 400 acres on the Ashley River in November 1672 and an additional warrant for 410 acres when his wife Sarah, children Shem and Ann and two additional servants joined him in Carolina. He may have dreamed of lush fields of crops, but in those first years in Carolina, he worked as a carpenter, shipwright and appraiser for the Proprietors. In 1679 he received a grant for 450 acres of lowland on Charleston's upper peninsula, on which he could forage livestock and plant crops. The forest, not yet cleared for cultivation, provided a wilderness from which to gather lumber, shingles and materials for his carpentry and shipwright business. Animals of various sorts, with which the forests were plentifully stocked, supplied the Butlers with food, skins and recreation.

By 1700, the Butlers had moved to their land grant on the south side of the Ashley River where there was plenty of land for the ambitious to clear and cultivate. The property was surrounded by a vast wilderness, but the Butlers were not alone in their move. John Cattell and Edward Perry, former servants of Butler's, also received modest land grants near their former employer. It was astonishing how, with few exceptions, the graduations of Thomas Butler's servants led to prosperity.

THE BUTLER COMPOUND

In July 1703, Shem Butler, grown to his early thirties, moved with his wife Esther, sons Thomas and Joseph and daughters Rebecca and Sarah to an adjoining land grant. Shem Butler attacked the great forests with energy and borrowed to purchase a small number of slaves to assist in this task. The tropical scene was felled with saws and axes,

drug from the forest by oxen and then floated to Charleston for sale. For the next few years, the relentless blows of the axe and retort of the falling tree continued unabated until sunlight penetrated the ancient forest. The product of such backbreaking labor came to be known as Ashley River Town, or Shem Town, though in truth it never really amounted to much of a town. Streets were planned and dwellings contemplated, but the only mark of improvement was a clearing along the Ashley River and the establishment of a ferry by an act of the General Assembly where for four days in the spring and fall, rural residents sold crops and enjoyed a variety of entertainments, including cockfights and horse races.

Shem Butler's Ashley River Ferry also received a reputation for lawlessness. It was said to be a place where fugitive slaves "lurked" and where the rougher Scots-Irish settlers came to drink, fight and generally raise hell. The Butlers' Anglican neighbors may have frowned on the entertainments, but their complaints were lost in the bustle of frontier commerce. A market building large enough to house the entire General Assembly existed on the property by 1760, when that body convened at the plantation during a smallpox outbreak.

Archaeological excavations reveal that Shem Butler built a walled settlement just upriver from the Ashley River Ferry. The discovery of the Butler compound was very different from what archaeologists expected to find among the community of beautiful Ashley River estates. The compound's remains were first discovered by archaeologist Michael Hartley, who interpreted the fallen walls and brick piles he observed within the walled boundaries as the remnants of a Georgian plantation settlement. Georgian architecture developed in England (1730–1800) out of the Classical Revival style, which dominated Europe during the Renaissance and Enlightenment. Georgian architecture was most heavily influenced by Palladianism, a philosophy of design based on the writings and work of Andreas Palladio, an Italian architect of the sixteenth century who tried to recreate the style and proportions of the buildings of ancient Rome. Georgian architecture was defined by understated decorative elements and use of classical "orders." Subsequent excavations led by Dr. Eric Poplin, however, revealed the building remains at Schieveling Plantation, as the Butler compound came to be known, did not fit the concepts of layout or the use of space used at other Georgian plantations like Drayton Hall and Middleton Place. Additionally, the apparent construction date for the Butler settlement in the historic and archaeological records place it decades before the establishment of Georgian ideals in Britain or her far-flung colonies.

Exposed foundations indicate the one-acre compound consisted of a brick enclosing wall, possibly five feet high, with a number of buildings arranged along the inside. A timber frame building that served as a kitchen likely stood along the southeast wall, adjacent to the planter's residence. One- to two-story brick storage facilities stood in the northeast and northwest corners of the compound. The building in the northeast corner, defined by brick foundations measuring 17 by 22.5 feet, may have been a dairy or food storage area. This portion of the site also witnessed the majority of the secondary butchering activities, where meat was prepared for the dinner table. A brick floor between this corner and the southeast wall segment suggests that there was either

Baptist Enclaves

Archaeologist Eric Poplin. *Courtesy of Eric Poplin.*

a covered walkway or a workspace with a solid floor between the two. The northwest corner building had wooden floors and may have stored bulkier items, like grain. A number of tools recovered near a timber frame building in the southwest corner suggest that the structure witnessed the disposal of the butchering remains of a number of large animals, including cows, horses and pigs. Excavations also uncovered a brick-lined well inside the enclosure near the center of the south wall. Though not located by archaeologists, the plantation no doubt contained washhouses, poultry houses, stables and barns outside the walled compound.

According to Dr. Poplin, only two other plantation settlements identified in the South Carolina Lowcountry display a similar design or configuration, the former Legare Plantation on the Wando River in Charleston County and the Sams Plantation on Dataw Island in Beaufort County. The Legare Plantation had an enclosed space adjacent to the planter's house, with a number of buildings connected with the outside façade of the enclosing wall. Brick foundations and footings define these buildings and structures today. Like the Butler compound, the Legare settlement was constructed prior to 1730, possibly as early as 1700. The enclosure at the Sams Plantation incorporates the planter's house with three wings and a number of kitchens, storage buildings and slave residences in a rectangular enclosure. The enclosure and buildings were made of tabby, a lime- and wood-ash-based concrete with oyster shell serving as the coarse aggregate.

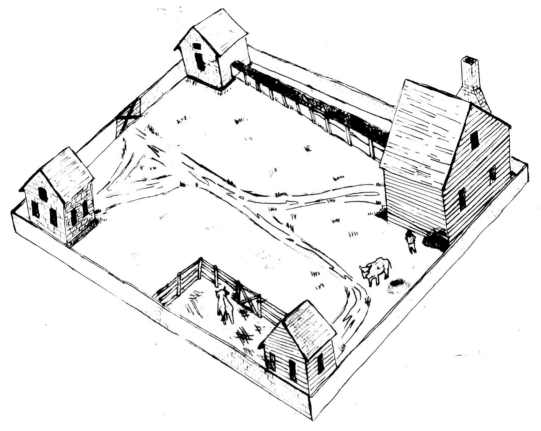

Butler Plantation. *Illustration by Pat Hendrix.*

The Sams compound was built in the 1820s, enfolding a number of existing buildings and facilities into the enclosed space. Dr. Poplin and architect Collin Brooker theorize that this may reflect a late eighteenth- and early nineteenth-century agrarian reform movement in Britain. Farms containing such enclosures are often referred to as "model" or "planned" farms, because they were built as a whole and concisely laid out by an architect or agricultural engineer. The capture of space within walled enclosures became a hallmark of this reform, particularly with respect to field systems. Reform plans called for the logical placement of the barns, sheds and other buildings necessary to produce and store crops so that the farmer or stock used as little energy as possible to move from one building or task to another.

If the Butler and Legare enclosures predate the British agrarian reform movement of the eighteenth century, Dr. Poplin believes they may have drawn inspiration from earlier settlement types. Many seventeenth-century English estates had farm buildings organized around courtyards, generally away from the manor house but close enough to permit the owner easy access. Historians believe the design evolved from medieval courtyard settlements, or even derived from Late Iron Age settlements, common throughout the British Isles and Western Europe with the advent of the Roman occupation of Britain.

Research suggests that the Butlers did not know much about farming before they came to South Carolina. Thomas Butler was a shipwright who lived and worked on the west bank of the Thames River, an area described as waste, fit only for "Cherokees and Savages." Shem Butler, for that matter, moved to Carolina when he was only a boy. In all likelihood, he had little exposure to farming practices in England prior to his arrival in Carolina. Then why did Shem Butler build this walled compound? Archaeologist Eric Poplin speculated that the enclosing wall could have simply restricted access to a garden used to produce a crop that required protection from wild or domestic animals that a wooden fence could not deter. Another use of the enclosed space could have been as an animal pen. The Butlers could herd sheep, cows or pigs into the space for feeding, protection, shearing or butchering. The proximity of the planter's house to the enclosure would argue against this, although early eighteenth-century olfactory sensitivities may not have been as great as those of later centuries. Also, it is possible that the enclosure evolved from a stock pen to a garden as the plantation became a country residence for its owners in later years. And there was defense. The Butlers could have built the wall around their frontier home for protection. And indeed they had cause for fear. The Roanoke settlement was attacked in the early days by an Indian war party, and deaths from ambush and on lonely plantations were not uncommon. Unfortunately, archaeologists have recovered no information concerning the plantation to date to support these suppositions.

Though slaves provided a great portion of the labor needed to build this settlement, the clearing and cultivation of the plantation would have required a continual outlay of capital by Shem Butler. The cost would have been worth it. The young planter could watch his home rise, pulled board by board and brick by brick from the riverbank where the trees and clay had waited for centuries. Though small by the standards of later Ashley River mansions, Shem Butler bore the small size of his dwelling by outfitting the house with a few expensive goods, hoping to give an air of respectability and comfort to his place of residence. Still there must have been great incongruity immediately about the planter's house. Large oaks had been planted to ornament the grounds, and azaleas and other flowers were no doubt gradually springing up around the house, yet the landscape had been only recently cleared of trees and stumps could be seen everywhere. These unsightly stubs abounded in the open fields adjacent to the compound, and fires were occasionally built to burn trees and underbrush. But these blights on the view must have seemed insignificant on the whole. Shem Butler could glance north to south, on both sides of the Ashley River, with pride, the prospect of prosperity expanding around him; the result of great enterprise, and much of it the product of his own expansive imagination.

While life at the plantation was probably rather predictable and mundane, the main house would have occasionally been the scene of festivities, including Christmas, weddings and other holidays. Visitors would have entered a home that was fitted as a parlor, though the fireplace, with its domestic arrangements, betrayed the culinary uses to which it was occasionally applied. The bright blaze from the hearth rendered the light from the candle and chandelier unnecessary, for the spartan furniture of the room

was illuminated by the glow of the fire. The floor was covered in the center by an old carpet carried across the Atlantic in the hull of a ship and worn threadbare. Feasts were conducted in the parlor room that doubled as the facility's meeting room during business hours. Archaeological evidence indicates that the kitchen had an iron stove and a wide range of crockery, including skillets and kettles. Utensils of both bone and metal were recovered from excavation pits around the Butlers' home. The Butlers could purchase their spoons made of pewter or silver from American silversmiths and pewter makers. Iron and steel knives and forks were made in England and exported to Charleston.

The Butlers also maintained expensive sets of dishes at the planter's house, indicating their wealth and presumed status among the emerging planter society. Most were tableware, ceramic vessels that were placed on the table for direct food service or as individual place settings. These items would include plates, soup bowls, serving dishes such as tureens, platters, cruet pieces, pitchers and teapots and coffeepots. During the Butler tenure (1700–46), delftwares were the primary tableware used by the planter and his family. Delftware often took the form of elegant plates often mistaken for fine porcelain, jars filled with medicines and deep punch bowls inscribed with inspirational toasts. Delftware takes its name from the town of Delft in the Netherlands where many successful potteries were situated. Beginning in 1567, delftware began to be produced in England when two Flemish potters arrived in Norwich, England. The center for delft production shifted to the London area soon afterward. Delft and stoneware were the main pottery forms in Europe until trade brought Chinese porcelain to the West in the seventeenth century.

South Carolina's First Revolution

The Butlers' move to the Ashley River was not a purely economic decision. The construction of their plantation coincided with a major political battle in which they, and the larger community of Baptists, were deeply involved. Beginning in 1700 with the death of Governor Blake, the colony entered a long period of turmoil and strife. The trouble began when Sir Nathaniel Johnson became governor in 1703. His first official act was to pass a law excluding all Dissenters, including the Butlers, from the General Assembly. "Cannot Dissenters," said the Baptists, "kill wolves and bears as well as churchmen, and also fell trees, and clear ground for plantations, and be as capable of defending them as churchmen?" The next assembly voted by a large majority to repeal the law but Johnson stubbornly refused to sign the act. The General Assembly then appealed to the Proprietors, but they sustained the intransigent governor. The Proprietors only yielded when the act met a royal veto from Queen Anne and when threatened with the loss of their charter. The Dissenters were restored to their share in the government. The Church of England, however, was made the state church and so it remained to the time of the American Revolution.

By 1710, the stretch of the Ashley River surrounding the Butler settlement had been acquired by fellow Baptists. Here, in the forest, in their own domain, they were

supreme. Self-reliant and sufficient, they stubbornly maintained their rights even as their enemies in Charleston denied them. It was not an entirely unconscious expansion. Even as a collection of loosely connected outposts stretched along the Ashley River and surrounded on all sides by enemies and wilderness, the emerging Baptist community was regarded by its inhabitants as the beginning of something new and revolutionary. Rather than live under the heavy hand of the Proprietors and the Anglican Church, they had started their own settlement apart from their more "genteel" neighbors on the Charleston peninsula. Religion was a quality little cultivated along the Ashley River for the first few years of its settlement, but as most of its inhabitants were devout men and women, when the homes had been built and the fields laid out, they began seriously to observe the spiritual customs that had been the principal care of their ancestors. The Butlers were leaders in the community, and Shem Butler's brother, Richard, was named a trustee of the Antipedo Baptist Church in Charleston. In 1725, he and his wife donated six acres to the Ashley River Baptist congregation as a site for a church.

After all those years of toil, the Butlers must have wished to dwell in peace and tranquility and enjoy all that the land could provide. But outside their carefully guarded compound, a dark shadow had fallen on Carolina. Continually harassed by Indian traders and driven from their hunting grounds by land-hungry Europeans, the Native Americans throughout the colony attacked in the Yamasee War of 1715. The Yamasee and their allies fell upon the unsuspecting settlers with unrelenting fury, destroying all frontier plantations and massacring one hundred people the first day. Refugees fled to Charleston as war parties moved as far north as the Stono River, burning homes and killing settlers. The Europeans unlucky enough to be captured by the Yamasee were subject to days of torture before being burned alive. The Butlers, advantageously located at the ferry into Charleston, must have trembled as the refugees recounted these tales before they crossed the Ashley River to the safety of the city walls.

Richard Butler, who sat on the General Assembly, signed a letter pleading for royal protection from the Indian attacks. The Proprietors dismissed his request as a ploy to undermine their authority and left the colonists to their own resources. At this moment, the colony teetered on the knife's edge, but these settlers were a tough and sturdy bunch and they would not be vanquished without a fight. Shem Butler's frontier settlement was equipped with nine guns, a blunderbuss, a backsword and two small quarterdeck cannons. Typically associated with a ship's anti-personnel armaments, the quarterdeck gun could be loaded with shot, mounted on a swivel and used with devastating effect. The wall surrounding the Butler compound could have easily been five feet high and, when defended with muskets and cannon, would have proved a formidable obstacle to even the most determined attack. Additionally, the surrounding fields would force any assailants to quit the cover of the woods before they could make any approach sufficiently near to render them dangerous. The enemy could burn the buildings and crops located outside that wall, but to breach it they would endure punishing fire from the Butlers and their armed servants. Their settlement was totally destitute of comfort and the arts, but animated with a high sense of honor and independence.

Just as the colonists were marching out to counterattack the Yamasee assault to the south, the Catawba and Congaree Indians launched a surprise attack from the north, killing everyone as they advanced. The Santee area was totally unaware of the danger and suffered some of the highest death tolls of any neighborhood during the uprising. Once news of the attacks on the Santee plantations reached Charleston, "ninety horsemen" under the command of Captain Barker rode out to meet them. The colonists were ambushed only a few miles outside of town and Barker was among those killed. At this point only sixteen miles stood between Charleston and total destruction.

It was undoubtedly a scene of utter pandemonium and terror, but many of the planters had organized and were preparing for another counterattack. With every home threatened, every able-bodied man turned out to fight. Shem Butler and his sons, Joseph and Thomas, joined Captain George Chicken's company of seventy planters and forty slaves who struck out to fight nearly four hundred Catawba warriors and their allies. The Europeans accepted battle in a withdrawn defensive position and waited for the Native Americans to advance. The Catawba and Congaree were outgunned but they placed great confidence in their warriors, who outnumbered the colonists four to one. There came the horrible crash of musket fire and dying horses, and there they stood locked together in battle. As neither side would withdraw, the struggle was prolonged and bloody. Confusion steadily increased. At last, the Catawba and Congaree were hurled back with severe losses from the musket fire. The slaughter ended only in the depths of the woods, and the scattered Indians became fugitives, hunted, starving, suffering, but still in arms.

As the war pressed on, the tide slowly turned against the Yamasee. They were first pushed into Georgia, then eventually moved to Florida. While the Yamasee and their allies staged a number of successful raids to the south through the 1720s, by 1728 the colonists had routed them and made the area accessible for renewed settlement.

The frontier colonists succeeded, after a desperate conflict, in destroying the Yamasee; but they never forgave the people who had exposed them to a danger they were left to combat alone. The sparks of anger kindled into a blaze; and the Butlers were soon calling for the replacement of their old enemies, the Proprietors. South Carolina's legislature sent a petition to Parliament in 1719, requesting that royal rule succeed that of the Lords Proprietors. After several years in limbo, the Butlers received a degree of certainty in 1729 when the crown purchased the Proprietors' interests, and in 1730 when the new royal governor, Robert Johnson, arrived in the colony.

Scattering of the Butler Clan

Shem Butler died in 1718 and devised the 313-acre tract containing the Butler compound to his son, Thomas Butler. Included in the plantation inventory were ten slave men, four boys, two girls, seven women and three infants. The plantation was fully outfitted with household goods, including pewter plates, cooking implements and furniture. There was an air of better life in a tea table and expensive dishes, as well as in an old mahogany chest of drawers. The chairs, dining table and the rest of the furniture were of the

plainest and oldest construction. There were a large number of items related to forest industries including saws, axes, augers, mills, adzes, spiders, cypress shingles, 2,500 feet of pine board and 2,034 feet of timber. Domestic animals, including an astounding seventy sheep and fourteen hogs, provided meat, wool and considerable profit on the open market. Shem Butler's monstrous herd of cattle formed the principal object of his wealth, excepting the land and slaves. A small quantity of corn was grown on the plantation while 80 acres were dedicated to the production of rice. Horses and oxen were used primarily as labor animals but archaeological evidence indicates that they were also eaten by the Butlers.

With the death of Shem Butler the family began to slowly drift apart. Shem's brother Richard received substantial land grants on the Combahee River but continued to live on the plantation his father had given him on the upper Ashley River. He died at his plantation in September 1748 and was buried without a minister present. Thomas and Joseph Butler moved to Prince William's Parish at the conclusion of the Yamasee War to lay claim to vacated "Indian Land." Thomas Butler appears to have frequently visited the Butler estates on the Ashley River. In 1739 his slave Abraham robbed a white man on Ashley River Road in an attempt to escape to Spanish Florida. Abraham was taken to Charleston and publicly executed as a warning to other slaves. Thomas Butler died in 1741 and left the care of his son to his brother Joseph.

In July 1752 Joseph Butler was back at the Ashley River when he was involved in a quarrel with his neighbor, Richard Baker. Captain Baker was a wealthy planter from a prominent family and heir to the splendid Archdale Hall. Having grown up on neighboring plantations, the two men had known one another since childhood; they moved in the same social circles, attended services at the Baptist church and fought shoulder to shoulder in the Charleston militia. Despite their long history, the dictates of honor prescribed dueling as the accepted remedy for settling disputes and Joseph Butler shot and killed Baker. He was pardoned of manslaughter by Governor James Glen but left Charleston, moving to Savannah in 1755 with his wife Mary LaRoche and four children. Joseph Butler's life was no less scandalous in Georgia. After amassing a huge fortune, Butler died in November 1775 and left the bulk of his estate to his mistress, Mary Crocker, and his five illegitimate children.

The Butlers, now dead or dispersed over South Carolina and Georgia, divided and sold their Ashley River holdings. The plantation compound was bought and sold by a number of local planters and sat largely abandoned before being purchased in 1785 by Ralph Izard, at the reduced price of £1,600. When Izard combined this tract with the adjoining Savages tract, he had the 1,056-acre plantation that he named Schieveling. The origins of the name are not known.

The Second Revolution

Ralph Izard "the younger" was the son of Ralph Izard and Rebecca Blake. He was called Ralph Izard Jr. to distinguish himself from his cousin Ralph Izard, who had served as

Circular Church. Photograph by Adam Hester.

ambassador and senator for the United States. Like most men being prepared for the life of a planter and gentleman, Izard was sent to England for a formal education. He was in London in March 1774 when he signed a petition against the Boston Port Bill and shortly thereafter returned to Charleston. Upon returning to the colony, the young Izard, with no wife or public office, filled up his time with the improvement of his estate or by the duties, pleasures and even follies of Charleston's social life. From his father he inherited three plantations, including Cow Savannah in St. George Dorchester Parish and Mount Boone and Fair Lawn on the upper Ashley River. He added to his substantial inheritance with the purchase of Villa Plantation and was bequeathed Spring Farm and Tomotley on his brother's death. He also owned a townhouse in Charleston and four outstanding rice plantations on the Pee Dee River: Weymouth, Hickory Hill, Milton and White House.

Ralph Izard Jr.'s first act of public service began with the onset of the American Revolution in 1775. He was a Whig during the war, serving as an aide-de-camp to Colonel Henry Lee (Light Horse Harry), father of Robert E. Lee, and supplying provisions to the South Carolina militia. There was an uneasy calm in the first months but British preparations were underway to open the Southern campaign with an attack on Charleston.

Beginning in 1776, Charleston's defenses were greatly strengthened, Ralph Izard and other planters laboring in concert with a great body of their own slaves to erect fortifications along the Ashley River to command the ferry and prevent a crossing there on Charleston. Similar redoubts were hastily constructed all around the city in preparation for the inevitable British attack. They had considerable work to do. With the termination of hostilities associated with the French and Indian War in 1763, the project to build defenses across the Charleston Neck was discontinued, and the cannons on the existing horn work dismounted. In 1765, two years after the war, a Northern visitor described this work on "the Path" as "mounds thrown up and ditches round the back part of the town but all ruinous and nearly useless." Likewise, a British informant in 1774 declared these land defenses as one of "3 apologies for fortifications belonging to Charles Town…no gates have been hung nor guns mounted upon it and what is built of it is now rather a nuisance than otherwise."

"Mud and Sand, Faced with Palmetto Tree"

Fellow Charlestonian William Moultrie was charged with the construction of Fort Sullivan, constructed on Sullivan's Island to command the approach to the harbor and guard the city's flank from amphibious assault. The engineers did not have stone or brick available to construct the walls, so they used palmetto logs to build two parallel walls sixteen feet apart and filled in the gaps with sand. Excavations by Stanley South indicate that the structures of brick, palmetto logs and yellow pine were secured together with nails and spikes and mortar made from oyster shell. As the British fleet approached Charleston in early June, only the south and east walls were complete. After a brief

inspection, Major General Charles Lee declared the fortification was nothing more than "a Slaughter pen." He proposed that the fort be abandoned but was overruled by South Carolina Governor John Rutledge.

Archaeological excavations indicate an arsenal of pistols, muskets, solid shot, gunflint and a variety of other items that provided a time capsule of American and British arms and domestic artifacts. Officers and enlisted men mainly ate domestic animals, but the bones of deer, horse, dog, rat and raccoon indicate that they had a varied, if somewhat unappetizing, diet. Cattle kept nearby served multiple purposes: the flesh could be eaten and the bone was apparently split and used to scrape and prepare the leather hides. From the harbors and rivers soldiers also caught drum (locally called redfish or spot-tailed bass) and catfish, and from the marshes and inlets they collected oysters, conchs and mussels. Of course the diet was not entirely meat; archaeologists also recovered peach seeds, watermelon seeds and walnut hulls from the fort's inundated trash pits.

At 11:00 a.m. on June 28, 1776, British Commodore Peter Parker began his bombardment of Fort Sullivan with one hundred guns from nearby ships. Three of the ships attempted to move into the harbor west of the fort but, "through the incompetence of the pilot," got stuck on a shoal and became an easy target for the Americans. As a portion of the fleet floundered in shallow water, British troops under the command of Sir Henry Clinton landed on nearby Long Island, but found the creek to Sullivan's Island too deep to wade. The American garrison held their post with firmness, returning a steady and remarkably well-directed fire at the British ships. The fort itself withstood the assault thanks to the spongy palmetto logs and the sand, which absorbed the cannonballs without shattering. The British fleet finally moved off in a most ruinous state, having lost two hundred men, including Lord William Campbell and several other officers. Sir Peter Parker suffered further humiliation when his pants caught fire in the midst of battle.

The British returned, however, when a major expeditionary force landed on Seabrook Island in the winter of 1780. All the American forces being withdrawn to the city, the British cavalry under the command of Banastre Tarleton moved up the Ashley River, away from Charleston, taking the plantations with virtually no resistance. To slow the British approach, the Americans had erected a fortified earthwork on Shem Butler's old ferry property (now called Ashley River Ferry), immediately south of the abandoned Butler compound. Under the cover of fog on March 29, the British bypassed the old Butler Plantation and crossed the Ashley River upstream from the fortified ramparts and established themselves outside the city's defenses. By April 1, the British had moved into place to begin their siege works on the Charleston peninsula. While engineers worked to take the city, the British cavalry continued their sweep up the river, taking all plantations and the town of Dorchester. Ralph Izard's slaves were seized along with three hundred bondsmen and taken by the British troops to the Charleston peninsula to aid in the construction of the English earthworks. On April 1, Major James Moncrieff, chief engineer for the British army and a veteran of several British colonial wars, directed the excavation of the enemy's first siege parallel eight hundred yards from the American lines. The Rebel South Carolinians were totally unprepared for the attack and Charleston was captured in May after offering a feeble defense.

Ruins of Sheldon Church, burned by the British during the American Revolution. *Photograph by Adam Hester.*

Baptist Enclaves

During the last three years of the war, more than two hundred battles and skirmishes occurred throughout South Carolina and no colony paid a higher price for its freedom. After the American defeat at Camden, the war settled in a low-level insurgency that burned across the South Carolina Backcountry. The violence was all-consuming, pitting family against family and neighbor against neighbor with both sides devoted entirely to the work of butchery and slaughter. Ralph Izard, for his part, joined a group of dragoons (men who rode to battle on horseback but fought on foot) under the command of Henry "Light Horse Harry" Lee, the father of Robert E. Lee. Using lightning fast raids, they ambushed British troops, sabotaged supply lines and plundered the homes of Tory sympathizers. Their most notorious act came when, disguised as British sympathizers, Izard and a group of cavalry captured six Tories in North Carolina and hacked off their heads, arms and legs. It was an act of savagery that was rivaled only by the murderous acts of "Bloody Ban" Tarleton, the British officer who burned churches, executed prisoners and left whole communities as smoldering ruins. It was no empty boast when Tarleton proudly stated that he had had sex with more women and killed more men than any man in North America.

Form, Form, My Brave Fellows

No planter, however fond of killing the British, could afford to completely ignore his estate or family. According to one historian, Ralph Izard was returning to his plantation when he was nearly captured by the British. H.A.M Smith writes:

> *During the occupancy of Dorchester by the British a party from that garrison or from Charles Town visited the Fair Spring mansion house (near the public road, a little above Bacon's Bridge) for the purpose of capturing Mr. Ralph Izard, then an Aide-de-camp to Col. Lee, of the Legion, of whose presence at his home they had been apprized. He had scarcely time to conceal himself in a clothes-press before the house was entered by the British soldiers. Nothing saved him but the composure and urbanity of Mrs. Izard (a Miss Stead) who maintained her self control, notwithstanding the threat to her of personal indignity and the plunder of her house. Affected by her behavior credence was given to the information that Mr. Izard was not there. The party being drawn off Mr. Izard crossed the Ashley in the rear of the house and gave alarm to a body of American troops. The enemy had again returned to the Fair Spring house for another search, and again retired, but not in time to evade the pursuit of a body of American cavalry, who had been pushed across Bacon's Bridge, and overtaking the returning enemy completely routed them.*

Soon thereafter, Ralph Izard rendezvoused with other American troops to push the British out of South Carolina entirely. Seeking to first reduce the British presence in the Backcountry, they determined to drive the British from the chain of posts that they stubbornly occupied. After the first victory came at Fort Watson, the posts of Nelson's

Down & Dirty

Randy Luther and Stan South in Kosciusko's mine, dug in an attempt to blow up the star fort at Ninety Six, South Carolina. *Courtesy of SCIAA.*

Ferry, Fort Gramby, Silver Bluff, Fort Conwalis and Georgetown rapidly fell into the hands of the Americans. The Fort at Ninety Six, South Carolina, would be a tougher undertaking. Garrisoned by 550 battle-hardened Loyalists, the fort was defended with a stockade on the west and a star fort on the east.

The American forces began siege operations at Ninety Six in May 1781, but the full assault did not begin until June 18. Light Horse Harry Lee's legion, including Ralph Izard, fought their way to the walls of the west redoubt, but at the star fort, the Loyalists repelled the Americans with a fierce counterattack. With their failure to take the fort with a headlong attack, Colonel Thaddeus Kosciusko, a Polish engineer fighting with the Americans, convinced General Nathanael Greene to attack from below. His plan was to dig a tunnel underneath the star fort, fill it with gunpowder and bring the wall down with one massive explosion. But just as the Americans were finishing their excavations, Lieutenant Colonel John Harris Cruger launched a nighttime sortie against the American forces and discovered the entrance to the tunnel. One British newspaper stated that the Loyalists "discovered a subterraneous passage in which…miners were at work, every man of whom was put to death, and their tools brought into the garrison." Though Colonel Kosciusko managed to escape with life, he was bayoneted in "his seat of honor" as he ran for the American lines.

With their tunnel now discovered and a British rescue column advancing on Ninety Six, the Americans abandoned the siege and crossed the Saluda River before the English could give chase. While the British were congratulating themselves on driving out the American troops, Ralph Izard and a large group of cavalry doubled back and surprised one of their foraging parties within a mile of the English camp. Thinking themselves safe, the small party of British troops was caught completely off-guard, chased down and massacred. With their strength and spirit sapped by the incessant guerilla warfare, the remaining British troops abandoned Ninety Six a few weeks later and garrisoned at a post closer to Charleston.

After spending the summer resting along the High Hills of the Santee River, the American forces began to advance on the British positions along the coast. Anticipating the American offensive, the British dispatched a large force to engage and destroy the Rebels in one decisive battle. The Battle of Eutaw Springs (Orangeburg County), as this engagement came to be known, proved to be the bloodiest and most important of the many battles Ralph Izard fought. The fight commenced on September 8, 1781, when a combined force of militia and Continental Regulars engaged British forces under the command of Colonel Stewart. As the two sides collided in pitched battle, the Continental charge broke the British lines, and Ralph Izard joined a group of cavalry to turn the enemy's flank and rear. In the ensuing confusion, Izard joined officers on both sides in a hand-to-hand fight using swords. It was a hellish fight. Soldiers on both sides were so exhausted that they collapsed and were bayoneted where they fell while others were trampled by horses in the melee. At length the British lines gave way and their soldiers began a hasty retreat. Unfortunately, the half-starved and poorly provisioned Rebels did not consolidate their victory but stopped to plunder the evacuated English camp. The English regrouped, charged and bayoneted scores of men as they rummaged

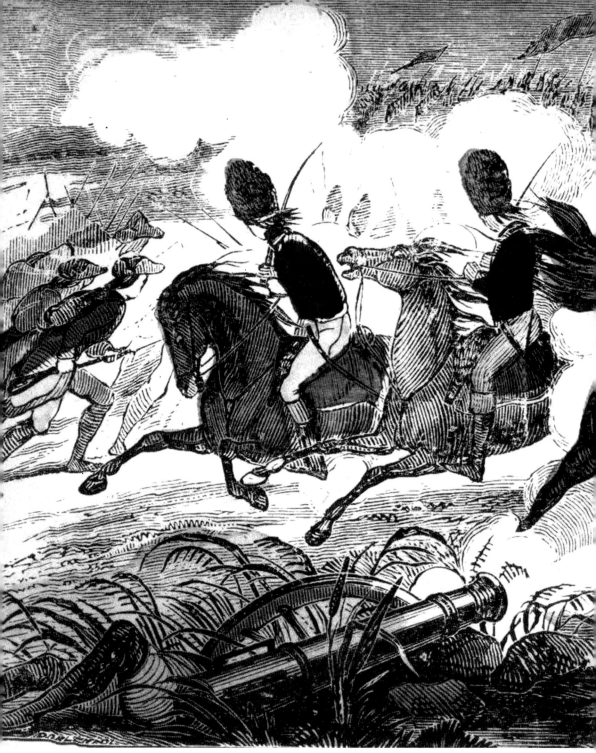
The Battle of Eutaw Springs. *Courtesy of John Frost, 1860.*

through the abandoned wagons. Dozens were slaughtered as the British Calvary joined the route and trampled and shot the remaining stragglers.

In terms of sheer slaughter, this was the greatest battle fought in South Carolina during the American Revolution. The Redcoats ended the day with control of the battlefield, but their losses were enormous with over one thousand men killed or captured. The next morning they packed their things and abandoned any hope of holding the Backcountry. Only six weeks later Lord Cornwallis marched his broken army to Virginia where they were defeated by the combined American and French force. The British surrender at Yorktown in 1782 effectively ended British military activity in the South and forced a negotiated peace. The thirteen colonies gained full independence, and the English evacuated Charleston entirely in December 1782.

A Country Home

Like his fellow soldiers, Ralph Izard returned to his life as a planter and worked diligently to restore his fortunes. When the estates of the adherents of the Crown fell under the hammer, by acts of confiscation, he appeared with cash in hand to purchase extensive possessions at comparatively low prices. The plantations proved to be enormously shrewd investments. A tax return for St. Andrew's Parish lists an astounding 11,620 acres and 460 slaves as Izard's taxable property in 1795.

In 1785, Ralph and Elizabeth Izard purchased the old Butler compound and added the adjoining 443-acre Savages Tract. The previously unnamed plantation became known as Schieveling Plantation thereafter. Izard lived an additional five years at Fair Spring Plantation until 1790, when he moved with his wife and seven young children to Schieveling. The plantation had probably fallen into ruin during the American Revolution as British troops ranged over St. Andrew's Parish stripping homes and sacking barns. Ralph Izard may have invested considerable sums making the plantation suitable for his growing family and enhanced the grounds of Schieveling with a formal garden. One historian noted that "wherever the Izard family had a country residence great attention was paid to the garden and grounds as well as to the mansion." Though they may have briefly considered Schieveling their primary residence, it appears likely that the Izards spent considerable time at their fine townhouse on Broad Street. While Ralph Izard drew the bulk of his wealth and prestige from the plantations, an unhealthy climate, combined with a huge slave population, necessitated the seasonal migration of the Izard family to the Charleston peninsula.

The removal of the family to Charleston is also supported in the archaeological record at Schieveling Plantation. Researchers would expect the Izards to have purchased and subsequently broken plates, cups, bowls and other dateable artifacts produced during their residence at the plantation. But none of these were sifted out of the soil at Schieveling. Researchers developed several hypotheses that could explain the absence of these artifacts. One possibility is the use of older types of ceramics by the Izards during their occupation of the Schieveling planter's house. That is, they might have

used the plantation as a country estate and never bothered to buy more fashionable ceramics. Perhaps they used Chinese porcelains, which retained their high status into the nineteenth century, although the Staffordshire potters began creating a light sturdy refined bodied ware (creamware) that quickly came into fashion. Since wealth was beginning to be symbolized more by newness and fashion than by age, even the wealthy sought the creamware table and teaware. There is no indication that the Izards graced their table with these new ceramics. Also, there are types that remained in use well after their manufacture period. North Devon gravel tempered, British Brown stoneware and other sturdy storage vessels could remain intact for decades after their initial arrival at Schieveling. Thus, the Izard ceramic assemblage may be masked within the early eighteenth-century assemblage.

In the following decades, most of the porcelain used on the Ashley River plantations was formerly known as "China trade porcelain." This type, commonly referred to as Chinese export porcelain, included the blue and white Canton ware. Canton porcelain was manufactured and fired in the kilns at the province of Ching-Te Chen, then sent by the East India Trading Company to the seaport of Canton to be decorated by Chinese artists. The archaeological record suggests that the Canton blue-and-white patterned dinner and tea sets were favored by Charleston's elite classes as well as the wealthy planters and merchants all over South Carolina. It is remarkable to think that these fragile ceramics traveled the entire globe before being carelessly broken on Charleston's plantations. But the wealthy probably did not lament the loss for too long; they simply had the shattered plate discarded in the yard by a slave along with the leftover bones from dinner. Imagine it: food prepared by Africans and served on Chinese porcelain. It was a small world, even then.

A Slave Settlement on the Ashley River

The Izards were not the only residents at the plantation. Archaeologists also uncovered the faint remains of three slave houses, to the south and east of the compound's brick wall. Two of the cabins were similar in size and configuration, containing but one room, and were covered with oak or pine boards. These cabins were built with heavy timber frames and daubed with the clay or mud of the Ashley River. There were probably two windows, a door and a large brick fireplace at each house.

At a purely descriptive level, most slave houses were plain, timber-framed structures covered with split wood shingles, with brick chimneys on the side and one or two shuttered or unglazed windows. Most had a front porch where one might find a little shade and a breeze on a hot summer day. Porches were all but absent from English modes of architecture, suggesting that Africans may have contributed more to Lowcountry architecture than previously thought. Many scholars argue that the entire design may mask African architectural traditions. According to Coastal Carolina University Professor Charles Joyner:

Post and frame slave house. Courtesy of the Library of Congress.

Outwardly the cabins were marked by European notions of symmetry and control, but inwardly they concealed interiors marked by African spatial orientations. The two-room house was crucial to the Yoruba architectural tradition, and its continuity in Waccamaw slave cabins was not accidental. That continuity is eloquent testimony that West African architecture was not forgotten in the Crucible of slavery...Buildings throughout West Africa feature rooms small enough to facilitate intimacy in social relations. Slaves who came to All Saints Parish (Georgetown County) from Senegal and Gambia in the north all the way to Angola and the Congo in the south shared a cultural preference for such arrangements.

Some archaeologists believe that the slave cabin and work areas are similar to what slaves knew from Africa. *Courtesy of the Library of Congress.*

Although many scholars accept the notion that the vernacular slave house reflects cultural continuity with Africa, others disagree. Dr. Poplin's archaeological work on Lowcountry plantations suggests that the architecture appears to be a continuation, with slight spatial modifications, of older English practices for housing domestic servants and field laborers. Excepting the addition of porches, these slave houses appear to be British hall-and-parlor types, identical to their English antecedents, rather than African dwellings. African survivals may have been present in certain aspects of plantation life, including language, music and religion, but as far as slave housing is concerned, the last truly African dwellings were probably abandoned or replaced by English vernacular houses during the early eighteenth century.

But what might the inside of the cabin have looked like? Imagine one small room with a crude table and several chairs in the center. Along the edges of the room were one or two benches, an old cast-iron pot and a few chipped and cracked plates and glasses from the planter's house. There were also reminders of home. Archaeology suggests that Angolan slaves recently arrived to Schieveling Plantation made *colonoware* pots identical to those made in West Africa. These could usually be found in a sideboard or cooking food in a large open fireplace. With the kitchen right there in the house, the smells of the cabin would have been very strong, part salt and part smoke, the lingering scent of food roasting over warm coals mixed together with the perfume of the woods and the nearby mud flats. Since candles were hard to come by, slaves probably spent considerable time around the fireplace or an outside hearth. It was considered bad luck to let the fire die out, so there was usually a log smoldering in the fireplace, an old cast-iron kettle singing over the charcoal. In the corner of the room were beds made of sacks of Spanish moss and old clothes. Some slaves slept on a pine plank, their heads raised on an old shirt, a wool blanket the only covering. When the weather was bad, the wind and rain blew in through cracks, and the family would huddle close for warmth. The windows were usually curtained or shuttered, but during the summer slaves made the unenviable choice between a breeze and mosquitoes. The night, however miserable, was preempted at both ends; slaves rose early and worked late.

More important than their appearance or material comforts, the slave cabin provided a sanctuary from the authority of Europeans. Up at dawn, working in the fields, then a few hours to do as one pleased, slaves spent the majority of their free time at the house. Hunger was there and so was despair. But it was also in the cabins that slaves played music, smoked or gossiped, made friends, fell in love, established and passed on traditions, worked in their own gardens and raised families. And in a way, each cabin must have lived and had some personality all its own. It was the center of a slave's small private life, and was something that Europeans could never really control. It was home.

The Decline of Schieveling Plantation

Ralph Izard died prior to 1813, when his heirs divided his considerable estate, consisting of moneys, a town and country residence, sundry valuable farms in the settled parts of the colony and large tracts of uncultivated land in the new area. His wife, Elizabeth Izard, received Milton Plantation and a lifetime share in Weymouth. Her only son, Ralph Stead Izard, inherited Hickory Hill and 240 slaves and received Weymouth Plantation on his mother's death. Schieveling appears to have gone to Elizabeth but was also almost certainly home to her son. Unfortunately, the house burned; according to legend, Ralph Izard Jr. was just returning to Schieveling from his wedding trip when "his wife and himself turned into the avenue from the public road they looked upon the house in flames." Ralph Stead Izard died in 1816 at the age of thirty-three. His wife, Esther Middleton, died three years later and was survived by their children, Anne

Stead and Ralph Stead Izard Jr., only an infant when his father died. He was educated in Europe and traveled extensively throughout the continent and Mediterranean before returning to South Carolina to assume his place among the community of planters. He lived in Georgetown where he served the community "in various civic capacities and always with dignity and usefulness."

In 1826, the heirs of Elizabeth Izard sold the 1,056-acre Schieveling Plantation to Dr. Charles Drayton. Drayton was the son of Charles Drayton, the owner of nearby Drayton Hall. He held the land briefly, selling it to Joseph Bee in 1829. Bee also turned over the land quickly, selling it to Henry Augustus Middleton in 1835. Middleton, who was connected to Ralph Izard Jr. by marriage, held onto Schieveling Plantation through the remainder of the antebellum period. As the Civil War concluded, there were no laborers to work the land and the plantation was reclaimed by oak and pine, briars and palmetto and swamp. By the early twentieth century, the old plantation must have looked a lot like that primeval forest the Butlers had cleared over two hundred years before.

The Decline of the Ashley River Estates

Reconstructing the Planter's House at Spring Farm Plantation

But they reached it at last. It loomed, bulked, square and enormous, with jagged half-toppled chimneys, its roofline sagging a little; for an instant as they moved, hurried, toward it Quentin saw completely through it a ragged segment of sky with three hot stars in it as if the house were of one dimension, painted on canvas curtain in which there was a tear; now, almost beneath it, the dead furnace-breath of air in which they moved seemed to reek in slow and protracted violence with a smell of desolation and decay as if the wood of which it was built were flesh.
—William Faulkner, Absalom, Absalom!

"A Community of Planters"

Far up the north bank of the Ashley River, Elihu Baker built a modest home and established himself among the community of Ashley River plantations in the years before the American Revolution. The clearing of the land and the construction of the plantation buildings were of small consequence and left virtually no record in history. However, contrary to modern preconceptions of plantation life, it was places like Baker's Spring Farm Plantation that represented, in small scale, the outlines of St. George's Parish history from the late seventeenth century well into the twentieth. Before the American Revolution, owners of the plantation tried their hand at growing rice and indigo. These pursuits were abandoned as the war came to a close, and many of the fields became overgrown and reverted to forest. Much of the land remained this way

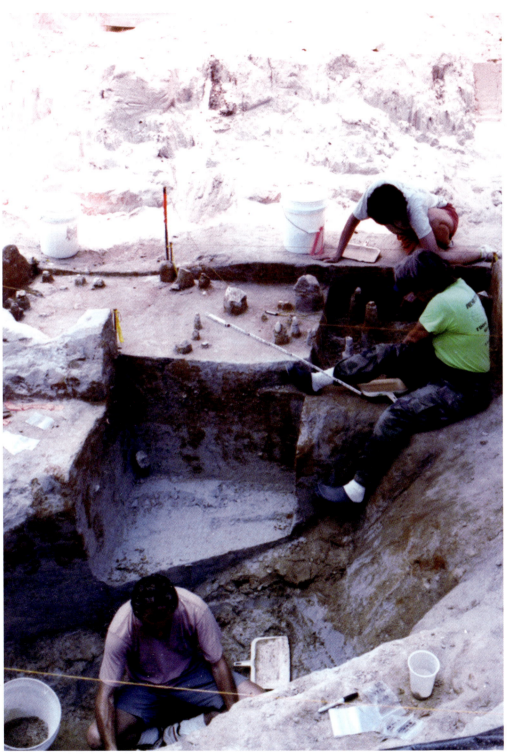

1. Field crews working at the Topper site in Allendale, South Carolina. *Courtesy of Tommy Charles. SCIAA/University of South Carolina Photo.*

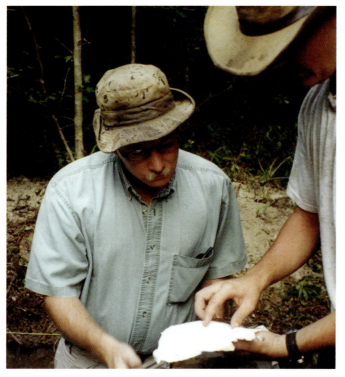

2. Archaeologists Eric Poplin and Pat Hendrix mapping an archaeological site in Charleston County. *Courtesy of Pat Hendrix.*

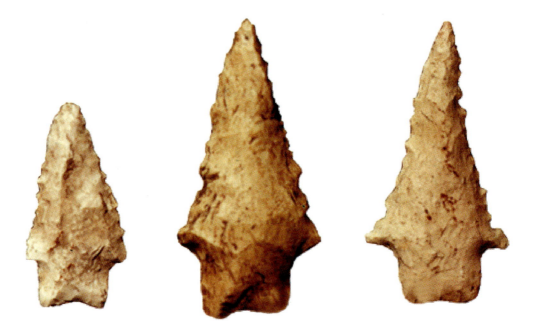

3. The high degree of craftsmanship evident in the Paleo-Indian period continues in well-made Early Archaic toolkits consisting of corner-notched hafted points. *Courtesy of Tommy Charles. SCIAA/University of South Carolina Photo.*

4. Mississippian people often placed their dead in ceremonial structures before burial. *Engraving by Theodore DeBry, after a watercolor by John White. Courtesy of the Library of Congress.*

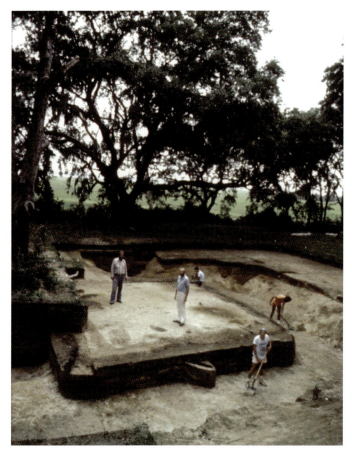

5. Field crews working under the direction of Stanley South uncovered the remains of the Spanish defenses during excavations on Paris Island. *Courtesy of SCIAA/University of South Carolina.*

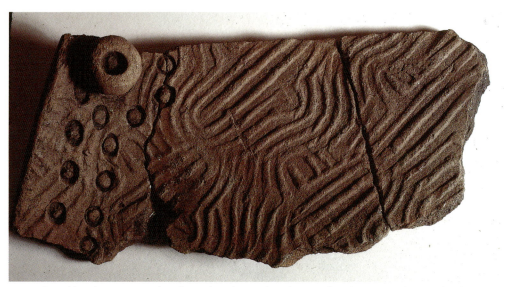

6. Artifacts like this pottery sherd are the physical evidence of prehistoric cultures that have vanished from South Carolina. *Courtesy of SCIAA/University of South Carolina.*

7. Stan South's archaeological crew excavating the west fortification ditch around the 1670 fortified area of Charles Towne. *Courtesy of SCIAA.*

8. Artifacts like this sugar jar found by archaeologists with New South Associates are the evidence of hard work and industry often neglected in Charleston's written record. *Courtesy of New South Associates.*

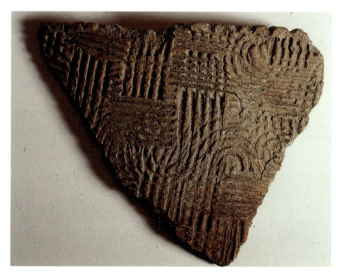

9. Because of its widespread use and durability, pottery is one of the most common finds at archaeological sites. Differences in shape, decoration and style are very useful to researchers in dating, identifying and comparing sites. *Courtesy of Tommy Charles. SCIAA/University of South Carolina Photo.*

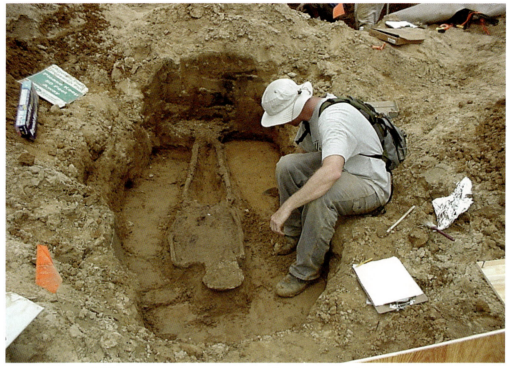

10. Brockington field crews unearthing remains at Johnson Haygood Stadium. *Courtesy of Pat Hendrix.*

11. John Laurens's pencil, showing tooth marks, recovered from the Cooper River. *Courtesy of SCIAA/University of South Carolina.*

12. Delftware was usually painted by artists using brushes made with the hair of martens and squirrels. *Courtesy of Pat Hendrix.*

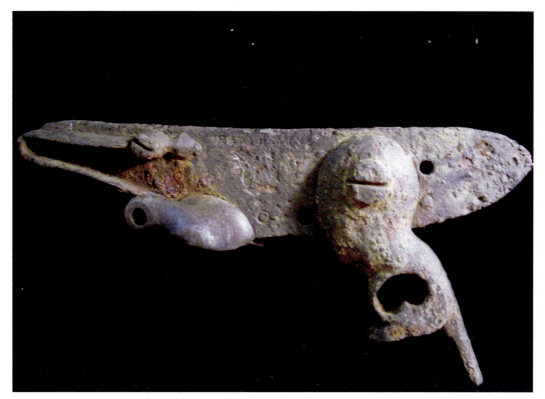
13. Flintlock recovered from the Cooper River. *Courtesy of Steve Nash.*

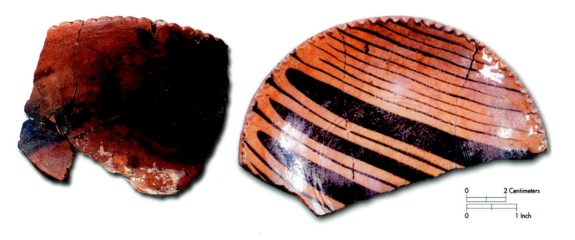
14. Colonoware made to look like European pottery. *Courtesy of New South Associates.*

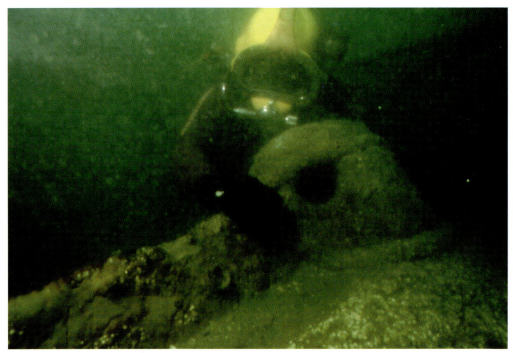

15. An archaeologist wearing a Kirby-Morgan Superlite 17 helmet examines the forward hatch of the *H.L. Hunley* prior to its recovery on August 8, 2000. *Courtesy of SCIAA/University of South Carolina.*

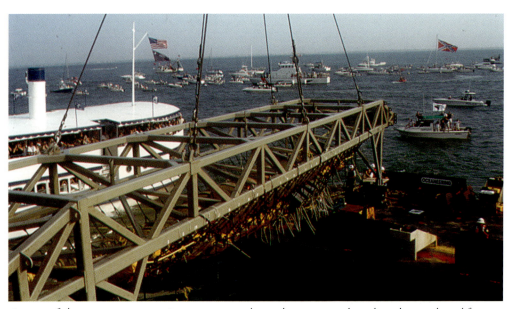

16. Free of the water over its 136-year resting place, the *H.L. Hunley*, slung beneath its lifting truss, is maneuvered over to the deck of its transport barge. *Courtesy of SCIAA/University of South Carolina.*

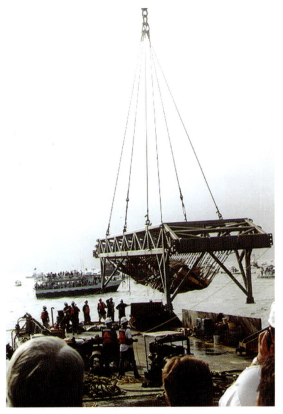

17. The *H.L. Hunley*, suspended from its supporting truss, just after it was raised from the sea bottom off Charleston, South Carolina, on the morning of August 8, 2000. It is being placed on a barge for transport to the conservation facility in North Charleston. *Courtesy of SCIAA/ University of South Carolina.*

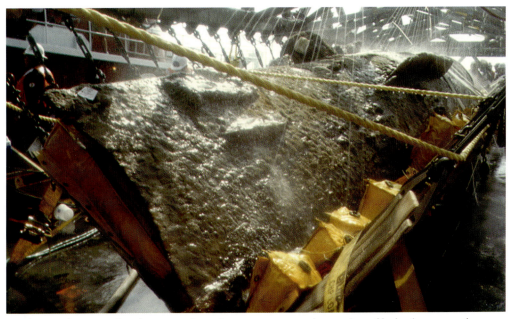

18. The *Hunley* on its five-hour trip from the recovery site, three miles off Charleston Harbor, to the Warren Lasch Conservation Center. *Courtesy of SCIAA/University of South Carolina.*

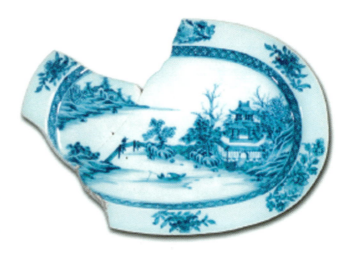

19. Expensive porcelains found by archaeologists with New South Associates at the Charleston Judicial Center suggest the scope of global trade during the eighteenth century. *Courtesy of New South Associates.*

20. Archaeologist Joe Joseph at Parris Island. *Courtesy of SCIAA/University of South Carolina.*

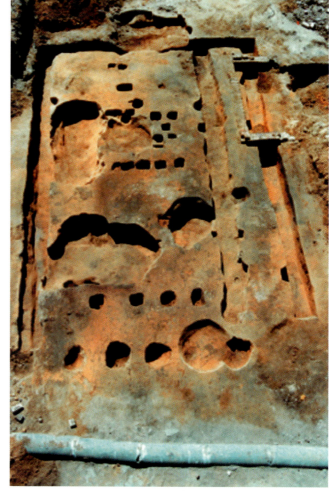

21. The archaeological remains of an earthen walled structure found by crews with New South Associates indicate that buildings made of mud once existed in downtown Charleston. Though typically associated with African traditions, earth-walled architecture was also familiar to the English, French and Native Americans. *Courtesy of New South Associates.*

22. Artifacts like this Rhenish stoneware cup can sometimes be found on late eighteenth-century plantations. *Courtesy of SCIAA/ University of South Carolina.*

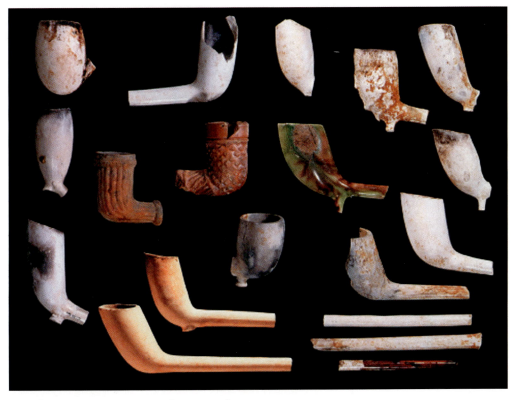

23. Tobacco pipes. *Courtesy of New South Associates.*

24. Glassware recovered from excavations of the Judicial Center in downtown Charleston. *Courtesy of New South Associates.*

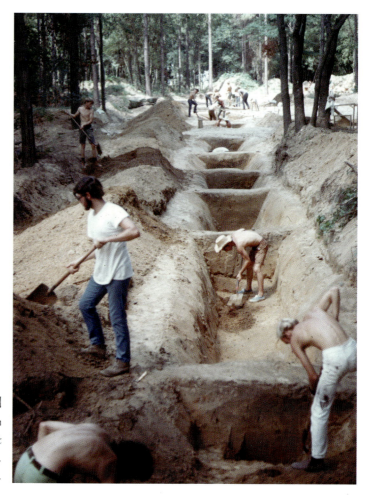

25. The archaeological crew excavating the main fortification ditch at Charles Towne Landing. *Courtesy of SCIAA.*

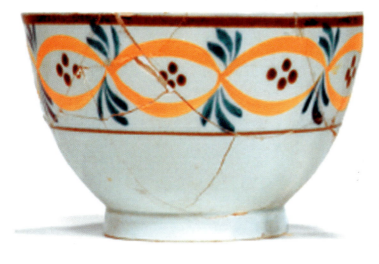

26. Pearlware was fashionable during the late eighteenth century. *Courtesy of New South Associates.*

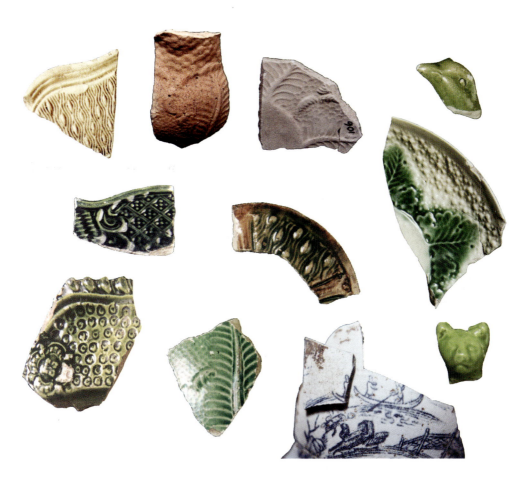

27. Creamwares like those pictured here were not produced abroad but along the Wando River in the kilns of John Bartram. *Courtesy of SCIAA.*

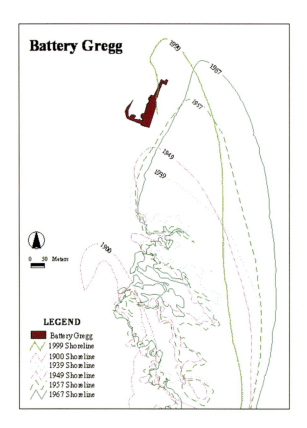

28. The position of Battery Gregg relative to 1900–99 shoreline positions. Courtesy of Christopher Nichols.

29. Washover Fan at the southern end of Morris Island, circa 1999. This low-altitude, large-scale aerial photograph was taken by C. Nichols and E. Vanderhorst with the aid of a kite camera built by Dr. S. Stearns.

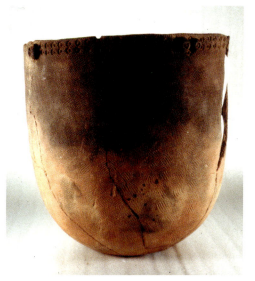
30. Reconstructed Native American pot. Courtesy of SCIAA.

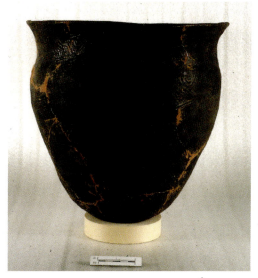
31. Mississippian pottery. Courtesy of SCIAA.

32. Air view of abandoned Lowcountry rice fields. Pictures like this show the staggering effort put in by African immigrants to make these swamp lands the most lucrative property in the world. Photograph by Dana Beach.

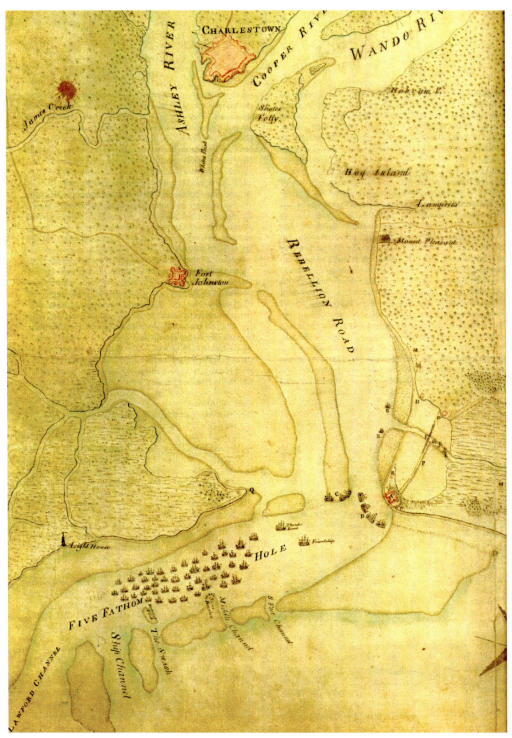

33. Revolutionary war-era map. *Courtesy of the Library of Congress.*

The Decline of the Ashley River Estates

until the area became associated with phosphate mining following the Civil War. After the decline of phosphate mining, the scarred and trashed landscape was overgrown first by briars and wildflowers, and then by stands of oak, cedar, bay and pine.

The land that came to be known as Spring Farm Plantation was first brought under cultivation by Elihu Baker sometime between 1734 and 1759. In about 1770 it came under the ownership of Benjamin Waring, who hired an architect and built a plantation house overlooking the Ashley River. He lived there until December 1785 when he sold it to Walter Izard as the "plantation known as Spring Farm containing 449 acres." Though a wealth of information exists about Spring Farm in census records, until recently virtually nothing was known about the construction and appearance of the planter's house. However, recent excavations of a site corresponding to the location of the planter's house on an eighteenth-century plat have given some insight into the design and construction of the home. Archival research and archaeological testing indicate that the remains are of a structure built sometime after 1770, perhaps the same home built for Benjamin Waring. This date correlates roughly to the era of Georgian architecture, a tradition inspired by Old World architects.

Georgian architecture is named for its floor plan, associated with eighteenth-century English Georgian architecture and the series of English kings named George. Often composed of two stories, these structures were built from either brick or wood, and chimneys, windows and exterior doors were placed symmetrically to provide a balanced appearance. Doors were centrally located on the eve of the house, and windows were equally spaced on each side of the door, with matching windows at equal spacing on the second story. Windows were designed with moveable sashes, each having nine or twelve panes of glass. The Georgian plan shape was square or nearly so, consisting of a central hallway with two rooms on either side. The roof was usually hipped, but sometimes gabled. Chimneys were sometimes in the exterior walls, but were usually located in the interior of the house between each pair of rooms. There was a wide variance in the specifics of these structures, but they were by most accounts very stylish homes.

Archaeological excavations of the area where the Spring Farm Plantation house once stood uncovered brick fall and fragments of mortar: the remains of fallen chimneys. The center foundation had been removed, and one of the brick pier foundations was destroyed when the house was abandoned and subsequently scavenged, but the foundations that supported the chimneys remained intact, and the main foundations revealed the dimensions of the house. Porch footings were also found, occurring at four-foot intervals in a straight line about nine feet from the house, which had a porch on either side. Large nails and heavy spikes indicate that the builders used heavy timber framing (post and girt). The high incidence of nails suggests clapboard siding, and the large number of windowpane fragments indicates multiple windows. Mortar is found in large quantities throughout the site, though there is no indication of decorative mortar joints. Brick that retained mortar failed to show raked, scored or V-joints, and joints were not troweled flush with the face of the brick. Excess mortar may have been left because the pier foundations were located underground and were not visible to visitors.

Spring Farm house. *Illustration by Pat Hendrix.*

By all indications, the Spring Farm Plantation house fell short of many of the grand mansions of the Ashley River. Archaeologists believe that the house represented a compromise between the financial realities of the owners and their desire to reflect their planter status. More accessible by the Ashley River than by road, the Georgian house offered an attractive and affordable solution to living in comfort and style. The timber-framed, clapboard-sided structure was not adorned with massive columns or hearths made of marble, but the house was quite large, shingled in slate and blessed with many practical attributes. Porches on either side captured the prevailing breeze, whichever direction it was moving. The brick piers, similarly, allowed air to more easily circulate, a greater advantage than all the conveniences and adornments of Drayton Hall.

The Decline of the Ashley River Estates

"A Melancholy Scene"

By the late eighteenth century, the colonial plantations of the Ashley River had fallen on hard times. Upon traveling along the river as agricultural and geological surveyor, Edmund Ruffin described the scene:

> *The river banks offer many beautiful sites for residences, which were preferred as such by the early settlers, & for a long time the Ashley River plantations were the most highly appreciated and productive lands in the colony. Now these lands are almost left untilled, are rarely inhabited by the proprietors…& the whole presents a melancholy scene of abandonment, desolation & ruin…But little rice is made, & only by a few persons. One occupant only on the left bank cultivates cotton for sale…The principal business now pursued is cutting wood to sell in Charleston.*

This certainly seems to have been the case at Spring Farm. In 1787, Walter Izard hired Joseph Purcell to survey the land and give account of the plantation's value for taxation. Though most of the acreage was portioned off in a checkerboard pattern of monotonous regularity, some of the land was overgrown with pine and hardwood. All of the tidal rice land was listed as old, suggesting that the owners had all but given up on rice planting. The modest income generated from the plantation came from cutting the timberlands on the interior portions of the property, with provisions and cotton being produced in the upland fields toward the river.

Before his purchase of Spring Farm, Walter Izard served as an officer of Continental forces and contributed large sums of his personal estate to the cause of independence. In 1779, Izard married Mary Fenwick, daughter of Edward Fenwick and Mary Drayton. She died just two years later. Izard's fortunes appear to have come from Tomotley Plantation in Prince William Parish, but he chose to live at Spring Farm. In his later years, Izard divided his time between serving St. George Dorchester in the General Assembly and enjoying the benefits of membership in the St. George Jockey Club. Having been plagued by poor health for many years, Walter Izard died in July 1788, and the property passed to his brother Ralph Izard. Though Ralph was to own the plantation, Walter's will stipulated that his friend and fellow veteran Thomas Gadsen was to receive:

> *Twelve Cows & A Bull six Oxen with an Ox Cart Chains Yokes &c. Complete twenty Ewes & two Rams my furniture Bedding Blankets &c. at Spring Farm Provisions Fodder Poultry & Hogs there, also I devise to him the sum of six hundred Pounds Sterling to be paid a year after my death, & I wish him to accept the free & fullest use of Spring Farm for the Term of His Natural Life without Impeachment of Waste & the Use of two Sawyers two of my best Carpenters & Berwick my Bricklayer for the Term of eighteen Months for Spring Farm.*

The 1790 Federal Census indicates that Spring Farm was staffed by "one free white male under sixteen years of age" and "two free white females including head of household" who worked the plantation with the labor of nineteen slaves. The small number of slaves working Spring Farm, a fair measure of economic capacity in antebellum South Carolina, suggests the plantation was little more than a middling farm. Walter Izard's will indicates that timbering and livestock were the most important sources of income at the plantation. Rather than devise farming implements to Gadsen, Izard left him livestock, sawyers and carpenters. This may underscore the abandonment of rice agriculture by the late eighteenth century and the turn toward forest industries on Spring Farm.

Luckily for archaeologists, residents at Spring Farm were not very tidy. Out with the trash went pieces of bone, broken plates and just about everything else imaginable, casually tossed from the porch into the yard. The bones were sometimes carried off by animals, but the ceramics were covered by soil, thus entering the archaeological record. Large quantities of creamware and pearlware ceramics, in vogue during the eighteenth century, were found scattered around the area associated with the Spring Farm planter's house. To archaeologists, this suggests that Spring Farm was occupied primarily during the Izard and Gadsen ownership when these tablewares were fashionable. Porcelains recovered from Spring Farm are very thin vessels from small cups, bowls and plates. Based on the discovery of these artifacts, it appears the eighteenth-century owners of Spring Farm continued the English tradition of high tea.

Gadsen must have died sometime before 1795, for in that year Ralph Izard sold the plantation to Dr. Samuel Wilson. The £1,200 sterling paid by Wilson was probably close to the actual value of the estate, including residence, outbuildings and acreage. Wilson was a physician in Charleston and "an assiduous ornithologist…frequently referred to by Audubon in his [book on] birds of North America as the result of observation in his aviaries, which seems to have been on quite an extensive scale." Wilson owned Spring Farm for seven years, but he lived and conducted his business in Charleston, and may have only bought Spring Farm as a real estate investment. His estate inventories mention multiple investments in Charleston real estate, ostentatious ceramics and even wines; but it makes no mention of farming implements. In 1802, Wilson sold the plantation to Thomas Whaley along with the 250-acre adjoining tract called Baker's for £2,500 sterling. The £1,300 sterling increase was partially the result of the addition of Baker's Plantation, but also reflected inflation at the turn of the century. In spite of the declining profitability of the Ashley River estates, Spring Farm was likely holding its value through desirability of location, general excellence of buildings and abundance of timber.

Supervision of the plantation was taken over by Thomas Whaley's two sons, who probably followed the lumber industry to some extent and certainly must have planted cotton on the highland, for by this time Eli Whitney's gin had brought about radical changes in South Carolina's economy. Like neighboring plantations, gardening and livestock also held important places in Spring Farm's economy. Thomas Whaley held

the title to Spring Farm for four years before he died and conveyed his "two tracts on Ashley River, containing upwards of seven hundred acres to be equally divided between my two sons Thomas Whaley, my son Archibald share and share alike." The brothers also inherited lucrative plantations on Edisto Island and apparently saw little value in operating a modest plantation along the Ashley River. Within a few months of inheriting Spring Farm and Baker's Plantation, they transferred the title to Philip Moore of Charleston. The deed and the specifics of the conveyance are unknown.

The Forest Primeval

Not much is known about Philip Moore's ancestry or point of origin, and no records concerning his birthplace or accounts of his earlier life are extant. In 1779, a Philip Moore served as a private in Captain Felix Warley's company during the American Revolution. This was probably the father of the Philip Moore who owned Spring Farm, but it is not impossible that a thirteen-year-old boy would have served as a private in the Revolution. The first certain information concerning Philip Moore is that he was married to Besheba Hariet Hamlins at the Independent Congregational (Circular) Church of Charleston on April 16, 1797. Two years later his daughter Mary was baptized there.

In 1800, Moore leased from John McIver for five years the east side of Meeting Street "bounded on South on alley called Rope Lane." For the next nine years, he is listed in directories as having a cabinetmaker's shop at 28 Meeting Street, undoubtedly the leased property. The 1800 Federal Census indicates that Philip Moore lived in St. Philips Parish with his family and six slaves. Although Moore purchased Spring Farm sometime in 1806, he appeared in the Charleston directories as "Charleston Cabinet Maker" until 1816. Thereafter, he was listed as a lumber sawyer or lumber broker, with the exception of 1831 when he was listed as both "Chst cabinetmaker & lumber merchant."

As timber was everywhere and easily cut, Moore had little trouble securing enough lumber for his carpentry business. His business was profitable enough that in 1816 he took up timbering full time. Timbering was a family business by 1827 when Philip Moore's son-in-law, Archibald M. Pepper, purchased Spring Farm's adjoining 1,495-acre Cedar Grove Plantation. The Pepper family held the tract for six years, during which time they cut many of the large oaks from the Cedar Grove landscape.

In 1829 Philip Moore was charged with assaulting Charles Drayton and was subsequently convicted. A petition to the governor signed by Moore contended that the conviction was founded on the testimony "of the Prosecutor himself" and that the stabbing "happened under circumstances of great provocation." Philip Moore held that he had reacted after "seeing a large knife in the hands of the said Charles Drayton, which was held by him at a short distance from your petitioner and in a threatening manner. That after all however, the injury which said Prosecutor received from petitioner was proved to have been slight and not to have confined him at

The brick harvested from the plantation house at Cedar Grove was used in the construction of Charleston's grand homes. *Photograph by Adam Hester.*

The Decline of the Ashley River Estates

all." One can only imagine the two men, arguing over some perceived insult, feebly fighting one another with table knives. It was pure foolishness. In any event, a number of business associates and personal friends of Moore attached comments to the petition testifying to his good character and assuring the governor that this episode was an anomaly in an otherwise spotless record. The letter reached Governor Miller after Moore's conviction and sentencing and his friends asked that the governor commute the thirty-dollar fine "which he [Moore] is not able to pay without great hardship and inconvenience to himself and family." Despite Drayton's protestations, Governor Miller granted Moore's request and put the judgment aside.

In any case, the incident may have prompted Moore to move to Spring Farm, because in the next census he is shown living with his family and fourteen slaves at the plantation. A few of the men probably worked as carpenters, sawyers and general laborers, while women and children worked in the house and fields. Regardless of race or sex, they all grew, tended and harvested the food they ate, just as they spun the thread and wove the clothes they wore. They hunted, cut wood and tended to the hogs and cattle, milled the corn, built the fire and stirred the pot. It was a tough living, but the Moore family was at least self-sufficient and better off than their neighbors, who were often harassed by creditors. Even the slaves fared well, enjoying an autonomy at Spring Farm that was unheard of on other plantations. The alternative to working the forests, after all, was not freedom but working the fields of a rice plantation.

Plantations along the Ashley River changed hands frequently, and property values were extremely deflated, even twenty years before the Civil War. Referring to the adjoining Cedar Grove Plantation, owned by Philip Moore's son-in-law, Archibald Pepper, Edmund Ruffin remarked:

> *It consists of 1400 or 1500 acres, of which 900 were of wood-land, & much of it very good soil. The mansion house was brick, & of three stories…& constructed in the very best manner. After Charleston had suffered by the great fire…there arose such a demand for building materials…this plantation was bought for the purpose of demolishing its superb old mansion & selling the bricks…The speculation was a profitable one…He died before the work of demolition was completed…and part of one of the walls still stands as memorial of the remarkable evidence of a declining community.*

Everywhere along the Ashley River there were abandoned houses, farmsteads and fields with just a few families remaining, neighborless, in their mansions. Despite the almost indescribable beauty of the area, it was an immensely sad landscape. The sheer difficulty of making a living from the poor soil had almost defeated the people. Moore survived by growing garden crops and cutting lumber. Census records indicate that crops of corn, peas and wheat were raised, as were cattle, poultry and hogs. Spring Farm, overgrown with briars and brambles, provided the animals with good foraging ground and allowed Moore to feed "a stock of cattle throughout the year." Moreover, raising animals required minimal capital and labor, an important consideration for a man of limited means.

The thickets and stands of timber provided more than foraging grounds; one visitor saw the forests as raw materials for "goodly Boxes, Chests, Table, Scrittories and Cabinets." As a cabinetmaker, Moore undoubtedly harvested timber from Spring Farm for his business in Charleston and for export on the world market. Each kind of wood had its own characteristics and he certainly knew them all. Pine was soft and easy to work with and was favored for masts, interior paneling and clapboards. Hardwoods were used to make fine furniture and larger trees were used in the construction of ships. The best stands of yellow pine and cypress were used in the construction of Charleston homes. When the local market was down, there was always demand from the Caribbean for ship timber and for the fires that boiled sugar cane. Another important customer was the American Navy. At that time, shipbuilders needed the long arching branches of Lowcountry oaks to make braces to connect the hull of the ship to the deck floors. Even portions of the USS *Constitution* were made from timber harvested from South Carolina's forests.

Timber was more easily transported, and more profitable, if it was cut before it left the plantation. According to historian Peter Wood, most slaves on Lowcountry plantations "worked in pairs, spent most of their lives chopping and sawing timber, and very few slaves would not have at some point have used a wedge to split rails, a froe to slice shingles, or a adze to square a beam." In his book *Black Majority*, Wood quotes a contemporary at Smithfield Plantation on the Combahee River whose labor must have closely resembled the work at Spring Farm:

> *A tall pine tree would be cut down in the woods and trimmed...Then three or four yokes of oxen would slowly draw the heavy weight to the pit. Here expert axemen with broad axes would square the timber, cutting off the bark and sap wood. The saw pit was a broad ditch over which on posts was frame work of beams, making a parallelogram. Upon this the timber was hoisted and the head-carpenter carefully marked on it the lines of the cuts. A carpenter mounted on the frame and another below pulled the long course up and down.*

Notwithstanding the benefits of forest industries, Moore's Spring Farm property muddled along in obscurity. As much as Ruffin and other contemporaries wrote about Cedar Grove, it is remarkable that neighboring Spring Farm was ignored. This glaring omission may be as telling as the flattery heaped on its more prosperous neighbor.

Despite census records showing an occupation of Spring Farm during the mid-nineteenth century, very little of this settlement is reflected in the archaeological record. This is quite puzzling given that the Moore occupation of Spring Farm postdated a new age of consumer consumption during which the wide availability of inexpensive, American-made ceramics, or Whiteware, encouraged the less affluent to spend their money on tableware previously accessible only to the planter class.

Whiteware, near absent in the archaeological record of Spring Farm, should have made an appearance during the Moore occupation. Additionally, many middle-class households like Spring Farm had porcelain teacups, though few could afford a whole

service. The greater demand for cups by the middle class further lowered the cost of these vessels. Surprisingly, there was no sign of these inexpensive tewares at Spring Farm. Researchers can only assume that Philip Moore's modest income prohibited him from purchasing new ceramics for Spring Farm, or that he spent most of his time at the neighboring Cedar Grove Plantation.

The 1840s were surely a sad time for Philip Moore. On August 8, 1840, both his wife and son George died. Their death cards have not been located, but historic records reveal that 1840 was a particularly bad year for yellow fever. The funerals of Harriet and George Moore were held at the Circular Church on Meeting Street, but due to a new ordinance in Charleston prohibiting burials in the city, their bodies were transported up the Ashley River and buried at Spring Farm. The Moore family cemetery still lies along the Ashley River bluff reserved in the conveyances of subsequent owners. The small brick-walled enclosure is in a deserted forest partially covered by briars and a cluster of large oaks. Several of the trees are rooted within the burying ground, and many of the headstones are broken. Among those buried at Spring Farm are Moore's twenty-year-old daughter, Penelope (d. 1852); James and Anna Marie Jenkins, the children of daughter Amanda Moore; Thomas Jenkins; and Philip Moore (d. 1857).

By the 1850s, Spring Farm was in ruins. The 720-acre tract, of which only 100 acres were cultivated, was worth a paltry $905 and with farming implements worth another $100. The plantation had two horses, two mules, four milk cows, twelve other cattle and thirty-five pigs, worth a collective $418. The plantation's fields grew three hundred bushels of corn, ninety pounds of rice, three hundred bushels of peas and two hundred bushels of sweet potatoes. Having worked as a carpenter since childhood, Moore might never have understood why mismanagement turned his riverfront plantation into a virtual wilderness. Nevertheless, it must have been quite striking for Moore to survey the neighboring Chatsworth Plantation that was valued at $4,000 in the same census.

Philip Moore died in 1857. His obituary read: "Departed This Life, in this city, on 30th June 1857, Mr. Philip Moore, at the advanced age of 88 years and 10 months. His Relatives and Friends are invited to attend Funeral Services, at the residence of Mr. A.M. Pepper, Meeting Street, Ward No. 5, This morning, at Eight o'clock, without further invitation." Death notices list the cause of death as "Old Age." His body was taken by boat up the Ashley River and buried at the family cemetery on Spring Farm.

Moore's estate was divided among all his surviving children and grandchildren. On February 11, 1858, George Buist, executor of Moore's estate, sold Spring Farm and two additional tracts to Thomas P. Lockwood for $2,800. The deed specified the family cemetery to be set aside "for any or all of the family or Decedents of the said [illegible] who may desire to be interred therein." Lockwood had held the title for only two years when he sold Spring Farm to Benjamin Rhett in 1862 "in the first year and Sovereignty and Independence of the Confederate States of America." In each place "United States" was written in the deed the word was subsequently scratched out and replaced with "Confederate States." Rhett paid for the property with newly printed Confederate currency, which became worthless as the war plodded along.

Phosphate mining. *Courtesy of the Library of Congress.*

As the terrible, prolonged and wasteful struggle that we know as the Civil War wound down in Charleston, Spring Farm—like the community of planters—fell into ruin. With Lee's surrender at Appomattox Court House, the foundations of the planters' pride and prestige fell to the ground. All along the Ashley River, Union forces exercised a blind and thoughtless vengeance on their adversaries, whose houses they burned to the ground. The few plantation homes that remained were scattered at random over endless miles of wilderness. By 1870, the vacant space was interrupted only by ruins and ghostly remains of a bygone era. Benjamin Rhett, however, made quite a fortune by selling Spring Farm at the conclusion of the war, because the immediate future of the area was not in agriculture or forest products but in phosphate mining.

Underground phosphate deposits were discovered along the Ashley River in the 1840s, and their marketable potential as a fertilizer was recognized shortly after the Civil War. Francis S. Holmes, owner of Ingleside Plantation, located about four miles north of Spring Farm, was a professor at the College of Charleston. Holmes joined forces with N.A. Pratt, another local scientist, to organize a company to mine the deposits. Unable to find local investors, they recruited capital in Philadelphia and formed the Charleston Mining and Manufacturing Company in late 1867, the first to mine phosphates in commercial quantities. Phosphate mining started a speculation bubble in the Charleston area, as owners of now worthless rice fields along the Ashley, Cooper and other Lowcountry rivers rushed to sell their ancestral estates. Many Charleston businessmen, one-time enemies of industrial interests, put aside their old grudges and joined Northern capitalists to obtain the rights to the region's phosphate deposits. Land prices along the Ashley River, which were severely depressed prior to and during the

The Decline of the Ashley River Estates

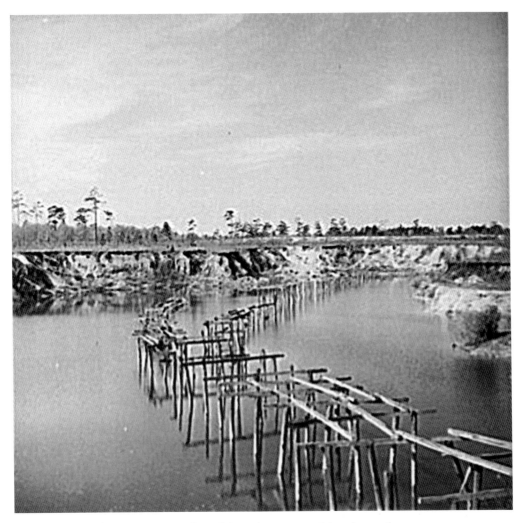

Abandoned phosphate mine converted to a fishpond. *Courtesy of the Library of Congress.*

Civil War, suddenly boomed, and the elegant plantation homes and formal gardens that lined the river were engulfed and swept out of existence by the inrushing flood of phosphate mines. The banks of the Ashley took on a severe industrial look, with large wharves, tram railroads, mills, storage sheds, smokestacks and sprawling worker camps scattered for miles upriver.

Despite the changing character of the physical environs, the cruelty of slavery would continue to haunt those old fields. Mined by a large unskilled labor force that consisted mostly of freed slaves, the work was hard, conditions were poor and the pay abysmal. In a cruel irony, the Northern interests that had played such a critical role in destroying the plantation economy now exploited the impoverished and unsophisticated freedmen in unthinkable ways. When laborers began to immigrate North, the authorities simply picked them up for imaginary crimes and assigned them to chain gangs to carry out

the miserable work. The first and most laborious part of their job was to dig a pit or ditch fifteen feet long, six feet wide and four to seven feet deep. The rock could then be shoveled out by hand into wheelbarrows, carried to mechanical washers and stored in drying sheds before being ground and manufactured into fertilizer, or prepared for shipment to fertilizer manufacturers on the Charleston Neck.

Archaeological investigations at Spring Farm uncovered a well-defined phosphate trench filled with nineteenth-century bottles a few feet from where the house once stood. A quick glance at the house configuration revealed the source: phosphate miners, hot and weary from a day of hard labor, sat on the house's front steps drinking generous amounts of beer, casually tossing the bottles into the ditch. The discovery of these bottles indicated to archaeologists that the house had not collapsed before the phosphate company purchased the property, and that it was probably appropriated for storage or, at minimum, for a little shade by laborers.

The production of phosphates for fertilizer along the banks of the Ashley River continued to increase until the earthquake of August 31, 1886. The earthquake marked the beginning of the end for Lowcountry mining. Only two years later, the mining companies discovered beds of higher quality phosphates in Florida and Tennessee. The operations slowly dropped off in South Carolina until World War I, when they were abandoned completely.

With the end of phosphate mining, the scarred landscape was overgrown with brambles and scrub oak. Most plantation homes that survived were abandoned and consumed by the forests. The ruin was the more visible from the stupendous Drayton Hall, which had survived the injuries of time and fortune. However, it was not the Union army or phosphate mining that destroyed Spring Farm. The old house was pulled down board by board and brick by brick by the area's innumerable poor who scavenged the old order to create a new.

The Confederacy's Secret Weapon

The Raising and Excavation of the *H.L. Hunley*

Then March in Carolina and still the walking backward slow and stubborn and listening to the Northward now because there was nothing to hear from any other direction because in all the other directions it was finished now, and all they expected to hear from the North was defeat.
—William Faulkner, Absalom, Absalom!

THE FEDERAL BLOCKADE

The rumors were flying in the summer of 1863. Whispers that some new weapon that could break the back of the Union's South Atlantic Blockading Squadron had intensified among both armies. The help could not come at a better time for the Confederates; the war effort and morale were being slowly strangled by the blockade that sat unchallenged off the coast of Charleston. After an intense debate among Confederate officials, it was decided that this new weapon was to be secreted by flatcar to Charleston for anti-blockade duty under the command of General P.G.T. Beauregard, Confederate States of America.

Rich Wills, former assistant underwater archaeologist at the Naval Historical Center, believes that, though built at the Parks and Lyons Machine Shop in Mobile, Alabama, the submarine was sent to Charleston where the naval siege and heavy shelling were destroying Charleston through steady attrition. Furthermore, General Beauregard in Charleston was willing to champion unconventional weapons, while the more

conservative General Dabney H. Maury and Admiral Franklin Buchanan in Mobile were apprehensive of the unproven technology. The civilian builders, who depended on bounties to recoup their considerable costs, were also eager to move to Charleston's deeper coastal waters, which promised to be a better tactical theater for preying on Union vessels.

A contemporary described the vessel at the time of delivery:

> *In the first place imagine a high pressure steam boiler, not quite round, say 4 feet in diameter in one way and 3-½ feet the other—draw each end of the boiler down to a sharp wedge shaped point. The 4 feet is the depth of the hold and the 3-½ feet the breadth of beam. On the bottom of the boat is riveted an iron keel weighing 4000 lbs which throws the center of gravity on one side and makes her swim steadily that side down. On top and opposite the keel is placed two man hole plates or hatches with heavy glass tops. These plates are water tight when covered over. They are just large enough for a man to go in and out. At one end is fitted a very neat little propeller 3-½ feet in diameter worked by men sitting in the boat and turning the shaft by hand cranks being fitted on it for that purpose. She also has a rudder and steering apparatus.*
>
> *Embarked and under ordinary circumstances with men ballast &tc she floats about half way out of the water & resembles a whale. But when it is necessary to go under the water there are apartments into which the water is allowed to flow, which causes the boat to sink to any required depth, the same being accurately indicated by a column of mercury. Air is supplied by means of pipes that turn up until they get below a depth of 10 feet, when they must depend upon the supply carried down which is sufficient for 3 hours! During which time she could have been propelled 15 miles!*

"More Dangerous to Those Who Use It"

Upon their arrival in Charleston, the civilian crew began a series of training exercises in the Charleston Harbor in preparation for the submarine's first attack. It was a difficult task that could not be carried out easily or quickly. General Beauregard was well aware of the delicacy and danger of the mission; unfortunately, he abandoned this cautious approach and replaced the crew with Confederate States Navy personnel. It was following this hasty move that the submarine was twice lost. In the first instance, two stories have circulated concerning the tragedy. It was long believed that Lieutenant John A. Payne was preparing for a nighttime attack when he inadvertently stepped on the lever controlling the dive planes causing the submarine to dive while the hatches were open, drowning five of her crew. Another theory suggests the submarine sank when the wake of a passing ship flooded the open hatches, trapping her crew at their stations.

The ship was raised from just off Fort Johnson wharf and another crew was assembled. Horace Hunley, commander of the operation, enlisted a crew from Parks

and Lyons Machine Shop in Mobile to man the vessel. Among the enlistees was Thomas W. Parks, son of the co-owner of Parks and Lyons. For all their familiarity with the boat, the crew was killed during routine diving exercises in the Charleston Harbor. General Beauregard described the tragedy three weeks afterward:

> *Lieutenant Dixon made repeated descents in the harbor of Charleston, diving under the naval receiving ship which lay at anchor there. But one day when he was absent from the city Mr. Hunley, unfortunately, wishing to handle the boat himself, made the attempt. It was readily submerged, but did not rise again to the surface, and all on board perished from asphyxiation. When the boat was discovered, raised and opened, the spectacle was indescribable and ghastly; the unfortunate men were contorted into all kinds of horrible attitudes; some clutching candles, evidently endeavoring to force open the man-holes; others lying on the bottom tightly grappled together, and the blackened faces of all presented the expression of their despair and agony.*

The crew was exhumed from the submarine and buried at Magnolia Cemetery. The group of dedicated submariners honored Horace Hunley's contributions by naming the boat *H.L. Hunley*. General Beauregard, who considered the boat "more dangerous to those who use it than the enemy," balked at continuing the project but eventually relented to the wishes of his young lieutenant, George E. Dixon. Described by one contemporary as "very handsome, fair, nearly six feet tall and most attractive presence," Dixon radiated confidence and optimism. He had worked on the submarine project since the earliest days in Mobile, and was a steadfast supporter of the new technology. With Lieutenant Dixon back in charge, the submarine was salvaged from the bottom of the Cooper River and refitted for another try. Dixon and Lieutenant William Alexander enlisted another volunteer crew, including "Joseph F. Ridgaway, James A. Wicks, J.F. Carlsen, Arnold Becker, Frank Collins and two men who may have been named C. Lumpkin and Miller." Some of these men had served aboard the CSS *Indian Chief*, "an elite collection of veteran mariners, merchant seamen, career Navy men, blockade runners." Their ages ranged from twenties to forties, half born in America and the others foreign born. Dixon, for all his "Southern" grace and charm, was in fact born somewhere well above the Mason-Dixon Line, probably Ohio.

In November 1863, the *Hunley* base of operations was moved to Battery Marshall on Sullivan's Island. In order to prevent detection from Federal spies, the crew trained in the dead of night, often harassed by bad weather. Dixon's frustration with the boat's slow progress was evident when he lamented, "There is one thing very evident and that is to catch the Atlantic Ocean smooth during the winter months is considerable of an undertaking, and one that I never want to undertake again. Especially when all parties interested are sitting at home and wondering and criticizing all of my actions and saying why don't he do something." The lieutenant, however, was certain that the time would come when the preparation would pay off. "I am out-side every night in a small boat so that there is not a possibility for any

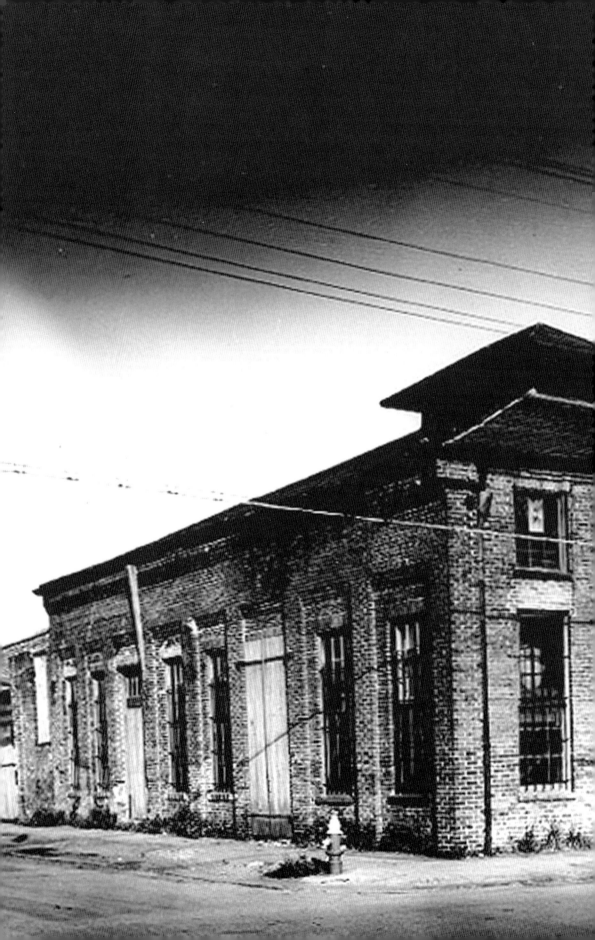

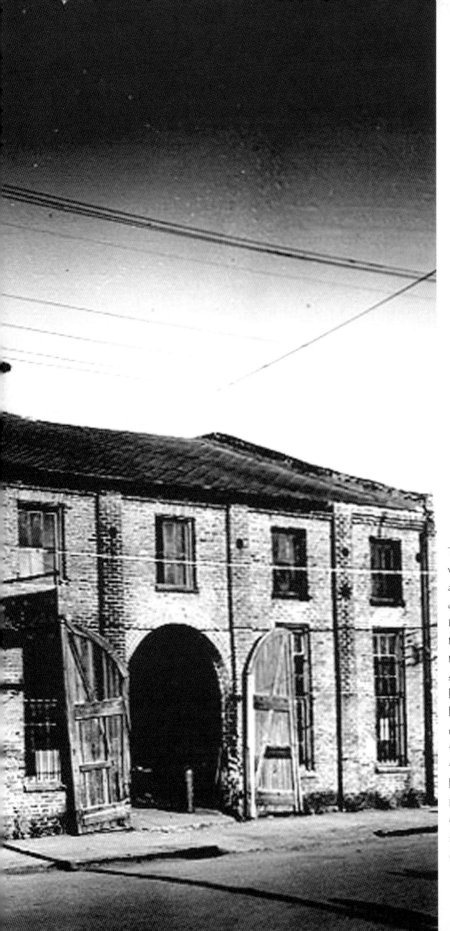

The submarine was constructed and designed by civilians at the Parks and Lyon Machine shop in Mobile, Alabama, seen here. The boat was known by a variety of names including "the Fish Boat," "the torpedo boat" and "the Porpoise." Courtesy of the Library of Congress.

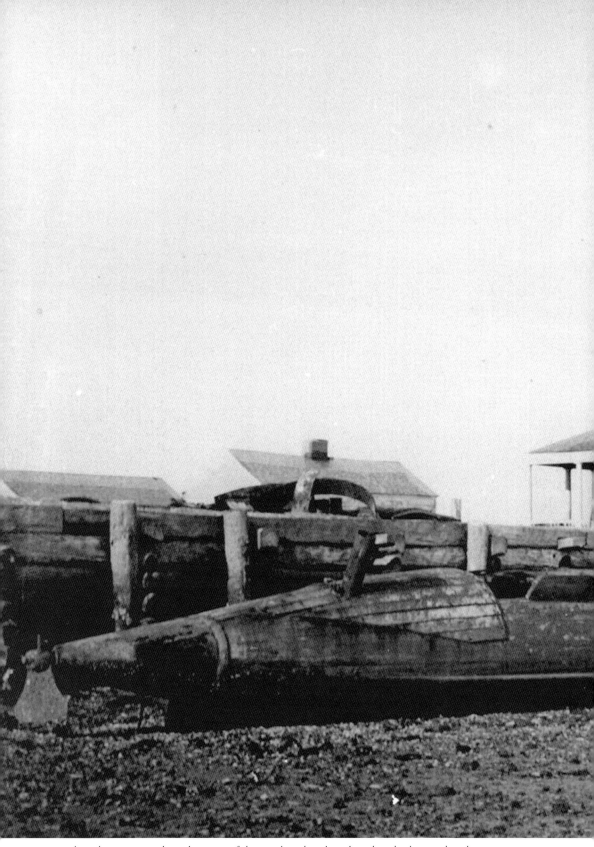

The submarine *David*, predecessor of the *Hunley*, abandoned on the Charleston shoreline. *Courtesy of the Library of Congress.*

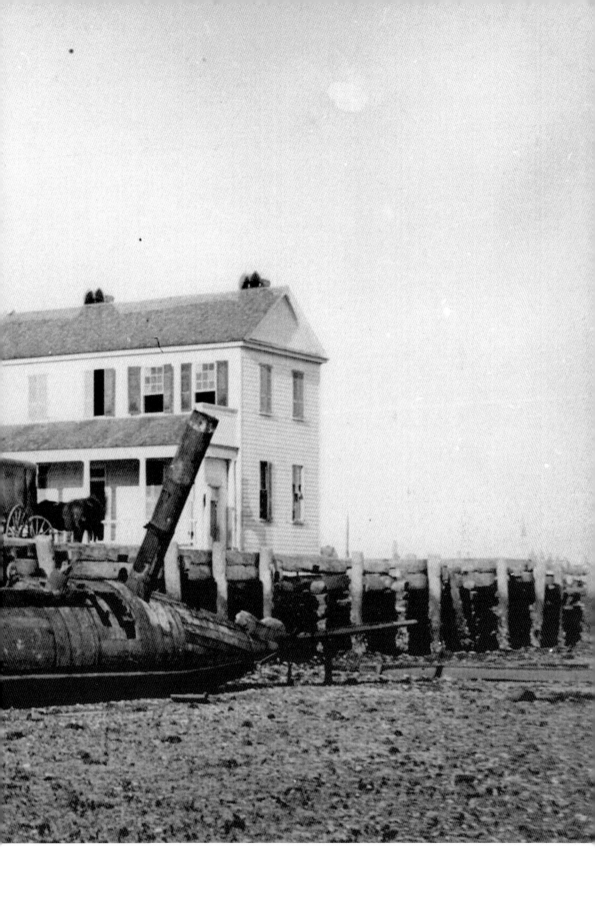

good night to pass with out my being able to take advantage of it," Dixon wrote. "I have my boat lying between Sullivan's and Long Islands, and think that when the night comes that I will surprise the Yankees completely."

"That Fateful Night"

On the evening of February 17, 1864, the luckless submarine was ready for another attempt. A recognition signal using a blue lamp was arranged between Dixon and Lieutenant-Colonel Dantzler for the purpose of guiding the boat back to Battery Marshall. With Lieutenant George Dixon at the helm, *H.L. Hunley* and her complement of eight left Breach Inlet. Her unsuspecting target was the USS *Housatonic*, "a powerful new vessel, carrying eleven guns of the largest caliber, which lay at the time in the north channel opposite Beach Inlet, materially obstructing the passage of our blockade-runners in and out which lay at anchor on blockade duty." Seconds before the *Hunley* made contact, the *Housatonic*'s lookout spotted the submarine and sounded the alarm. Lieutenant F.J. Higginson, the ship's executive officer, reported:

> *I went on deck immediately, found the Officer of the Deck on the bridge, and asked him the cause of the alarm; he pointed about the starboard beam on the water and said "there it is." I then saw something resembling a plank moving towards the ship at a rate of 3 or 4 knots; it came close alongside, a little forward of the mizzen mast on the starboard side. It then stopped, and appeared to move off slowly. I then went down from the bridge and took the rifle from the lookout on the horse block on the starboard quarter, and fired at this object.*

The *Housatonic* sank in approximately three minutes. The ship took five souls to the bottom, including Ensign E.C. Hazeltine, Quartermaster John Williams, Fireman Second Class John Walsh, Landsman Theodore Parker and yeoman Charles O. Muzzey. Though she had won the immediate battle, other dangers awaited *Hunley* in the Charleston Harbor: tidal currents racing through narrow channels and the squalls and storms that moved in over the Atlantic Ocean. The crew surely realized the risk, since in better weather conditions the boat had twice gone to the bottom after simple errors. Unfortunately, her maiden voyage was not as intended. The *Hunley* and its crew never returned to Battery Marshall.

The Discovery and Raising of *H.L. Hunley*

In 1995, Ralph Wilbanks, Wes Hall and Harry Pecorelli III of Clive Cussler's National Underwater Marine Agency (NUMA) were conducting a search for the *Hunley* in partnership with the South Carolina Institute of Anthropology and Archaeology. Diving in thirty feet of water, the team realized that they had found the vessel after discovering

the forward hatch buried in three feet of mud and sand. The boat was oriented toward her intended destination at Battery Marshall, though the submarine was due east of the USS *Houstonic* wreck. The submarine rested on its starboard side at about a forty-five-degree angle and was encrusted with ferrous oxide bonded with sand and shell concretions. Probing revealed an approximate length of thirty-four feet with most preserved under the sand and muck.

The discovery should have been a moment for the crew to bask in the adulation of the entire archaeological community, but there were problems from the very start. From the moment that the news leaked out, overlapping claims by South Carolina, Alabama and the federal government immersed the *Hunley* in a bureaucratic nightmare that would take a year to untangle. Additionally, underwater archaeologists Mark Newell and Lee Spence had invested considerable time and energy in locating the vessel. Their claims to the submarine's discovery would prove enormously controversial and fierce. Clive Cussler, for his part, refused to divulge the location of the wreck until he was assured that a plan was in place to preserve the *Hunley*. His obstinacy was accompanied by charges of piracy, fraud and grandstanding. In the first two instances the charges were ridiculous, on the latter there can be little doubt that Cussler's detractors were exactly right. It would take several months of haggling and negotiation before *most* of the parties were satisfied enough to begin a serious investigation of the wreck.

Beginning in May 2000, an international team of professionals from the Naval Historical Center's Underwater Archaeology Branch, National Park Service, SCIAA and various other individuals investigated the wreck and collaborated on raising the vessel. By recording artifacts found within the cabin, archaeologists hoped to gain a clearer understanding of the last moments aboard the vessel. They also hoped to unravel and record details of ship construction, which had been lost through time. The structural information recovered from the *Hunley* would have a special significance; she was simply one of a kind. Finally, they had to devise a strategy of raising, preserving and exhibiting the submarine. It would prove enormously costly due to the engineering involved in lifting and transporting the vessel and the need to build a specially designed conservation laboratory.

One of the most difficult aspects of raising the boat was the lack of visibility, a problem that became even more acute when the seafloor sediments were disturbed during efforts to probe the buried portions of the *Hunley*. The divers had to resign themselves to dealing with this problem by using time-tested techniques to probe and map the wreck. The silty bottom was a continuing irritation but the divers knew that this oxygen-starved environment helped preserve the *Hunley*. If she had sunk on a sand bottom, the boat may have deteriorated or been broken to pieces decades before her discovery. In the end, the nearly constant gloom that hung over the site did not stop the recovery. Harnesses were driven beneath the hull to form a lifting rig and attached to a truss designed by Oceaneering International, Inc. At length the ship was lifted from the ocean floor and gently brought aboard using the crane from *Karlissa B*. On August 8 the sub broke the surface for the first time in over 136 years and was greeted by hundreds of people in nearby boats. Her brief and long delayed voyage ended when she entered

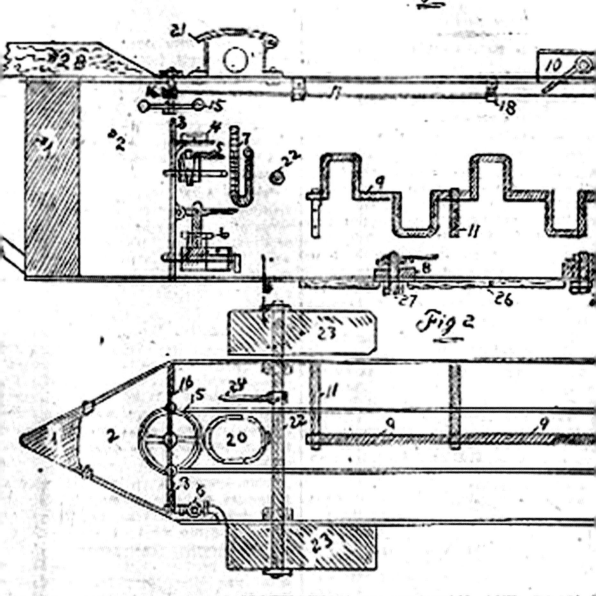

Inboard profile and interior plan of the *Hunley*. Courtesy of the Library of Congress.

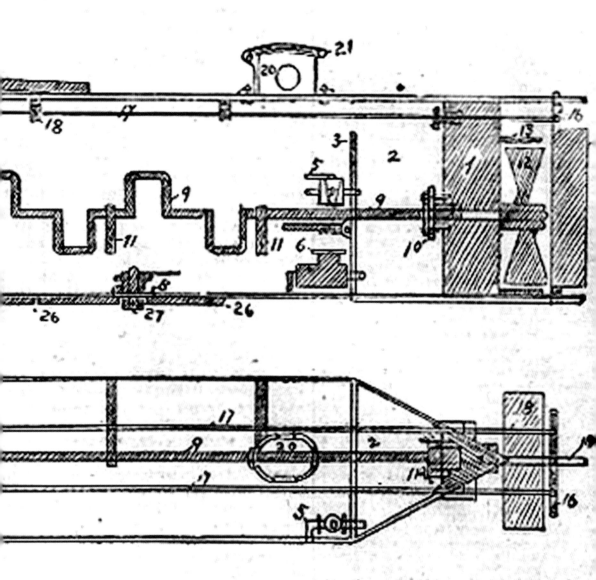

OF THE CONFEDERATE SUBMARINE BOAT HUNLEY.

W. A. Alexander.

bulkheads. No. 4. Compass. No. 5. Sea cocks. No. 6. Pumps. No. 7. Mo...
No. 10. Stern bearing and gland. No. 11. Shaft braces. No. 12. Propell...
No. 16. Steering lever. No. 17. Steering rods. No. 18. Rod braces. No. 19. A...
Cast-iron keel ballast. No. 27. Bolts. No. 28. Butt end of torpedo boo...
shaft. No. 31. Keel ballast.

Charleston, only a few miles from where she had begun her journey. The removal operation reached its successful conclusion when the submarine was secured inside the Warren Lasch Conservation Center in a specially designed tank of fresh water to await conservation.

Excavation and Preservation

Many years of work lay ahead for Robert Neyland, Maria Jacobsen and the other archaeologists investigating the wreck. A preliminary evaluation of the vessel was made using a new technology called a Cyrax 3-D laser scanning system that allowed archaeologists to scan the interior of the *Hunley* before excavation. Using that information they first entered the submarine through an existing hole in the stern ballast tank. Eventually the excavation team removed several hull plates to gain access to the central compartment and retrieve the crew and artifacts in the interior. For the first several months, archaeologists worked through the mud-sodden interior, cleaning, recovering, recording and preserving all the evidence it contained. All aspects of the vessel were treated in the same way, being cleared and measured so that investigators could preserve the wreck through all available techniques.

After cleaning and conservation, portions of the vessel revealed clues as to its dimensions and method of construction. Many had thought the vessel would resemble a bulky cylindrical steam boiler but the neatly tapered bow gave the vessel a streamlined elegant appearance. Even minute details came to light, such as how the steering mechanism and crankshaft worked, the condition and nature of the hull plates and riveting techniques. The *H.L. Hunley* was far more technologically advanced than originally believed with adjustable diving planes, water ballast tanks and movable snorkel tubes for drawing air into the vessel while submerged. Archaeologists discovered that the ship's commander could control the ship rudder using a "joystick," possibly the first such device in maritime history. The design of the ship's weapon system was solved with discovery of the *H.L. Hunley*. It was long believed that the spar was a twenty-two-foot yellow pine boom rigged to the ship's upper bow. However, the spar proved to be a seventeen-foot hollow iron rod mounted with a Y-shaped joint at the bottom of the bow.

Before discovery of the submarine, it had been speculated that some of the crew had escaped and their bodies were subsequently lost at sea. This theory proved false when eight skeletons were found, more or less, in their stations. The distribution of the skeletons in the cabin was recorded graphically, and the resultant depositional pattern provided archaeologists with clues to the events on the *Hunley* after she sank. Archaeologists meticulously excavated the cabin, skeletons were carefully exposed and forensic evidence was collected before the remains were removed. The first of the crew's remains, discovered in the snorkel box part of the crew compartment, were still intact skeletons and not scattered about the *Hunley*'s interior as earlier feared. Fortunately, the sediment had provided a protective layer, preserving the

remains of the crew. Although all the remains were in good condition, Lieutenant George Dixon's were especially well preserved, indicating to archaeologists that he may have been covered by the protective sediment sooner than the others were. The fine sediment covering Dixon's remains indicate there was no large breach in the hull but that the water came in relatively slowly through a breach small enough to keep larger shells out. The upper layers were much coarser sediment, including relatively large shells. This material would have entered the hull through larger openings, probably breached after the vessel was on the bottom for some time. This information suggests that there was no catastrophic damage to the hull during the attack on the *Housatonic* and that she did not sink as a result of the torpedo's detonation, although she may have been crippled by leaks. The major hull damage discovered by archaeologists occurred some time after the sinking and was not a consequence of the attack or related to a U.S. Navy ship dragging an anchor into the retreating submarine. Considered with the location of the crew's remains, this information intimates asphyxiation rather than drowning, although the evidence is far from conclusive at this point.

The thick mud into which the wreck settled helped preserve the *Hunley*, and sediments quickly sealed off the ship from harmful oxygen with the result that fragile textiles and personal items survived 136 years on the ocean floor. Alongside the crew's remains were artifacts that revealed their individuality and also their habits. Excavators recovered a wooden pipe with tobacco still in the bowl, eight canteens, a leather wallet, a sewing kit, a thimble and Lieutenant Dixon's pocket watch. Archaeologists also discovered a man's pinky ring with nine diamonds and a decorative brooch with thirty-seven diamonds beneath Lieutenant Dixon's right thighbone. The ornate jewelry was characteristic of the well-dressed and flamboyant Lieutenant Dixon, though no one is sure what sentimental value these personal items had for the Confederate officer.

Even the smallest components of the wreckage, such as textiles, did not go overlooked. Items of clothing found aboard the *Hunley* reveal that the sailors were generally in step with Civil War fashions. Although little remains of their garments, the more durable objects such as buttons, shoes and buckles were located during excavation. Archaeologist Mike Scafuri found the first crew artifacts, two well-preserved buttons, on the bench in the opening amidships. Using manufacturer's marks on the backs of the buttons, the *Post & Courier* identified the buttons as possibly coming from the coat of crewman Corporal C.F. Carlson. Buttons from Union uniforms were also discovered during excavation of the submarine. The South's inability to produce adequate quantities of clothing forced Confederate soldiers to appropriate discarded Union clothing. That was apparently the case on the *Hunley*, where there is a wide range of both Confederate and Federal buttons. These types of finds will prove vital in providing a clearer understanding of life and work during the Civil War.

The discovery of a Union soldier's dog tag in a Confederate submarine caused quite a sensation among the investigators. It was speculated that Ezra Chamberlain,

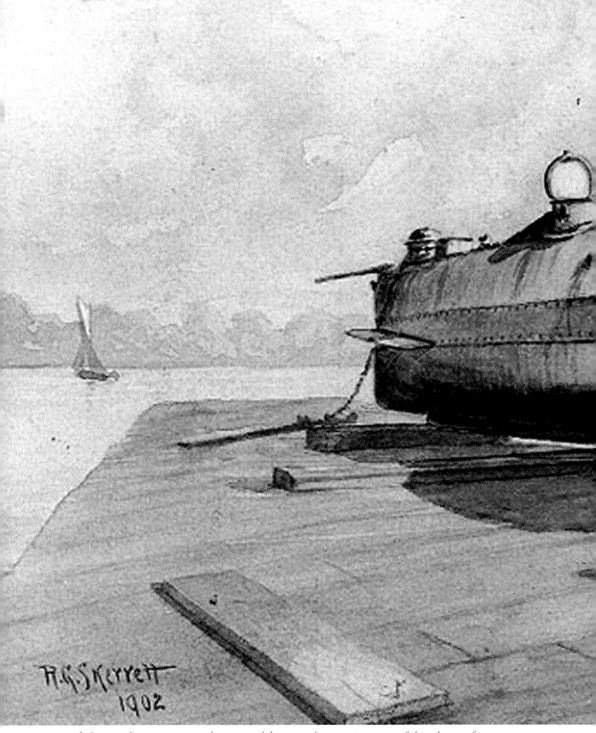

Confederate submarine *H.L. Hunley*. Artwork by R.G. Skerrett. Courtesy of the Library of Congress.

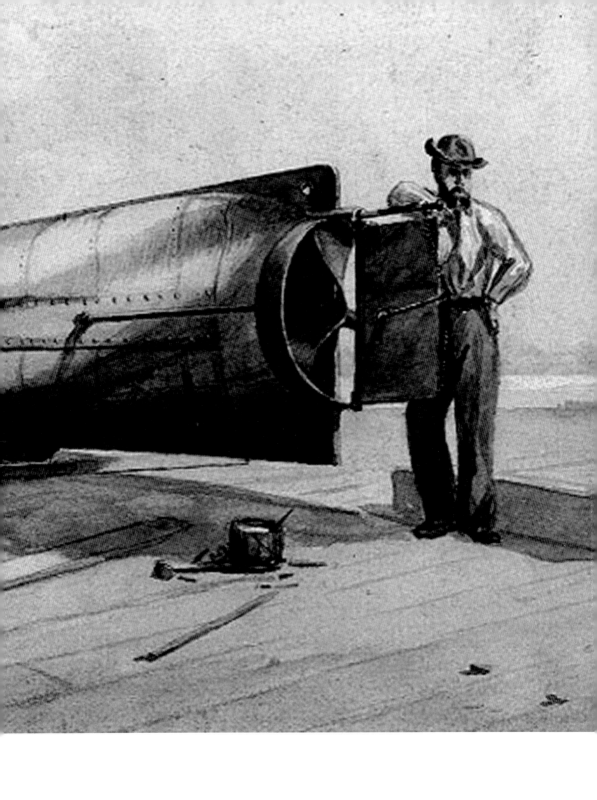

a Union infantry soldier, had defected to the Confederacy or was a prisoner pressed into hazardous service aboard the *Hunley*. After intensive research into the soldier's origin and ultimate demise, these theories were proven unlikely. At age twenty-one, Ezra Chamberlain had joined the Seventh Connecticut Infantry at his home in Killingly. After two basically uneventful years as a carpenter, Chamberlain was involved in the ill-fated assault on Fort Wagner, Morris Island, on July 11, 1863. Private Chamberlain was killed in action, and his body was left behind as the Union forces were driven into a hurried retreat. The dog tag was probably taken as a battlefield souvenir by Confederate artillery Corporal C.F. Carlson on Morris Island. After duty at Fort Wagner, Carlson became one of the final *Hunley* crewmembers. It is likely that Carlson had taken the identification tag from Chamberlain's remains on Morris Island and was subsequently carrying it around his neck when the *Hunley* was lost.

Perhaps the most emotional moment for archaeologists was the discovery of the gold coin Lieutenant George Dixon carried with him when the *Hunley* sank on that fateful February night. For over 136 years, it was not known if the coin actually existed. According to historical accounts, Lieutenant George E. Dixon had been given a twenty-dollar gold piece by his Southern belle, Queenie Bennett, from Mobile, Alabama, before he marched off to fight in Tennessee. In 1862, Dixon was shot in the Battle of Shiloh, and the bullet struck the gold coin in his trousers pocket, bending it into the shape of a bell. The gold coin had saved his leg, if not his life. During the excavation, the gold coin was discovered near the remains of George Dixon. True to contemporary accounts, the coin bore the dent from the bullet and was inscribed:

Shiloh
April 6, 1862
My life Preserver
G.E.D.

Senator Glenn McConnell said the coin is estimated to be worth as much as $10 million. "But it's really priceless," he said, "because it is absolutely irreplaceable." The Friends of the *Hunley* announced that Dixon's gold coin would be made a permanent part of the *Hunley* exhibit in North Charleston.

Though there are still many years of work ahead, patient and systematic laboratory procedures, combined with careful recording and exhaustive archival research, have allowed jumbled pieces of the *Hunley* puzzle to be reassembled. In terms of structural characteristics, nothing comparable to the inherent features of the submarine exists in the world; she was an engineering marvel. But results of the excavations together with documentary data and contemporary descriptions should remove forever any romanticized notion of a pristine vessel adorned with modern comforts. In their place are the images of claustrophobic spatial arrangements, dank smells of men, sounds of cold murky water pressing on all sides and a vessel always

The Confederacy's Secret Weapon

one mistake from the ocean floor. When the hatch was open for practice, light and air were admitted; otherwise, only a dim light filtered down through several small windows. But nothing about the *Hunley* was for aesthetics or comfort, for it was in the line of duty that she was expected to fight. Everything about the ship was designed to a single end: the ability to bring the fight to the Union's South Atlantic Blockading Squadron.

Morris Island

How the Land Shaped History and History Shaped the Land

We saw the lightning and that was the guns; and then we heard the thunder and that was the big guns; and then we heard the rain falling and that was the blood falling; and when we came to get in the crops, it was dead men that we reaped.
—Harriet Tubman

In 2000, graduate student Chris Nichols was conducting research for his thesis to pinpoint historical sites on Morris Island and to document the effects that the geomorphology of the island has had on land use. Man's role in the recent morphology and geography of the island was also outlined. The historical information yielded an interesting story of the history of Morris Island. The desolate island, now occupied only by nature, was once populated by soldiers, a lighthouse community and a small school. Today, there are no easily seen physical reminders of this rich past except for the Morris Island Lighthouse.

The dynamic coastline and morphology of Morris Island have had a controlling influence on the island's land use and cultural history since the eighteenth century. Even the name of the island has seen significant change. For instance, in the eighteenth century, three separate islands composed what we now call Morris Island; these include Republican Island or Pelican Bank, Mawrace's or Light House Island and Middle Bay Island or Coffin Land. Other names include Morrison's Island, Maurice's Island and Cummins Island.

Pre-Civil War

In August of 1670, Englishman John, Lord Carteret, returning from Virginia on the ship *Carolina*, stopped on Morris Island to collect marsh grass for his cattle. His party was attacked by Westo Indians, but they were not killed. Native Americans likely occupied the island seasonally for hundreds, if not thousands, of years prior to Carteret's visit. The first land grants on Morris Island were made to Jonathan Drake and John Herne on April 14, 1710, for Cummins and Middle Bay Islands. Charleston's first lighthouse was built on Morris Island in May of 1767 by the Colony of South Carolina, but the light took nearly ten years to complete. A copper plate and the light's cornerstone were found by construction crews during the building of the modern Charleston Main Light. It read:

> *The first stone of this beacon was laid on the 30th of May 1767 in the Seventh year of his Majesty's reign, George the III King of Great Britain, etc...Lord Charles Greville Montagu, governor (Commander) in chief, Honorable William Bull, Esq., lieut. Governor; Hon. Peter Manigault, Esq., speaker; Wm. Woodrop, Sam'l Reid. Rob't Rivers, John Torrans, John Forbes, Henry Laurens, Thomas Savage, Sam Cardy, arct.; Thomas You, engr., Fenwick Bull, clerk, Adam Miller, brick layer.*

A crude lead engraving of the tower was also unearthed.

In 1776, the British fleet attempted to take Fort Sullivan (now Fort Moultrie) on Sullivan's Island immediately to the north of Morris Island. The sandbars immediately offshore made it tricky for the fleet to navigate into Charleston Harbor. During the attack, three British frigates ran aground on a sand shoal "owing to the ignorance of the pilot." One ship remained stranded until the next morning when the British thought it "proper to scuttle and set her on fire."

The light on Morris Island was used to guide ships to the peninsula of Charleston. A plan of Charleston Harbor depicted both the lighthouse and the lower beacon in 1776. The navigational course into the harbor was written as follows:

> *The Course. Mid-Channel is West. Southerly in as far as the Lower Beacon, now Stands not being fixed at the place, first stated by Capt. William White and John Turke. The Course to the upper Beacon, is W ½ N. the Course out East Northly.*

The lighthouse was taken over by the U.S. government in August of 1789. There were only eight lighthouses in operation between Portsmouth, New Hampshire, and Charleston when the United States "accepted from the states the title to and joint jurisdiction over the lighthouses on the coasts." The land around the lighthouse, then called Middle Bay Island, was ceded to the U.S. government on January 20, 1790. This first lighthouse was described as a "strange building, not over fifty feet high and twenty feet in diameter." From 1812 to 1819, the tower received $5,000 from Congress for repairs, and was fitted with a revolving light with six to eight reflectors in a lantern, each with a lens in front.

Charles Town

Bayley yr River

the Windmill

I.

Morris Island, 1670. Courtesy of Christopher Nichols.

Charlestonian John Clement, noticing that Cummings Point was building land, applied for and received a grant for a tract of land on the northernmost portion of the island, which was called Pelican or Republican Island. After Clement died, his widow sold Republican Island to John Malliard (or Maitland). Malliard then applied and received a grant for the entire island called Maurice's Island in 1818. Malliard sold a few tracts of land on Morris Island from 1818 to 1825, usually of one acre. His creditors took him to court and the entire island was sold at a public auction in 1825 to T.H. Jervey, B.F. Pepoon and A.G. Rose. An 1833 plat surveyed by Charles Parker by request of Newman Kershaw depicts roads (South Street), docks, buildings and a road to the "New Beacon" on Morrison's Island.

In 1834, the City of Charleston reportedly purchased a lazaretto for $6,000 on Morris Island. An "old small pox hospital" on the island was referred to and mapped in Civil War records in 1861. Jervey, Pepoon and Rose sold lots in the Cummings Point area of the island from 1833 to 1845. As evidenced by an 1852 plat of Morris Island, these three men planned to develop the island into a neatly organized town. The small town was laid out on the northern end of the island and was composed of 257 lots (each containing approximately 0.57 acres), roads (North and South Streets) and a "hospital" owned by the State of South Carolina. But this seemingly ideal town never came to be, as shown by a smaller undated plat where half of the proposed town is under water.

The community that was planned on Cummings Point in the 1850s eroded away into the sea before it got underway. The fact that the settlement was eroding at such rapid rates was a glimpse to the future for these prospective inhabitants. Surprisingly, the warning was heeded, lessons were learned and no settlement was commenced. The very thin, low relief barrier ridge area would not have been safe ground for refuge during a large storm. The few houses that were there, like the Beacon House, became shelters and firewood for troops during the Civil War before being engulfed by the surf.

Nonetheless, there were residents and summer visitors on Morris Island during the mid-nineteenth century. Charleston resident Louisa Lord, who spent the summer of 1850 there with her family, describes the island as follows:

> *Living so exposed to the ocean there is always plenty of sea breeze which is quite a treat, there are about three or four families living here. We all are near each other and are very intimate, our neighbors being all very sociable and pleasant people, there are not restrains of fashions and we do just as we like which is a great convenience.*

The United States government established a range light in congruence to the old light in 1837. As a guide through the ship channel, other small beacons stood to the east and south of it. In 1838, the light was described as an octagonal brick structure standing 102 feet tall from the base to the revolving light. It is unclear whether this tower was "relocated a mile or so to the south" of the eighteenth-century tower, or if the 1838 tower was simply rebuilt near the original locale.

A new first-order Fresnel lens was installed in the rebuilt tower in January of 1858. In December of 1860, the same month that South Carolina seceded from the Union, a Lighthouse Board inspector reported that the governor of the state of South Carolina enabled "forcible possession…of the lights, buoys, etc., of this Charleston harbor." As the Union's Stone Fleet noticed on their last voyage in December of 1861, the lighthouse had already been torn down by Confederates. The Lighthouse Board issued a report in 1862, which decreed the following: "Charleston, lens and lantern destroyed."

CIVIL WAR ON MORRIS ISLAND

In early January of 1861, a steamer by the name of *Star of the West* was sent from New York to Charleston for the purpose of reinforcing Major Anderson and his troops in Fort Sumter. The steamer proceeded up the Main Ship Channel along Morris Island when it was "opened on by a masked battery near the north end of Morris Island by a detachment of Citadel Cadets." Only a red palmetto flag was seen flying on Morris Island. Nothing else indicated the existence of a battery. The works here were very simple and built very hastily, leaving the guns and gunners entirely exposed. "A broadside of light navy shell guns could have disabled it, and the guns of Fort Sumter completely commanded it."

The shots thrown at the *Star of the West* were seen as blatant acts of war by the United States, and were thus the first hostile shots of the Civil War. For the next three months, beginning in January, slave labor and Confederate troops built batteries along the Morris Island coast with the plentiful sand and trees available. Troops working here were "quartered in the buildings constituting the small pox hospital." By April 5, 1861, the batteries on Morris Island were in place for the planned attack on U.S. Major Anderson in Fort Sumter. Included in this array of batteries was an ironclad fortification where railroad T-iron was placed at a forty-five-degree angle over heavy timbers.

With tensions mounting between the North and South, Fort Sumter was first fired upon on the morning of April 12, 1861, from Fort Johnson. A heavy bombardment was kept up on Fort Sumter by Morris Island batteries, Fort Johnson, the floating battery and Fort Moultrie on Sullivan's Island until Major Anderson's surrender the following day. The scene on Morris Island, after the surrender, was described as follows:

> *A horseman galloped at full speed along the beach, waving his cap to the troops near the Light-house. These soon caught up the cry, and the whole shore rang with the glad shouts of thousands.*

Charleston became a crucial target and symbol of Secession for the Union army during the Civil War. By 1863, the harbor was protected by Fort Sumter at the mouth of the harbor, Fort Moultrie on Sullivan's Island and Batteries Wagner and Gregg on Morris Island.

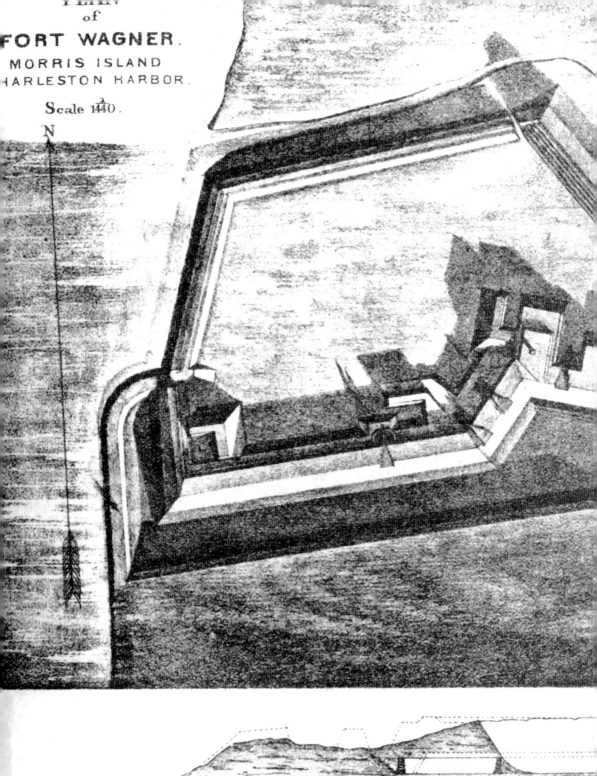

PLAN of FORT WAGNER.
MORRIS ISLAND
CHARLESTON HARBOR.

Scale 1/1440.

N

Vertical Section

The approximate resultant of fire from the several
Scale 50 f

N.B. The firing was a little too much to the right to open the body of the bomb-proof
which was insufficient to open the bomb-proof, even had the direction
soon have been breached.

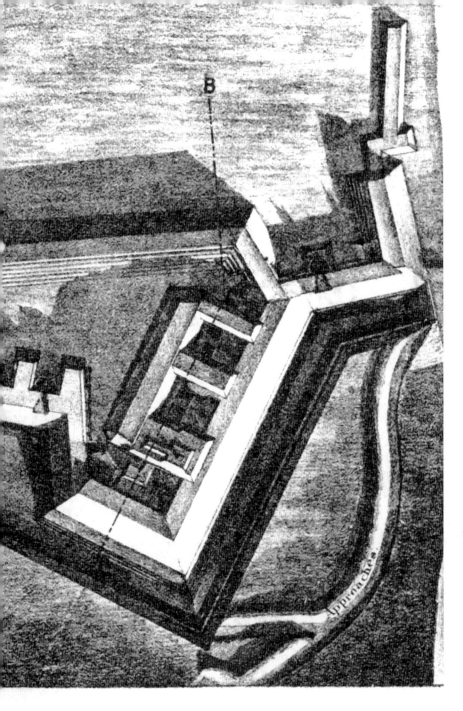

ine A. B.

ing batteries, Sept. 5th & 6th.

section is simply intended to show the quantity of sand removed,
right. The magazine connecting with the bomb-proof would

1852 plan of Fort Wagner. Courtesy of Christopher Nichols.

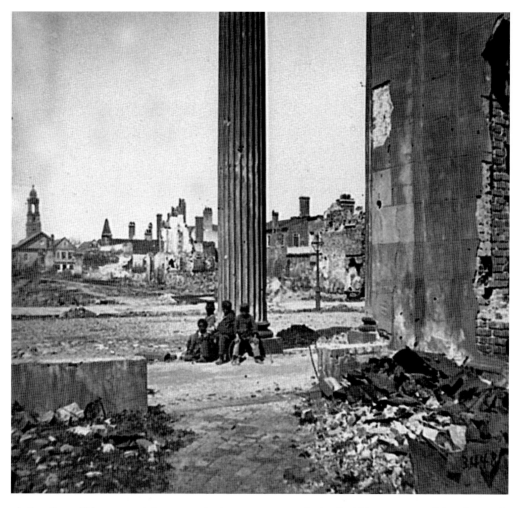

Shelling from offshore turned downtown Charleston into a virtual pile of rubble. *Courtesy of the Library of Congress.*

On April 7, 1863, Union ironclads, under the command of Rear Admiral Samuel Francis DuPont, made an attempt to attack Charleston from the sea. His vessels moved up the Main Ship Channel along Morris Island and began firing on the Confederate forts. The largest vessel, the *New Ironsides*, could not properly navigate the channel and had to drop anchor while the other ships were dueling with the Confederate forts. The Confederates had three times as many artillery pieces and forced the ironclad squadron back. A badly damaged ironclad, the *Keokuk*, sank off the southern end of Morris Island the next day as DuPont refused to risk another attack. During this attack, a Union brigade landed on Folly Island and put a battery of two guns on the island's northern end (Little Folly Island). On May 10, a Confederate raiding party was sent across Lighthouse Inlet to drive the Federal pickets back, but the Confederates missed the Union battery, hidden in the vegetation and sand hills.

Visions of powerful earthworks and fortifications on Morris Island protecting Charleston and southerly marshes never materialized for the Confederates. During the summer of 1863, Union troops had been constructing fortifications at the northern end of Folly Island under the watchful eye of the Confederates. The works were hidden from view of the Confederates by "the formation of the island, covered with ridges of sandhills" and "dense jungle." Though the Confederates knew of the works, there were other positions on nearby James Island to worry Confederate General Beauregard. During the initial attack on Morris Island, Union troops "made a strong demonstration against James Island by the Stono River." These troop movements were only intended as decoys, but Beauregard stated that they were made with "such strength that at any moment it could have been converted into a real attack of the most disastrous kind to us."

Plans for strengthening the lower stretch of Morris Island below the famous Confederate Battery Wagner near Cummings Point included a network of causeways connecting James Island with Morris Island. Beauregard had ordered the construction of two Confederate batteries of two guns each on Black Island, which commanded Lighthouse Inlet. This island was to be connected with the mainland by a "branch from the bridge planned to connect James and Morris Islands." A proposal was made by Brigadier General Ripley "to place several heavy guns at different points on the shore [of Morris Island] to command the whole anchorage from inside the Bar to Fort Sumter." These works were not built because of the lack of labor, transportation and engineers.

So, on July 10, 1863, "only nine independent one gun batteries met the concentrated fire of 47 guns in the masked Federal Batteries on Little Folly Island, and 8, 11 and 15-inch guns in the Monitors offshore." Following a three-hour morning barrage of fire, nearly 2,500 Union troops crossed Lighthouse Inlet in small boats. Three-quarters of the island was taken in a single day, and only Battery Wagner and Cummings Point remained in Confederate hands. Casualties were 294 Confederates dead, wounded and missing and 107 Union soldiers dead, wounded and missing.

The following day, on July 11, 1863, Union troops made their first assault on Battery Wagner. The attack lasted less than half an hour and resulted in "a complete repulse of the assailants who retired to the sand hills of the island, out of range of the Confederate battery." There were an estimated four hundred Union casualties and twenty-four Confederate casualties on this day. General Q.A. Gillmore of the United States Army then ordered the construction of heavy batteries on Morris Island from 1,300 to 1,900 yards in front of Battery Wagner. These works would give the Federal armies cover in the planned grand assault on Battery Wagner.

The famous offensive charge led by the African American Fifty-fourth Massachusetts Regiment occurred on July 18, 1863. The attack began with all available Union batteries opening up on Battery Wagner. The navy joined in with substantial fire from the ironclad fleet. This bombardment lasted for eleven and a half hours and averaged fourteen projectiles thrown per minute. Union armies

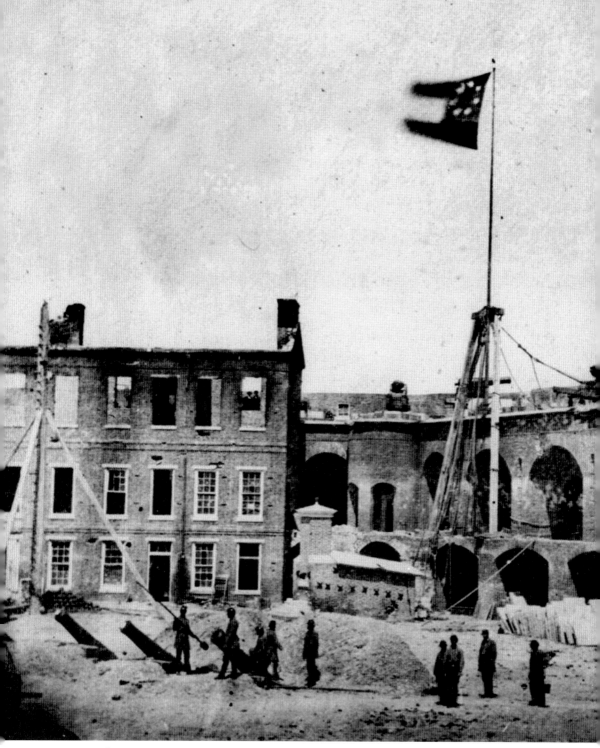

View of Fort Sumter, circa 1865. Courtesy of the Library of Congress.

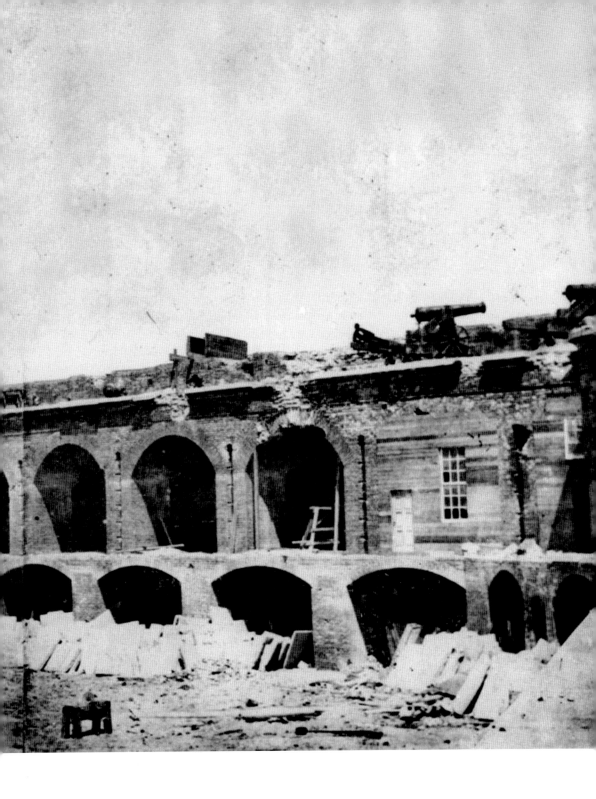

stormed Battery Wagner at twilight so that the move might not be distinctly seen from James Island, Sullivan's Island or Fort Sumter. The resulting melee was a Union catastrophe, where total casualties were 1,689 (Union 1,515 and Confederates 174). The garrison of Wagner was held by the Charleston Battalion, two North Carolina units, two companies of Georgia men and the First South Carolina Infantry. Union forces consisted of troops from Connecticut, Pennsylvania, New Hampshire, Massachusetts and New York.

After these unsuccessful attempts, Gillmore began the slower, safer combination of bombardment from afar and slow encroachment to the Confederate works. In this mode of the campaign, the Union military employed relatively new techniques like trench warfare and continuous bombardment with cannon fire from the land coupled with ironclad attack from the sea. Gillmore's only difficulty in this approach was "the shifting nature of the material he had to dig in, and the narrow ground on which to approach." His right flank was protected by the ironclads and his left was protected by an impassable marsh, only exposed to the fire of batteries on James Island, $2\frac{1}{4}$ miles distant. A series of trenches were dug to Battery Wagner. Soldiers were constantly working under the protection of cannon fire and even used calcium lights to shine on Battery Wagner at night.

Finally, on September 6, 1863, Union sappers reached the ditch in front of Wagner. The Confederates evacuated both Battery Wagner and Battery Gregg on September 7, and Federal forces entered Wagner without a fight. Morris Island was occupied by Federal forces for the rest of the war. From Cummings Point on Morris Island, the Union army pummeled Fort Sumter into a heap of bricks, rocks and sand, which actually did much to increase its strength and versatility. Rubble absorbed the cannon fire rather well in comparison to the rigid, brittle walls of Fort Sumter.

Confederate forces on James Island were in constant artillery battle with Union men on Morris Island and Black Island. It was not until February of 1865 that Confederate forces evacuated Charleston and Fort Sumter because General Sherman's troops were moving against Columbia.

Many narratives and Civil War histories describe conditions and troop movements on Morris Island, Folly Island and James Island. Troops stationed on Morris Island described it in a variety of ways:

> *This Morris Island is the most desolate heap of sand-hills I ever saw. It is so barren that you cannot find so much as a gypsum weed growing…The beach at some points is at least one-third of a mile in width, descending at an almost imperceptible angle into the more refreshing breakers.*
>
> *They harass our fatigue parties considerably with their shells, but they only succeed in killing and wounding one or two men a day. I have visited all parts of the island, the regiments, the batteries, the forts, the hospitals, the depots, the ruins of the light-house, the skeleton of the Beacon House, the old batteries that triumphed over the rebel strongholds, the vicinity of the 'Swamp Angel,' and the solemn grave-yards…Henceforth this island is peculiarly the property of the muse of history.*

The Civil War was finally over on Morris Island in 1865, and the island was deserted again.

The lay of the land had dictated the way that the Civil War battles were fought, and it brought new technologies to this small arena of war. Many of the beach ridges in the interior of the island were used as batteries because of their position, relative elevation to the salt marsh and sand composition. The approach to Battery Wagner was quite treacherous, with the surf on one side and the marsh on the other. General Gillmore described the stretch as twenty-five yards wide where the "sea frequently breaks entirely over the island during spring tides." Had the island been occupied by Confederates in larger numbers, the war would have been much bloodier still. Once General Beauregard realized that there was no way to expel the enemy from Morris Island, as "the surface of Morris Island did not permit maneuvering of troops," he was resigned to adopt a defensive stance at Battery Wagner.

Morris Island, and Cummings Point in particular, underwent a tremendous amount of area and shoreline change during the Civil War and immediately afterward. This may have been largely due to the war. The systematic clearing of vegetation from the island by the Union and Confederate armies (for visibility and defense purposes) and the bombardment of the island contributed to this relatively high rate of area loss (1.1 percent per year) and erosion rates. The heavy bombardment by Union troops on the Confederates in Batteries Wagner and Gregg violently disturbed the sediment and killed vegetation on Cummings Point. In fact, estimates of more than nine thousand Union shells from the land and sea poured into Battery Wagner during a single day, at a rate of nearly one every two seconds. A trench along the beach, dug by Union sappers as they moved toward Wagner, and a large moat in front of Wagner also contributed to the erosion of the island during these years.

Post-Civil War

Because of the permanent state of flux of the Charleston Harbor ebb-tidal delta, the Main Ship Channel was rapidly migrating. The Lighthouse Board reported in 1865 "that an almost total change had taken place, leaving no channel in the harbor as it was in 1860, and opening new ones." It was necessary, because of this natural barrier island change and ebb-tidal delta movement, to establish lights at useful, navigationally relevant positions. All others would be deleted because of their lack of utility.

Despite the secretary of the treasury's 1867 recommendation that the range lights be placed elsewhere, the U.S. Congress made the first of three appropriations for a new lighthouse on Morris Island in March of 1873. The amount of $60,000 was granted for "commencing the rebuilding of a first-order seacoast light on Morris Island destroyed during the war." Two other appropriations of $90,000 total were received in 1874 and 1875.

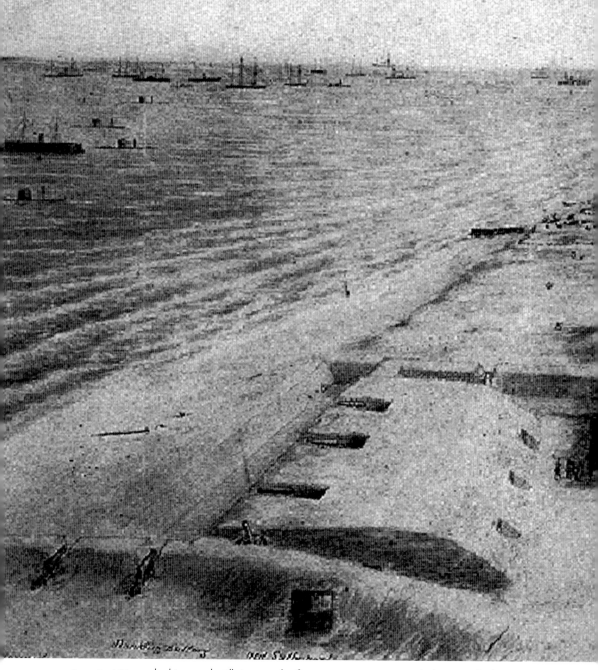

From Fort Wagner looking south. All sites south of Cummings Point were eroded away in the late nineteenth and early twentieth centuries. *Courtesy of Christopher Nichols.*

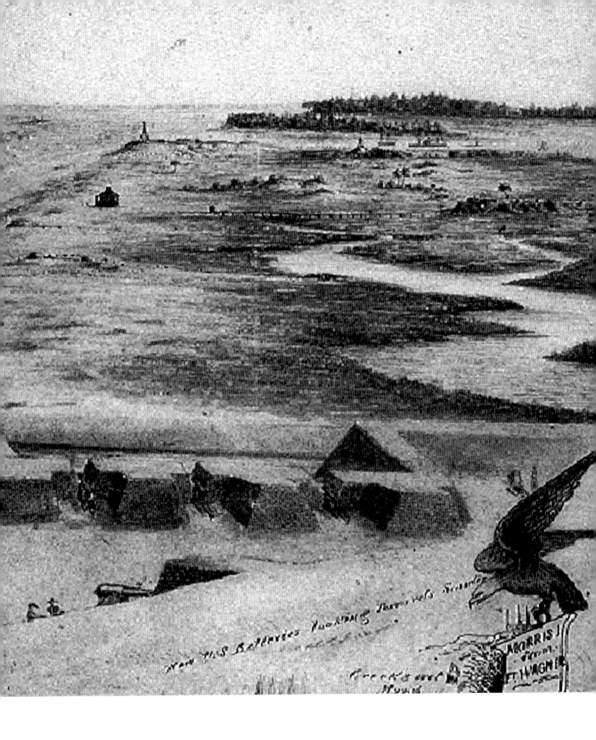

R.H. Conwell, a correspondent to a Boston newspaper, mentioned that a Union veteran of the Fifty-fourth Massachusetts was living on the island with his family in the old bombproof of Battery Gregg. He was harvesting old iron from the sand and selling it by the ton.

The presently existing lighthouse tower was completed on dry land in 1876 after a delay owing to the unhealthiness of the location. This unhealthiness was due to hundreds of buried Civil War soldiers being exposed from the rapidly eroding shoreline and the existence of a postwar quarantine station. Many of the dead were exhumed after the war and reburied in the National Cemetery at Beaufort, South Carolina. R.H. Conwell provided the following account of Morris Island a few years after the Civil War:

> *A sad sight met our eyes when, following our guide, we reached the level sea beach. Human skeletons from which the sea had washed the sand lay grinning upon the shore and fill us with sad sensations, which still haunt our dreams...The same wave that uncovered their naked bones also brought up the richest and rarest shell of the great deep.*

The postwar quarantine station on Morris Island was moved to Fort Johnson on James Island after "the late violent gale during the month of September of 1874 rendered the buildings untenable." Recommendations were made for the quarantine station to be moved to another site: "Immediate action is absolutely necessary, as there is no place for sick seamen coming into port with contagious diseases."

The Morris Island Light of 1876, which still exists today, though no longer in use, rises 158 feet above sea level, and the brick tower is 33 feet in diameter at its base. Material from the lighthouse destroyed during the Civil War was used in making concrete for this tower. The focal plane height is listed as 155 feet and the light is visible for 18¾ miles. The foundation includes 264 pilings in a circle with a radius of 22 feet, giving each pile a load of 12 tons. The total cost was $149,993.50, and a first-order Fresnel lens was installed.

Since the time of its construction, the light has survived numerous hurricanes. The storm on August 25, 1885, caused considerable damage to the Morris Island Lighthouse community. The rear beacon of the Morris Island range was destroyed, part of the brick wall enclosing the tower and dwelling of the main light was overturned, the bridge between the beacons was carried away, most of the walkways connecting the several lights were destroyed and the boathouse was overturned. Within days, the range was reestablished by a temporary beacon. A forty-foot-high wooden skeleton structure was built in 1885.

The Charleston earthquake of 1886 threw the lens out of position and cracked the tower in two places. The lens was replaced and the cracks were repaired without delay.

In 1894, a petition to the U.S. was made by Michel Vendenheim (a French citizen) for losses consisting of four acres of land on Morris Island, personal property, a large house and outside buildings. His land and property were made use of by General Gillmore and the military forces of the United States.

During the 1890s, George Andrew Shierlock and others lived and attended school at the "Sheltering Arms" on Morris Island, operated by the Reverend A.E. Cornish. The Charleston County School Board maintained a one-teacher school on Morris Island for the children of the lightkeepers. On Monday morning, the teacher was met at Folly Beach near the present-day remains of the Coast Guard Station by a man in a rowboat. She was then ferried to Morris Island until Friday afternoon. A room of the lightkeeper's house was fitted with desks and blackboards as a makeshift schoolhouse. An automobile on Morris Island, used by the keepers, was said to be the only vehicle in the state legally operating without a license tag, since it was driven on the Morris Island beach and not the highways. As the dirt roads and beach were being engulfed by the Atlantic Ocean at alarming rates, the car was no longer usable and was subsequently transformed into a chicken house.

The Charleston jetties were completed in 1896, and the Main Ship Channel off Morris Island was no longer the primary navigational channel into the harbor. The protective offshore shoals underwent shoreline progradation and began infilling the southern portion of the old Main Ship Channel immediately, but the break in the jetties (known locally as "Dynamite Hole") prevented this sediment from reaching the rapidly eroding Cummings Point by 1900. When the offshore shoals were no longer protecting the island, the southern end of the island began to erode at a rapid rate because of increased wave attack. In addition, the low relief in these areas and the lack of a well-developed foredune ridge made the island more susceptible to shoreline erosion.

So the range of lights on Morris Island were not needed in their full capacities. Destruction of vegetation, coupled with jetty construction, made the island very susceptible to coastal erosion and overwash, thus causing the high rates of barrier ridge area loss and shoreline loss near the lighthouse during the first four decades of the twentieth century.

Catherine Weber Shierlock, wife of George Shierlock, lived on the island with her husband and their baby daughter in a large four-room apartment near the base of the lighthouse in 1917. Her husband was the third assistant light tender. She recalls the island as a "very lonely place" during World War I, and after a few months, she returned to Charleston.

John D. Ohlandt, owner and preservationist of nearby Black Island, remembers visiting the lighthouse with his father in the 1930s as a young boy. He enjoyed playing with the young children on Morris Island and fishing in its creeks. Ohlandt once built a kite to tie onto his boat so that rowing would be much easier on his way to Morris Island from Folly Island. Ohlandt spoke of a man who would row him and his father to Morris Island and back. A honk of the car horn on the upper end of Folly Island was used to alert the lightkeepers of their arrival.

The light was turned off during both world wars so as not to aid the enemy. A watch was kept for enemy ships, but no soldiers were quartered there. During World War II, the Air Force practiced dropping bombs on the east end of Folly Island and shook the tower's foundation.

The last lighthouse keeper was W.H. Hecker, a soldier at Fort Moultrie for thirteen years, and his assistant was W.A. Davis. His family was ordered to leave their house in 1938 because of encroaching waves beneath their home and outbuildings toppling into the surf. Once again, barrier island morphology forced the end of a small settlement. Esther Hecker, wife of W.H. Hecker, describes her time on Morris Island as follows:

> *When we first went, there was so much land you could barely see water. When we left, the water was at the doorstep. But I loved that place. If the tide hadn't washed the land away, we'd be there still.*

The lightkeeper's quarters were destroyed in a 1938 hurricane. Dr. Prentiss, from Adams Run, South Carolina, used the boards of this house for a home on Edisto Island. Steel sheet piling was driven around the tower and filled with a concrete cap, as the light was left to weather the seas alone. In that same year, the Morris Island Light was automated. No other settlements have been attempted on Morris Island since the lighthouse was abandoned.

In 1953, a state park on Morris Island was proposed to the State of South Carolina in order to provide African Americans a beach for bathing and land for the erection of homes. This project never materialized but was originally brought up as a solution to segregation laws prohibiting African Americans from visiting state parks in South Carolina.

In 1962, the Charleston Light at Sullivan's Island was completed, and the Morris Island Light was deactivated. The old light was scheduled to be razed in 1965, but survived thanks to concerned citizens.

From 1969 to 1970, a dredge area was constructed by the United States Army Corps of Engineers (USACOE) using *in situ* material. The dredge area marked a relatively new attempt at utilizing this tiny island. This time, while improving the navigability of Charleston Harbor, the geographical entity known as Morris Island actually increased in area. No longer was it a thin strip of sand, but the island became a large, square section of elevated land surrounded by a ten- to twenty-foot containment dike.

Saint Elmo Felkel, owner of the lighthouse from 1966 to 1996, suggested that the lighthouse be turned into a tourist attraction, but these plans never materialized. In 1996, Felkel gave up the lighthouse in a foreclosure to Columbia businessman Paul Gunter, who then offered to sell for $100,000. Finally, in 1999, the lighthouse was purchased by Save The Light Incorporated, a nonprofit organization dedicated to preserving the lighthouse. Save The Light plans to "stabilize" the foundation with help from the USACOE and the State of South Carolina.

Currently, the lighthouse (constructed in 1876) is the only semblance of a permanent settlement on the island. However, the cultural significance of Morris Island is of tremendous value to the maritime history of the city of Charleston, the state of South Carolina and to the United States of America. The first lighthouse

guiding ships into the Charleston Harbor was officially started here in 1767 by the colony of South Carolina, and was one of only eight lighthouses in operation between Portsmouth, New Hampshire, and Charleston, South Carolina, when the federal government took over in 1789. The first hostile shots of the Civil War were thrown from Morris Island in January of 1861 at the steamer *Star of the West* coming from New York harbor to Charleston for the purpose of reinforcing Federal troops in Fort Sumter. After the war, the island was home to a tiny lighthouse community with a small schoolhouse and lifesaving station. The Morris Island Lighthouse of 1876 is the lone remaining sentinel of these times.

Bibliography

Adams, Natalie P. "Now A Few Words About The Works…Called The Old Royal Work." *Phase I Archaeological Investigations at Marion Square, Charleston, SC. Report submitted to Van Valkenburg and Associates, Inc. New South Associates Technical Report Number 556, 1998. June 26, 1998.*

Adams, Natalie, and Michael Trinkley. "Archaeological Survey of the Seasides Farm Tract, Charleston County, South Carolina." Chicora Research Foundation Research Series 35. Columbia, SC, 1993.

Anderson, David G. "The Internal Organization and Operation of Chiefdom Level Societies on the Southeastern Atlantic Slope: An Explanation of Ethnohistoric Sources." *South Carolina Antiquities* 17 (1985): 35–69.

Anderson, David G., Charles E. Cantley and A. Lee Novick. "Indian Pottery of the Carolinas: Observations from the March 1995 Ceramic Workshop at Hobcaw Barony." Council of South Carolina Professional Archaeologists, 1996.

———. "The Mattassee Lake Sites: Archaeological Investigations along the Lower Santee River in the Coastal Plain of South Carolina." U.S. Department of the Interior, National Park Service, Southeast Regional Office, 1982.

———. "The Mississippian in South Carolina." In *Studies in South Carolina Archaeology*, edited by Albert C. Goodyear III and Glen T. Hanson, 101–32. South Carolina Institute of Archaeology and Anthropology, Anthropological Studies 9, 1989.

Bibliography

Anthony, Ronald. "Colono Wares." In *Home Upriver: Rural Life on Daniel's Island, Berkeley County, South Carolina*, edited by Martha Zierden, Lesley Drucker and J. Calhoun. Prepared for the South Carolina Department of Transportation, 1986.

Blanton, Dennis B., Christopher T. Espenshade and Paul E. Brockington Jr. "An Archaeological Study of 38SU83: A Yadkin Phase Site in the Upper Coastal Plain of South Carolina." Prepared for the South Carolina Department of Transportation, 1986.

Brockington, P., M. Scardaville, P. Garrow, D. Singer, L. Frances and C. Hoyt. "Rural Settlement in the Charleston Bay Area: Eighteenth and Nineteenth Century Sites in the Mark Clark Expressway Corridor." Prepared for the South Carolina Department of Transportation, 1985.

Brooks, Michael J., P.A. Sotne, D.J. Colquhoun and J.G. Brown. "Sea level Change, Estuarine Development and Temporal Variability in Woodland Period Subsistence-Settlement Patterning on the Lower Coastal Plain of South Carolina." In *Studies in South Carolina Archaeology*, edited by Albert C. Goodyear III and Glen T. Hanson, 91–100. South Carolina Institute of Archaeology and Anthropology, Anthropological Studies 9, 1989.

Cable, John S. A Study of Archaeological Predictive Modeling in the Charleston Harbor Watershed. Report submitted to the Office of Ocean and Coastal Resource Management. New South Associates Technical Report Number 414. August 20, 1996.

Coclanis, Peter. *Shadow of a Dream: Economic Life and Death in the South Carolina Low Country 1670–1920*. New York: Oxford University, 1989.

Coe, Joffre L. "Formative Cultures of the Carolina Piedmont." *Transactions of the American Philosophical Society* 54, no. 5 (1964).

Colquhoun, D., M. Brooks, J. Michie, W. Abbott, F. Stapor, W. Newman and R. Pardi. "Location of archeological sites with respect to sea level in the Southeastern United States." In *Striae, Florilegiem Florinis Dedicatum* 14, edited by L.K. Kenigsson and K. Paabo, 144–50, 1981.

Covington, James W. "Stuart's Town. The Yemassee Indians and Spanish Florida." *The Florida Anthropologist* 21 (1978): 8–13.

Cushion, John P. *Pottery and Porcelain*. New York: Hearst Books, 1972.

DePratter, Chester B. "The Chiefdom of Cofitachequi." In *The Forgotten Centuries: Indians and Europeans in the American South, 1521–1704*, edited by Charles Hudson and Carmen Tesser, 197–226. University of Georgia Press, 1994.

———. "Cofitachequi: Ethnohistorical and Archaeological Evidence." In *Studies in South Carolina Archaeology*, edited by Albert C. Goodyear III and Glen T. Hanson, 133–56. South Carolina Institute of Archaeology and Anthropology, Anthropological Studies 9, 1989.

DePratter, Chester B., Charles Hudson and Marvin T. Smith. "The Route of Juan Pardo's Explorations in the Interior Southeast, 1566–1568." *Florida Historical Quarterly* 62, no. 2 (1983): 125–58.

DePratter, Chester B., and Marvin T. Smith. "The Juan Pardo Expeditions: North from Santa Elena." *Southeastern Archaeology* 9 (2): 140-146.

———. "Sixteenth Century European Trade in the Southeastern United States: Evidence from the Juan Pardo Expeditions (1566–1568)." In *Spanish Colonial Frontier Research*, edited by Henry F. Dobyns, 67–78. Center for Anthropological Studies, 1980.

———. "W.P.A. Archaeological Excavations in Chatham County, Georgia: 1937–1942." *Laboratory of Archaeology Series*, No. 29. Athens: University of Georgia, 1991.

Dobyns, Henry F. *Their Number Become Thinned: Native American Population Dynamics in Eastern North America*. Knoxville: University of Tennessee Press, 1983.

Edgar, Walter B. *Partisans and Redcoats: The Southern Conflict that Turned the Tide of the American Revolution*. New York: Harper Collins, 2001.

———. *South Carolina: A History*. Columbia: University of South Carolina Press, 1998.

Edgar, Walter B., and N. Louise Bailey. *Biographical Directory of the South Carolina House of Representatives: Volume II, The Commons House of Assembly, 1692–1775*. Columbia: University of South Carolina Press, 1977.

Espenshade, Christopher T. "The Changing Use Contexts of Slave-Made Pottery on the South Carolina Coast." Paper presented at the African Impact on the Material Culture of the Americas Conference, 1996.

———. "The Early Woodland Ceramics from the Minim Island Site (38GE46), Georgetown County, South Carolina." Paper presented at the Sixteenth Conference on South Carolina Archaeology, 1990.

Espenshade, Christopher T., Linda Kennedy and Bobby G. Southerlin. "What is a Shell Midden? Data Recovery Excavations of Thom's Creek and Deptford Shell Middens, 38BU2, Spring Island, South Carolina." Prepared for Spring Island Plantation, 1994.

Bibliography

Eubanks, Elsie, Bruce Harvey and Eric C. Poplin. "Archaeological Data Recovery of 38CH679-3 McLeod Plantation, Charleston County, South Carolina." Report prepared for the Hawthorne Corporation and the Historic Charleston Foundation by Brockington and Associates, Inc., 1996.

Ferguson, Leland G. "Low Country Plantations and River Burnished Pottery." In *Studies in South Carolina Archaeology*, edited by Albert C. Goodyear III and Glen T. Hanson, 185–91. South Carolina Institute of Archaeology and Anthropology, Anthropological Studies 9, 1989.

———. Mississippian Artifacts and Geography. Paper presented at the 1975 meeting of the Southern Anthropology Society, Clearwater Beach, 1975.

———. South Appalachian Mississippian. PhD diss., department of anthropology, University of North Carolina, 1971.

———. *Uncommon Ground: Archaeology and Early African America 1650–1800*. Washington, D.C.: Smithsonian Institution Press, 1992.

Fetcher, Joshua N. "Archaeological Data Recovery at 38CH1292, Charleston County, South Carolina." Prepared by Brockington and Associates, Inc., Mount Pleasant, SC, 2002.

Fetcher, Joshua N., Pat Hendrix and Kristrina Shuler. "Archaeological Data Recovery at Spring Farm, Dorchester County, South Carolina." Prepared by Brockington and Associates, Inc., Mount Pleasant, SC, 2005.

Fraser, Walter. *Charleston! Charleston!: The History of a Southern City*. Columbia: University of South Carolina Press, 1989.

Frost, John. *An Illustrated History of North America, From the Earliest Period to the Present Time*. New York: Henry Bill, 1860.

Garrow, Patrick H., and Thomas R. Wheaton. "Colonoware Ceramics: The Evidence from Yaughan and Curriboo Plantations." In *Studies in South Carolina Archaeology*, edited by Albert C. Goodyear III and Glen T. Hanson, 175–84. South Carolina Institute of Archaeology and Anthropology, Anthropological Studies 9, 1989.

Goodyear, Albert C., III. "The Early Holocene Occupation Internal Organization of the Southeastern United States: A Geoarchaeological Summary." In *Ice Age Peoples of North America*, edited by R. Bonnichsen and K. Turnmire, 432–81. Oregon State University Press, 1990.

———. "Evidence of Pre-Clovis Sites in the Eastern United States." In *Paleoamerican Origins: Beyond Clovis*. Edited by R. Bonnichsen et al. Texas A&M University Press, 2004.

BIBLIOGRAPHY

Goodyear, Albert C., III, and Glen T. Hanson. *Studies in South Carolina Archaeology*. South Carolina Institute of Archaeology and Anthropology, Anthropological Studies 9, 1989.

Goodyear, Albert C., III, James L. Michie and Tommy Charles. "The Earliest South Carolinians." In *Studies in South Carolina Archaeology*, edited by Albert C. Goodyear III and Glen T. Hanson, 19–52. South Carolina Institute of Archaeology and Anthropology, Anthropological Studies 9, 1989.

Gregorie, Anne K. *Christ Church 1706–1959: A Plantation Parish of the South Carolina Establishment*. Charleston: The Dalcho Historical Society, 1961.

Hardin, Kris L. "Technological Style and the Making of Culture: Three Kono Contexts of Production." In *African Material Culture*, edited by Mary Jo Arnoldi, Christraud M. Geagy and Kris L. Hardin, 31–50. Bloomington: Indiana University Press, 1996.

Hartley, Michael O. *The Ashley River: A Survey of Seventeenth Century Sites*. South Carolina Institute of Archaeology and Anthropology research Manuscript Series 192, 1984.

Hewat, Alexander. *An Historical Account of the Rise and Progress of the Colonies of South Carolina and Georgia*. Reprint Co., 1962. First published 1779 in London.

Hicks, Brian, and Schuyler Kroph. *Raising the* Hunley: *The Remarkable History and Recovery of the Lost Confederate Submarine*. New York: Ballantine Books, 2002.

Huddleston, Connie M. "Colonoware Analysis." In "Archaeological Data Recovery At 38CH1402 and 38CH1405 Park West Tract Charleston County, South Carolina," by Tina M. Rust, Ralph Bailey and Eric C. Poplin, Appendix A. Prepared for Land Tech Charleston, LLC, 2002.

———. "Plates and Scalloped Rims: Indications of Temporal Change in Low Country Colonoware Production." Paper presented at the Fifty-fifth Annual Meeting of the Southeastern Archaeological Conference, 1993.

Huddleston, Connie, and Eric C. Poplin. "French Huguenot Planters, Patriots, and Statesmen: Archaeological Data Recovery at the Legare Colonial Home, Charleston County, South Carolina." Prepared by Brockington and Associates, Inc., 1998.

Joseph, J.W. "Management Summary: Archaeological Excavations at 122 King Street, 100 Broad Street, and 98½ Broad Street." Report submitted to Charleston County Capital Projects. New South Associates Technical Report Number 466. May 30, 1997.

———. "Pattern and Process in the Plantation Archaeology of the Lowcountry of Georgia and South Carolina." *Historical Archaeology* 23, no. 1 (1989): 55–68.

Bibliography

Joseph, J.W., and Rita F. Elliott. "Restoration Archeology at the Charleston County Courthouse, Charleston, South Carolina." Report submitted to Liollio Associates. New South Associates Technical Report Number 194. September 15, 1993.

Joseph, J.W., and Theresa M. Hamby. "Archaeological Search for the Walled City of Charleston: The South Trust Bank Site at 93 Cumberland Street." Report submitted to the Historic Charleston Foundation. New South Associates Technical Report Number 981. April 15, 2002.

———. "A New Look at the Old City: Archaeological Excavation of the Charleston County Judicial Center Site (38CH1708)." Report submitted to Charleston County Capital Projects. New South Associates Technical Report Number 1192. August 2004.

———. "The Vendue/Prioleau Archaeological Study: Management Summary." Report submitted to Vendue/Prioleau Associates, LLC and the Charleston Department of Planning and Urban Development. New South Associates Technical Report Number 741. May 12, 2000

Joyner, Charles. *Down by the Riverside: A South Carolina Slave Community.* Urbana and Chicago: University of Illinois Press, 1985.

Lambert, Robert S. *South Carolina Loyalists in the American Revolution.* Columbia: University of South Carolina Press, 1987.

Lewis, Kenneth E., and Donald L. Hardesty. "Middleton Place: Initial Archaeological Investigations at an Ashley River Rice Plantation." South Carolina Institute of Archaeology and Anthropology Research Manuscript Series 148, 1979.

Lewis, Lynne G. "Drayton Hall: Preliminary Archaeological Investigation at a Low Country Plantation." National Trust for Historic Preservation, 1978.

Lumpkin, Henry. *From Savannah to Yorktown: The American Revolution in the South.* Columbia: University of South Carolina Press, 1981.

Martins, Susannah Wade. *The English Model Farm: Building the Agricultural Ideal, 1700–1914.* Cheshire, UK: Windgather, 2002.

McCrady, Edward. *The History of South Carolina in the Revolution, 1775–1780.* New York: Macmillan Company, 1901.

———. *The History of South Carolina Under the Proprietary Government, 1670–1719.* New York: Macmillan Company, 1897.

McCurry, Stephanie. *Masters of Small Worlds: Yeoman Households, Gender Relations, and the Political Culture of the Antebellum South Carolina Low Country.* New York: Oxford University Press, 1995.

McKee, W. Reid, and M.E. Mason Jr. *Civil War Projectiles II: Small Arms and Field Artillery*. N.d.

Michie, James. *Richmond Hill Plantation, 1810–1868: The Discovery of Antebellum Life on a Waccamaw Rice Plantation*. Columbia: University of South Carolina Press, 1990.

Miller, George L. "Classification and Economic Scaling of 19th Century Ceramics." *Historical Archaeology* 14: 1–40.

Miller, Ruth M., and Ann Taylor Andrus. *Witness to History: Charleston's Old Exchange and Provost Dungeon*. Orangeburg, SC: Sandlapper, 1986.

Misago, Kanimba. "Ceramics From the Upemba Depression: A Diachronic Study." In *African Material Culture*, edited by Mary Jo Arnoldi, Christraud M. Geagy and Kris L. Hardin, 103–29. Bloomington: Indiana University Press, 1996.

Noël Hume, Ivor. *A Guide to Artifacts of Colonial America*. New York: Alfred A. Knopf, 1970.

———. "An Indian Ware of the Colonial Period." *Archaeological Society of Virginia Quarterly Bulletin* 17 (1962).

Palladio, A. *The Four Books of Architecture*. Translated by I. Ware, 1727. Reprint 1965. First published 1570 in New York by Dover.

Pancake, John S. *This Destructive War: The British Campaign in the Carolinas, 1780–1782*. Tuscaloosa: University of Alabama Press, 1985.

Poplin, Eric C. "Variations in Early Colonial Plantations: Experimentation in the New World." Paper presented at the Thirty-sixth Annual Conference on Historical and Underwater Archaeology, 2003.

Poplin, Eric C., and Bruce G. Harvey. "Archaeological Data Recovery Investigations at Schieveling Plantation Tract, Charleston County, South Carolina." Prepared for the Schieveling Plantation, LLC, 2003.

———. "Cultural Resources Investigations of the Schieveling Plantation Tract, Charleston County, South Carolina." Prepared for the Schieveling Plantation, LLC, 1999.

Poplin, Eric C., Christopher T. Espenshade and David C. Jones. "Archaeological Investigations at the Buck Hall Site (38CH644), Francis Marion National Forest, South Carolina." Prepared for the U.S. Department of Agriculture, National Forest Service, 1993.

Poplin, Eric C., and Colin Brooker. "The Historical Development of Dataw Island." Prepared for ALCOA South Carolina, Inc., 1993.

Bibliography

Poplin, Eric C., and Connie M. Huddleston. "Archaeological Data Recovery at the Thomas Lynch Plantation (38CH1479 and 38CH1585), RiverTowne Development Tract, Charleston County, South Carolina." Prepared for RiverTowne Development, Mount Pleasant, SC, 1998.

Poplin, Eric C., Kara Bridgman and Patrick Severt. "Archaeological Investigation of 38CH1025 at the Pointe at RiverTowne Country Club, Mount Pleasant, South Carolina." Prepared for Associated Developers, Inc., 1998.

Poplin, Eric C., and Michael C. Scardaville. "Archaeological Data Recovery at Long Point Plantation (38CH321), Mark Clark Expressway (I-526), Charleston County, South Carolina." Prepared for the South Carolina Department of Transportation, 1991.

Poston, Jonathan. *The Buildings of Charleston: A Guide to the City's Architecture.* Columbia: University of South Carolina Press, 1997.

Quarterman, Elsie, and Katherine Keever. "Southern Mixed Hardwood Forest: Climax in the Southeastern Coastal Plain." *Ecological Monographs* 32 (1962) 167–85.

Ramenofsky, Anne P. "The Archaeology of Population Collapse: Native American Response to the Introduction of Infectious Disease." PhD diss., department of anthropology, University of Washington, 1982.

Rosen, Robert N. *Confederate Charleston: An Illustrated History of the City and the People During the Civil War.* Columbia: University of South Carolina Press, 1994.

Rowland, Lawrence S, Alexander Moore and George C. Rogers. *The History of Beaufort County, South Carolina: 1514–1861.* Columbia: University of South Carolina Press, 1996.

Rust, Tina M., Ralph Bailey Jr. and Eric C. Poplin. "Archaeological Data Recovery at 38CH1402 and 38CH1405, Park West Tract, Charleston County, South Carolina." Prepared for Land Tech Charleston, LLC, 2000.

Salley, A.S., Jr., ed. *Warrants for Lands in South Carolina 1672–1711.* Columbia: University of South Carolina Press, 1973.

Sassaman, Kenneth E., Mark J. Brooks, Glen T. Hanson and David G. Anderson. "Native American Prehistory of the Middle Savannah River Valley." Savannah River Research Papers 1. Occasional Papers of the Savannah River Archaeological Research Program, South Carolina Institute of Archaeology and Anthropology, 1990.

Saunders, Rebecca, ed. "The Fig Island Ring Complex 938CH42: Coastal Adaptation and the Question of Ring Function in the Late Archaic." Prepared for the South Carolina Department of Archives and History, 2002.

Bibliography

Severens, Kenneth. *Charleston Antebellum Architecture and Civic Destiny.* Knoxville: University of Tennessee Press, 1988.

Shick, Tom W., and Don H. Doyle. "The South Carolina Phosphate Boom and the Stillbirth of the New South, 1867–1920." *South Carolina Historical Magazine* 86 (1985).

Sirmans, M. Eugene. *Colonial South Carolina: A Political History, 1663–1763.* Chapel Hill: The University of North Carolina Press, 1966.

Smith, Henry A.M. *The Historical Writings of Henry A.M. Smith.* Spartanburg: The Reprint Company, 1988.

Smith, Marvin T. "Depopulation and Culture Change in the Early Historic Period Interior Southeast." PhD diss., department of anthropology, University of Florida, 1984.

South, Stanley A. "Analysis of Buttons from Brunswick Town and Fort Fisher." *Florida Archaeologist* 17, no. 2 (1964): 113–33.

———. "Archeological Excavation at the Site of Williamson's Fort of 1775, Holmes Fort of 1780, and the Town of Cambridge 1783–1850s." Institute of Archaeology and Anthropology, Research Manuscript Series 18, University of South Carolina, 1972.

———. *Archaeological Pathways to Historic Site Development.* New York: Kluwer Academic/Plenum, 2002.

———. "An Archaeological Survey of Southeastern Coastal North Carolina." South Carolina Institute of Archaeology and Anthropology *Notebook* 8 (1976): 1–55.

———. "Doorway to the Past: The Archaeology of Santa Elena." South Carolina Institute of Archaeology and Anthropology, Popular Series 2, 1992.

———. "Exploratory Archeology at Ninety Six (38-GN-1, 38-GN-5)." Institute of Archaeology and Anthropology, Research Manuscript Series 6, University of South Carolina, 1970.

———. "Historical Perspective at Ninety Six With a Summary of Exploratory Excavation at Holmes Fort and the Town Blockhouse." Institute of Archaeology and Anthropology, Research Manuscript Series 9, University of South Carolina, 1971.

———. *Method and Theory in Historical Archaeology.* New York: Academic Press, 1977.

———. "Palmetto Parapets: Exploratory Archaeology at Fort Moultrie, South Carolina, 38CH50." South Carolina Institute of Archaeology and Anthropology, 1964.

Bibliography

South, Stanley A., and Michael Hartley. "Deep Water and High Ground: Seventeenth Century Low Country Settlement." In *Structure and Process in Southeastern Archaeology*, edited by Roy S. Dickens Jr. and H. Trawick Ward, 263–86. Tuscaloosa: University of Alabama Press, 1985.

Southerlin, Bobby, Dawn Reid, Connie Huddleston, Alana Lynch and Dea Mozingo. "Return of the Yamasee: Archaeological Data Recovery at Chechesy Old Field, Beaufort County, South Carolina." Prepared for Chechessee Land and Timber Company, 2001.

Spillman, Jane Shadel. *The Knopf Collectors' Guide to American Antiques: Glass: Volume 1 Tableware, Bowls & Vases*. New York: Alfred A Knopf, 1982.

Stanford, Dennis. "Interview with Smithsonian Anthropologist Dennis Stanford." Taken from a video recorded in March 1997. Located at the Northern Clans, Northern Traces website: http://www.mnh.si.edu/arctic/arctic/html/dennis_stanford.html

Trinkley, Michael. "An Archaeological Context for the South Carolina Woodland Period." Chicora Foundation Research Series 22, 1990.

———. "An Archaeological Overview of the South Carolina Woodland period: It's the Same Old Riddle." In *Studies in South Carolina Archaeology*, edited by Albert C. Goodyear III and Glen T. Hanson, 73–90. South Carolina Institute of Archaeology and Anthropology, Anthropological Studies 9, 1989.

———. "Archaeological Testing of the Awendaw Shell Midden, Charleston County." U.S. Department of Agriculture, Forest Service, 1981.

———. "Archaeological Testing of the Walnut Grove Shell Midden, Charleston County." U.S. Department of Agriculture, Forest Service, 1981.

———. "Investigations of the Woodland Period Along the South Carolina Coast." PhD diss., department of anthropology, University of North Carolina, 1980.

U.S. Census. Manuscripts: Agricultural Schedule and Industrial Schedule, Charleston County. On file at the South Carolina Department of Archives and History, 1850.

———. Manuscripts: Agricultural Schedule and Industrial Schedule, Charleston County. On file at the South Carolina Department of Archives and History, 1860.

Waddell, Eugene. *Indians of the South Carolina Low Country, 1562–1751*. Spartanburg: The Reprint Company, 1980.

Waring, Antonio J., Jr. "The Indian King's Tomb." In *The Waring Papers: The Collected Papers of Antonio J. Waring, Jr.*, edited by Stephen Williams, 209–15. Papers of the Harvard University Peabody Museum of American Archaeology and Ethnology 58, 1968.

Weir, Robert M. *Colonial South Carolina, A History.* New York: KTO Press, 1983.

Wheaton, Thomas R., Amy Friedlander and Patrick H. Garrow. "Yaughan and Curriboo Plantations: Studies in Afro-American Archaeology." U.S. Army Corps of Engineers, Charleston District and U.S. Department of the Interior, National Park Service, Southeast Regional Office, 1983.

Whitehead, Donald R. "Late Wisconsin Vegetational Changes in Unglaciated Eastern North America." *Quaternary Research* 3 (1973): 621–31.

———. "Palynology and Pleistocene Phytogeography of Unglaciated Eastern North America." In *The Quaternary of the United States*, edited by H.E. Wright Jr. and D.G. Frey. Princeton University Press, 1965.

Wills, Richard. "The *H.L. Hunley* in Historical Context," located at the Naval Historical Center Website: http://www.history.navy.mil/branches/org12-7b.htm

Wood, Peter H. *Black Majority: Negroes in Colonial South Carolina from 1670 through the Stono Rebellion.* New York: Alfred A. Knopf, 1974.

Zierden, Martha. "Archaeology at the Miles Brewerton House, 27 King Street." *Archaeological Contributions* 29, Charleston Museum, 2001.

———. "Archaeology at the Powder Magazine: A Charleston Site through Three Centuries (30Ch97)." *Archaeological Contributions* 26, Charleston Museum, 1997.

———. "Excavations at 14 Legare Street, Charleston, South Carolina." *Archaeological Contributions* 28, Charleston Museum, 2001.

———. "A Trans-Atlantic Merchant's House in Charleston: Archaeological Exploration of Refinement and Subsistence in an Urban Setting." *Historical Archaeology* 33, 1999.

———. "The Urban Landscape in South Carolina." In *Carolina's Historic Landscapes: Archaeological Perspectives.* Edited by Linda F. Stire, Martha Zierden, Lesley M. Drucker and Christopher Judge. Knoxville: University of Tennessee Press, 1997.

Bibliography

Zierden, Martha, and Bernard Herman. "Charleston Townhouses: Archaeology, Architecture, and the Urban Landscape, 1750–1850" in *Landscape Archaeology: Reading and Interpreting the American Historical Landscape*, edited by Rebecca Yamin and Karen Metheny. Knoxville: University of Tennessee Press, 1996.

Zierden, Martha, Jeanne Caloun and Debi Hacker-Norton. "Archdale Hall: Investigations of a Lowcountry Plantation." *Archaeological Contributions* 10, Charleston Museum, 1985.

Zierden, Martha, Lesley M. Drucker and Jeanne Calhoun. "Home Upriver: Rural Life on Daniel's Island, Berkeley County, South Carolina." Prepared for the South Carolina Department of Transportation, 1986.

Please visit us at
www.historypress.net